CREATIVE LANDSCAPES OF THE BRITISH ISLES

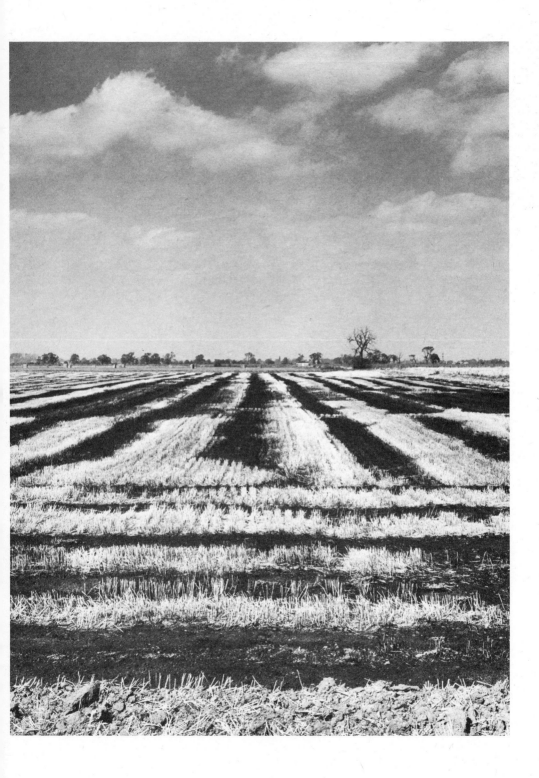

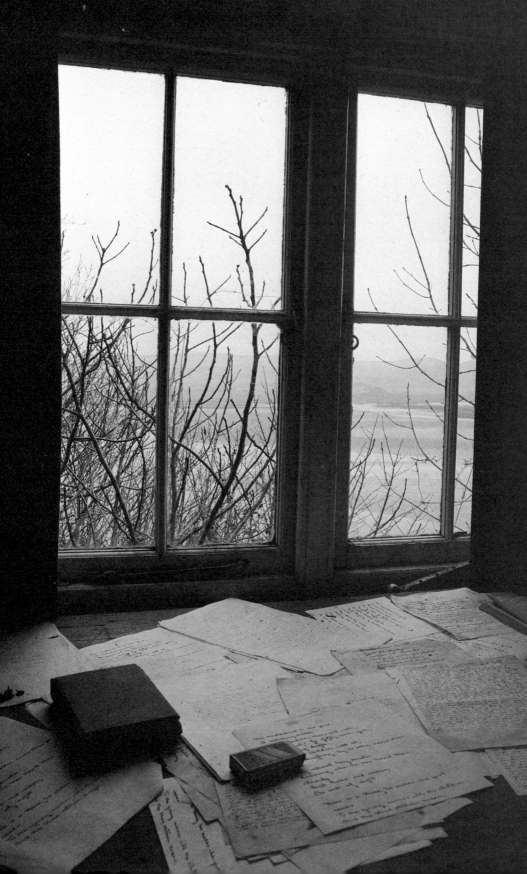

Bernard Price

CREATIVE LANDSCAPES OF THE BRITISH ISLES

Writers, painters and composers and their inspiration

EBURY PRESS

This book was designed and produced by
The Oregon Press Limited, Faraday House,
8 Charing Cross Road, London WC2H 0HG

First published in 1983 by
Ebury Press, National Magazine House,
72 Broadwick Street, London W1V 2BP

ISBN 0-85223-275-6

Design: Malcolm Harvey Young
Picture research: Marion Pullen

Filmset by SX Composing Limited,
Rayleigh, Essex, England
Printed and bound by Butler and Tanner Limited,
The Selwood Printing Works,
Frome, Somerset, England

HALF-TITLE The flat landscape of
John Clare country (*see* p. 78)

FRONTISPIECE Interior view of the 'writing-room'
of Dylan Thomas with its view to the sea (*see* p. 69)

Contents

CENTRAL

EAST ANGLIA

SOUTH WEST

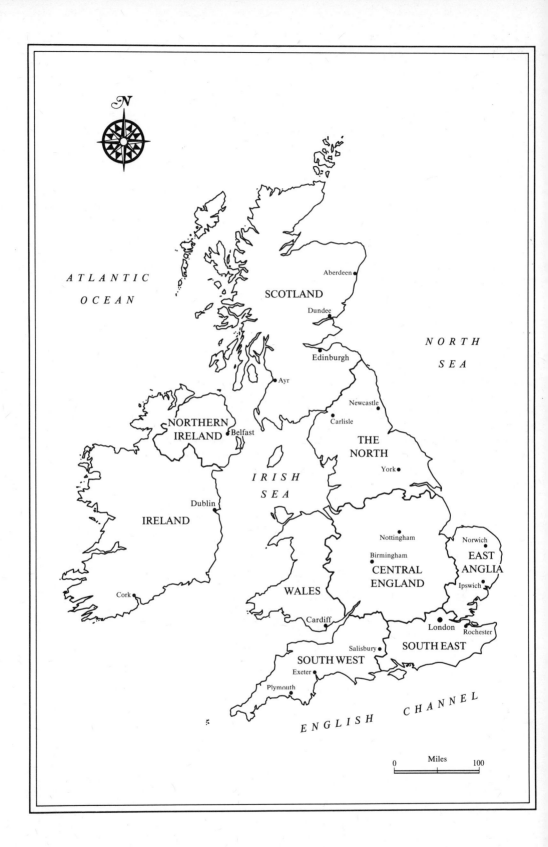

Introduction

The landscapes of Britain are as fine and varied as any to be found in the world; and the power of those landscapes and their impact on the creative mind has inspired a rich and glorious heritage of paintings, music and literature. This book, however, makes no pretence at being a comprehensive catalogue of locations —far from it. Everyone who loves the countryside and wild places will have their own favourite places that stimulate and refresh them. Here I have made a collection, an entirely personal choice, of places and the creative artists with whom they have become linked and the works that have resulted. In some cases, where a special affinity exists between artist and landscape, such areas may well be described as the spiritual home of the person concerned. Examples are not difficult to find: Samuel Palmer at Shoreham, Kent; John Constable and Dedham Vale; Gavin Maxwell at Sandaig, in the Western Highlands; Thomas Hardy at Egdon Heath, Dorset; Thomas Bewick at Cherryburn, Northumberland; Dylan Thomas at Laugharne; John Ireland and the South Downs; Charles Dickens in the lands that border the River Medway; and Frederick Delius and his lifelong remembrance of the moors of Yorkshire.

My choice has in the first instance been influenced by my preference for a landscape and, secondly, for the artist involved. In some cases the same landscape may have inspired numerous works by various authors and artists, so once again the decisions on what to include have been entirely mine.

For almost 40 years I have enjoyed exploring the British Isles on foot; I regard this as the ideal method by which to discover a true appreciation of landscape and a sense of place.

The motor car obviously has an important role to play in reaching areas of countryside, but beyond that the machine becomes an intruder. Far better the exploration that is governed by the personal compass of a stride; ease of access may become a double-edged sword, for the landscapes of quiet and beauty in Britain are easily wounded, sometimes mortally.

William Wordsworth put it more succinctly:

One impulse from a vernal wood
May teach you more of man,
Of moral evil and of good,
Than all the sages can.

Sweet is the lore which Nature brings;
Our meddling intellect
Mis-shapes the beauteous forms of things:—
We murder to dissect.

Scotland

Crossing into Scotland by way of Gretna Green it is good to reach Dumfries and the River Nith, a river and town so well known to Robert Burns. A few miles on and the landscape changes again. Here are the famous Maxwelton braes so beloved of Annie Laurie. Her home, Maxwelton House, still stands, with its courtyard and old marriage stones set into the walls. The Laurie family have now left the old house, but the song of Annie Laurie is still remembered and sung in many parts of the world. Not far away along Nithsdale is Burns's farm at Ellisland.

So many people who visit Scotland appear to head helter-skelter for the Highlands, not realizing that west of Dumfries is Kirkcudbrightshire, and a superb landscape of forests and fells that go on into Wigtownshire.

There is much bird life in this area—oyster catchers, blackcock, and if you are lucky, short-eared owls. Lapwings abound, but there was a time in Scottish history when they were not well regarded, and were known as the 'De'ils Plover,' remembering:

> When helpless Hill Folk, hard beset,
> Could naewhere but in muirlands get
> A night's safe quarters.
> Ye brocht the troopers on them set,
> And made them martyrs.

This magnificent walking country, which has attracted many artists, was considered recently as a possible site for the disposal of nuclear waste!

In the Cairngorms it is the mass of rocks and minerals that catch the eye, mica, quartz, feldspar, and other ornamental pebbles. It is, of course, the mountains that dominate here. In winter time there are gullies that fill with snow and are as deep and dangerous as quicksands. At Aviemore, there is Britain's only herd of reindeer, and there is also a nature reserve in the Cairngorm Mountains. Over on the west coast, beyond Glenshiel, is Sandaig, once the home of Gavin Maxwell and the setting of *Ring of Bright Water*.

In Perthshire, north and west of Stirling, is the landscape that so inspired Sir Walter Scott: the Trossachs, Loch Katrine and the Forest of Glenartney.

There is one area of art in Scotland that for many years has tended to be overlooked: the Victorian sporting illustrations of men in frozen pose together with their dogs, shooting blackcock or stalking deer. These book illustrations are an exciting glimpse into the past, and some of the illustrations were of outstanding skill. Leaders among these illustrators were J. G. Millais, A. Stuart-Wortley and Charles Whymper. In almost all such plates we see the landscape of Scotland, and the wildlife illustrations of Whymper can only be regarded as exquisite. The texts of such books often throw light on Scotland's rural life.

<div style="text-align:center">⋞⋗◦⋐⋫•⋞⋗◦⋐⋫</div>

ROBERT BURNS

The life of Robert Burns (1759–96) was a continual struggle against poverty. He attempted to earn a living by farming poor land, but the eventual failure of this venture led him to accept a post as exciseman at Dumfries; but it is as the poet of Scotland we remember him rather than as a farmer or government officer. He took refuge from his hard life with drink, women, and poetry, and the poems reflect the land and his loves.

He was born in a cottage at Alloway off the A77 just south of Ayr, now a Burns Museum.

His poem 'The Cotter's Saturday Night', as well as containing a hint of Thomas Gray (see p. 179), is deeply evocative of labour on the land:

> November chill blaws wi' angry sugh;
> The short'ning winter-day is near a close;
> The miry beasts retreating frae the pleugh;
> The black'ning trains o'craws to their repose:
> The toil-worn Cotter frae his labor goes,
> This night his weekly moil is at an end,
> Collects his spades, his mattocks and his hoes,
> Hoping the morn in ease and rest to spend,
> And weary, o'er the muir, his course does
> hameward bend.

Burns's mother was a singer of Scottish folk songs. This instilled in Robert Burns an abiding love of Scottish songs, which he collected throughout his life. 'My spirit', said Burns, was 'broke by repeated loses and disasters . . . my body too, was attacked by that most dreadful distemper, hypochondria, or confirmed melancholy.' Whenever his mind became darkened in these ways Burns invariably turned to the landscape along the River Ayr:

> I have various sources of pleasure and enjoyment which are, in a manner, peculiar to myself . . . such is the peculiar pleasure I take in the season of winter, more than the rest of the year. . . There is scarcely any earthly object gives me more—I don't know if I should call it pleasure, but something which exalts me, something which enraptures me —than to walk in the sheltered side of a wood or high plantation, in a cloudy, winter day, and hear a stormy wind howling among the trees and raving o'er the plain.

Periods such as these were responsible for such poems as 'The Gloomy Night', and 'O Raging Fortune's Withering Blast'. In his commonplace book he included some verses called 'Song', containing the lines:

The tempest's howl it soothes my soul, my griefs
it seems to join, the leafless trees my fancy please,
their fate resembles mine.

His first book of poetry, printed in Kilmarnock, shows well how Burns had the ability to create magical poems from small events of the countryside, such as 'To A Mouse, on turning her up on her nest with the plough', a poem with the immortal opening lines:

> *Wee, sleekit, cow'rin', tim'rous beastie,*
> *O, what a panic's in thy breastie!*

In 1788, following his marriage to Jean Armour, Burns took the tenancy of a farm at Ellisland, above the River Nith. For two years he lived in a hovel until a new farmhouse was built which enabled his wife and family to join him. Burns was a poet who rarely described the great mountain landscapes of Scotland, instead he poured his art into the observation of small things. He composed wherever he walked or worked; and the countryside of Robert Burns extends from Alloway just south of Ayr, and along the banks of the Ayr and the River Nith in Dumfriesshire.

In 1790 Burns was introduced to Francis Grose who was compiling a book called the *Antiquities Of Scotland*. Burns provided Grose with a list of what he considered to be suitable buildings for a book on Ayrshire; one of the buildings was Alloway Auld Kirk. Grose asked Burns to write a poem that would compliment the Kirk; and so it was that Burns composed the famous poem 'Tam O'Shanter' while walking a path along the banks of the Nith below Ellisland. The inn where Tam spent his drunken evening still stands in Ayr High Street and is now a Burns museum. The Auld Kirk and the bridge over the Doon also survive.

JOHN KEATS

When Keats and his friend Brown reached Scotland and began travelling through Dumfriesshire they were immediately struck by the poor living conditions of the people. Cottages provided little more than basic shelter, few had chimneys and most let the smoke escape through the open door. The two friends, who had been taken for pedlars in the Lake District, now walked like princes among a population that appeared to be barefoot. In spite of too many meals of porridge and oatcakes, the two men remained in the best of spirits and were eager for new sights and experiences.

As they travelled the length of Kirkcudbrightshire, Brown told the poet the story of Scott's *Guy Mannering*. Their destination lay beyond this lovely county at Portpatrick on the west coast, from where they took the packet boat to Ireland. They did not stay long; the countryside and the friendly Irish could not disguise the slums and human misery they saw all about them.

Returning to Portpatrick they set out for Ballantrae on 9 July. They followed the Ayrshire coast, and from the hills above Glen App were suddenly confronted with a view to Ailsa Craig some fifteen miles away. The next day the weather continued to improve, and

ABOVE Ailsa Craig (*see* Keats)

OPPOSITE The bridge over the Doon at Alloway (*see* Burns)

from the coastal path it seemed that Ailsa Craig followed them like a continuous presence. On reaching Girvan, almost opposite the great rock, Keats wrote his sonnet 'On Ailsa Rock'.

They journeyed on to the birthplace of Robert Burns at Alloway just south of Ayr. Today the cottage and museum bring many tourists to the area. The casual visitor is no doubt pleased to see the birthplace and the relics, but in Keats they produced more a sense of foreboding for himself, and helplessness as he pondered what he considered the unhappy life led by Burns. The images Keats garnered at Alloway stayed with him and were reflected in his poem 'After a Visit to Burns Country'. Even so Keats revelled in the sight of the River Doon and 'the Brig across it over which Tam O'Shanter fled'.

A walk to Loch Lomond followed later, and a visit to Loch Awe. In the Western Highlands they heard the cries of golden eagles flying high above them, and the Scots they met spoke only Gaelic.

The most important experience of their journey in Scotland was still to come. After much walking through rainstorms to Oban they embarked to the Isle of Mull and crossed the island on foot. The hardships of the journey brought Keats a fresh insight '. . . more experience, rub off more Prejudice, use me to more hardship, identify finer scenes, load me with grander Mountains, and strengthen more my reach in Poetry.'

On Iona, Keats became enchanted with this island toehold of Celtic Christianity, and was impressed by its ruins and tombs. A further boat journey to Staffa poured yet more images into his mind. Like Mendelssohn (see p. 17), Keats was overwhelmed by it: '. . . the colour of the columns is a sort of black with a lurking gloom of purple therein. For solemnity and grandeur it far surpasses the finest Cathedral.'

In spite of a cold and tonsilitis, Keats made his final brave gesture to Scotland by climbing Ben Nevis. 'Imagine', he said, 'the task of mounting 10 Saint Paul's without the conveniences of staircases.' The descent was even more difficult. 'Stick, jump, boggle, stumble, foot, hand, foot (very gingerly), stick again, and then again a game at all fours.'

Then came the journey back from Cromarty to London, on a fishing boat that made the journey in nine days. The two friends were exhausted, but the imagination of the poet was stocked to overflowing.

SEE ALSO PAGES 34, 154.

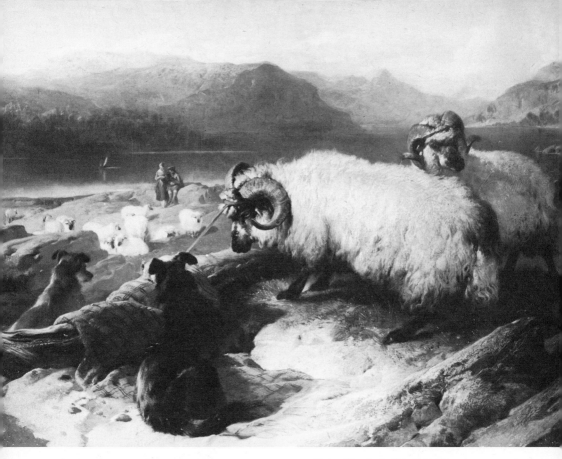

Tethered Lambs, by Edwin Landseer

EDWIN LANDSEER AND THE SCOTTISH HIGHLANDS

It was in 1824 that Landseer (1802–73) made his first visit to Scotland. He travelled with fellow artist C. R. Leslie, who planned to paint the portrait of Sir Walter Scott. Unfortunately they discovered that the great writer was away from Abbotsford so, before returning to England, they decided to see at least something of the Scottish countryside.

The grandeur of the Highland scenery was to Landseer a discovery and a revelation. He recognized in the mountains the face of beauty as well as something wild and forbidding; it was a landscape that captivated him. For years to come he visited the Highlands each autumn, deerstalking, drawing and painting.

During that first visit he sketched several of Sir Walter Scott's dogs at Abbotsford before going on to Loch Lomond, Loch Katrine and Loch Earn. Landseer's artistic education had lacked any tuition in landscape painting. This

was a disastrous omission at this stage of his career, now that he had just realized the power of landscape. The problem was not easily rectified, but it was his many paintings of red deer that were to give him the opportunity and the necessity of developing this particular artistic skill. (It was Landseer's delight in the deer that helped to produce this new direction in his art: he had once seemed destined to a lifetime of painting old ladies' pampered pets!) Some of the early Highland canvases are decidedly theatrical, however, and were completed with the help of another painter.

The Highland landscapes themselves provided the solution; his feelings for such scenery became so strong that he worked with a new intensity. An early critic wrote: 'Scotland taught him his true power, it freed his imagination: it braced up his loose ability; it elevated and refined his mind: it developed

his latent poetry: it completed his education.'

Landseer's landscapes became far freer than most of his paintings for they were not over-finished, a fault common to most of his work.

In the Royal Academy's 1961 Landseer Exhibition catalogue, Derek Hill wrote:

I had accepted the current opinions that Landseer was the epitome of all that was most boring and tiresome in Victorian painting, without questioning it. The revelation came on seeing the Tate panel [*Lake Scene: Effect of Storm*; a view across the Loch of Shelter Stone Crag], that gave me much the same sensation that Corot must have felt when he first saw a Bonington in a shop window in Paris. A sensation that in Corot's case made him abandon his job and devote the rest of his life to painting—'This is how a landscape should be painted.'

The Earl of Tankerville recalls in his memoirs his first meeting with Landseer:

We soon ensconced behind a heathery knoll within a few yards of our poacher, to watch his proceedings before we finally pounced upon him. He was a little, strong-built man, very like a pocket Hercules, or 'Puck' in the *Midsummer Night's Dream*. He was busily employed gralloching (removing the viscera) his deer. This he did with great quickness and dexterity, not omitting to wash the tallow and other treasures carefully in the burn and deposit them on the stone beside the deer. He next let the head hang over so as to display the horns, and then squatting down on a stone opposite took out of his pocket what I thought would be his pipe or a whisky flask: but it was a sketch book!

This extraordinary scene took place in the Glenfeshie Forest on the estate of Georgiana, Duchess of Bedford. He executed several sketches of the chase on the walls of two of the hunting lodges on the estate. They fell into neglect after her death and the last lodge was destroyed by a falling tree soon after the Second World War.

Landseer was also a frequent guest at the Balmoral estates on Deeside until the death of Prince Albert. Most of his work at Balmoral involved painting the royal dogs and the royal children. Landseer was knighted in 1850 and became Animal Painter to Her Majesty for Scotland. A delightful painting by Landseer depicts *Queen Victoria Sketching at Loch Laggan*, which is in the Royal Collection.

GAVIN MAXWELL

In 1960 Gavin Maxwell (1914–69), published a book that told of his life, and the animals that shared it with him in a lonely cottage on the northwest coast of Scotland. The book was called *Ring of Bright Water*. That bright water spread its refreshing ripples to many parts of the world. Here was a true story told by a highly accomplished writer, living a life of what seemed complete freedom, at one with the natural landscape and the elements. Not surprisingly, the book became a bestseller, not for any sensational reasons but for its timely reminder that there is an alternative to industrial life and computer living. As Gavin Maxwell was to put it: 'I am convinced that man has suffered in his separation from the soil and from the other living creatures of the world; the evolution of his intellect has outrun his needs as an animal, and as yet he must still, for security, look at some portions of the earth as it was before he tampered with it.'

There is also a Robinson Crusoe element to the book, in the useful objects washed up from time to time upon the beach; and, above all, there are Gavin Maxwell's otters.

In 1956 Maxwell travelled for some months with Wilfred Thesiger among the Marsh Arabs of southern Iraq. It was there that he had the idea of keeping an otter, and his home, ringed by water, might be the perfect place to attempt it. In due course Maxwell returned from the Tigris marshes carrying with him an otter. It proved to be an otter unknown to science and it was duly named *Lutrogale perspicillata maxwelli*. Maxwell called the otter Mijbil. Mijbil had free run of his new home on the borders of Inverness-shire and Ross and Cromarty, but was later killed from a blow by a roadmender's pickaxe. Another otter, Edal, became Mijbil's successor at Camusfeàrna, later joined by another called Teko.

Camusfeàrna was the name given by Maxwell to his home in the Western Highlands, meaning the Bay of the Alders. In *Ring of*

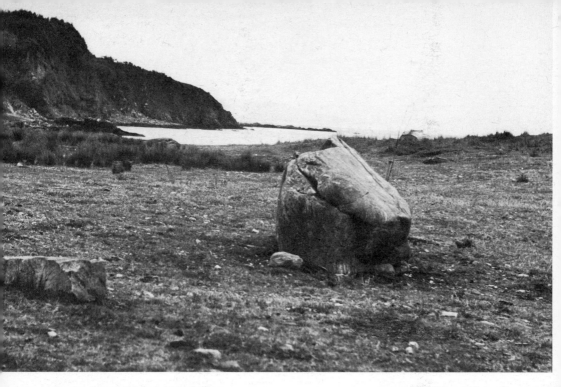

The site of Camusfeàrna (*see* Maxwell) OPPOSITE The River Nith (*see* Burns, p. 10)

Bright Water he gave no further identification of its location because 'identification in print would seem in some sense a sacrifice, a betrayal of its remoteness and isolation'. He received constant enquiries for news of Camusfeàrna and the otters. The letters showed that many people had seized upon Camusfeàrna as the personal Shangri-La they had been searching for all their lives: 'Whatever you are going to do, please never say that the Camusfeàrna of *Ring of Bright Water* never was. Say that it's gone, if you like, but not that you lied. I couldn't take that, because it was the only evidence I had that Paradise existed somewhere . . . Camusfeàrna will always be for me the Camusfeàrna you described. I want to keep that image even though I will never see it . . .' The impact of *Ring of Bright Water* has been a lasting one. It was made into a film under the same title, starring the British actors Bill Travers and Virginia McKenna.

In his book *Raven Seek Thy Brother* Gavin Maxwell divulged that Camusfeàrna was in fact near Sandaig Lighthouse, on the Sound of Sleat, about five miles southwest of Glenelg; the nearest main road is the A87. A brief

epilogue tells the final story of how in January 1968, '. . . fire swept through Camusfeàrna, gutting the house and destroying everything that was within it. . . Teko was saved, but Edal died with the house. . . On the rock above her are cut the words "Edal, the otter of Ring of Bright Water, 1958–1968. Whatever joy she gave to you, give back to nature".'

Maxwell, a Scot who wrote many fine books on wildlife, as well as being a poet and portrait painter, died the following year, and his ashes were buried under a rock marking the site of Camusfeàrna. The landscape, however, remains as Maxwell described it when he first brought an otter there:

When I think of early summer at Camusfeàrna a single enduring image comes forward through the multitude that jostle in kaleidoscopic patterns before my mind's eye—that of wild roses against a clear blue sea, so that when I remember that summer alone with my curious namesake who had travelled so far, those roses have become for me the symbol of a whole complex of peace. They are not the pale, anaemic flowers of the south, but a deep, intense pink that is almost

red; it is the only flower of that colour, and it is the only flower that one sees habitually against the direct background of the ocean, free from the green stain of summer. The yellow flag irises flowering in dense ranks about the burn and the foreshore, the wild orchids bright among the heather and mountain grasses, all these lack the essential contrast, for the eye may move from them to the sea beyond them only through the intermediary, as it were, of the varying greens among which they grow. It is in June and October that the colours at Camusfeàrna run riot, but in June one must face seaward to escape the effect of wearing green-tinted spectacles. There at low tide the rich ochres, madders and oranges of the orderly strata of seaweed species are set against glaring, vibrant whites of barnacle-covered rock and shell sand, with always beyond them the elusive, changing blues and purples of the moving water, and somewhere in the foreground the wild roses of the north.

FELIX MENDELSSOHN (-BARTHOLDY)

On 26 March 1829, Felix Mendelssohn (1809–47) wrote to his friend Carl Klingemann: 'Next August I am going to Scotland, with a rake for folksongs, an ear for the lovely, and a heart for the bare legs of the natives.' Mendelssohn sailed from Hamburg to London in mid-April; he was not a good sailor and for two days was very seasick. A warm welcome awaited him at the dockside from Klingemann, who was Secretary to the Hanoverian Legation in London.

In July the two friends set off for Edinburgh, stopping at York and Durham. Many excellent sketches from this journey to the Highlands demonstrate Mendelssohn's considerable skill with a pencil. He enjoyed Edinburgh

OPPOSITE Loch Na Keal, Isle of Mull (*see* Keats, p. 11) BELOW Fingals's Cave (*see* Mendelssohn)

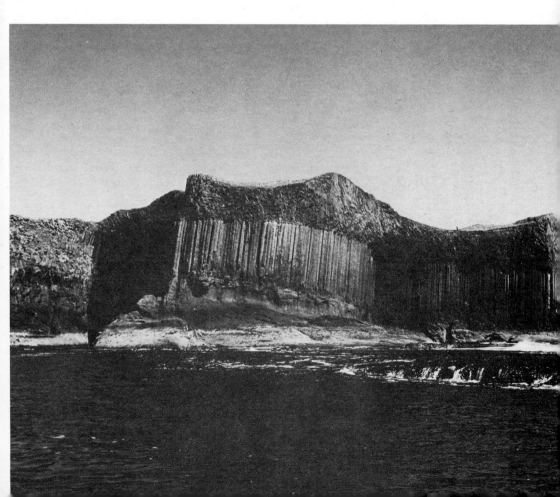

and started to compose his Scotch Symphony following a visit to the chapel of Mary Stuart in Holyrood Palace. He wrote: 'Everything round is broken and mouldering and the bright sky shines in. I believe I found today in that old chapel the beginning of my Scotch Symphony.' It was many years before he completed the work, and it was not performed until 1842, at Leipzig.

Their Highland journey took them to Stirling and on to Perth, Dunkeld, Blair Atholl, and Fort William. They then travelled to Oban and crossed the water to Tobermory on the island of Mull. Much of the journey had been accompanied by high winds and rain, but Mendelssohn maintained his output of drawings.

On 7 August, his view of the Hebrides became the inspiration for his now celebrated overture first called The Lonely Island, then The Hebrides, finally receiving its alternative title, Fingal's Cave. Next day, Mendelssohn and Klingemann visited the uninhabited island of Staffa and the breathtaking cavern of Fingal's Cave. The great black basalt columns, with their astonishing symmetry, echoed with the sea. Klingemann described its pillars as '. . . making it look like the inside of an immense organ, black and resounding, and absolutely without purpose, and quite alone, the wide gray sea within and without.' Mendelssohn, yet again, became desperately seasick, but the images and sounds he had seen and heard are magnificently recalled and interpreted in his Overture.

JOHN EVERETT MILLAIS

In 1848, Millais (1829–96), together with Holman Hunt and Dante Gabriel Rossetti, founded the Pre-Raphaelite Brotherhood. Among their original aims was to return to the careful study of nature. Within ten years the passions of the PRB appeared to have burned themselves out. The pictures they painted, however, remain in all their detail, clarity, colour and symbolism. Millais, a portrait painter of great quality, went on to become President of the Royal Academy and a baronet.

Millais painted some of his finest works in Scotland, and he made his first visit there in the company of John Ruskin and his wife Effie in 1853. Their destination was Brig o' Turk, a village close to Glen Finglas (known in the 19th century as Glenfinlas). Brig o' Turk is on the A821 west of Callander. A few miles on lies Scott's Loch Katrine and Ellen's Isle.

In a letter to his father Ruskin wrote:

> Millais has fixed on his place—a lovely piece of worn rock, with foaming water and weeds, and moss, and a noble overhanging bank of dark crag—and I am to be standing looking quietly down the stream—just the sort of thing I used to do for hours together —he is very happy at the idea of doing it and I think you will be proud of the picture —and we shall have the two most wonderful torrents in the world, Turner's St Gothard— and Millais' Glenfinlas. He is going to take the utmost possible pains with it—and says he can paint rocks and water better than anything else—I am sure the foam of the torrent will be something quite new in art.

The 'torrent' is no longer what it was, as a dam has made it but a dribble of its former self. It was in this setting that an atmosphere of unspoken thoughts and tensions developed. All was not well in the marriage of John Ruskin and Effie—he had refused, or was unable, to consummate it. Instead Ruskin encouraged the friendship of Effie and Millais. The painter completed three works here, the portrait of Ruskin, hat in hand, standing on rocks by the cascading white water; The Waterfall with a cameo of Effie sewing; and Effie Ruskin at Glenfinlas, a beautiful portrait of Effie showing her with foxgloves in her hair. On 3 July 1855, Effie married Millais.

In 1856 Millais painted Autumn Leaves. It was painted in the garden of Annat Lodge, near Perth, where he and Effie were living. His first real Scottish landscape was completed in 1870. Millais's son was to explain how Chill October came into being:

> . . . now came upon him in over-whelming force the desire he had long entertained to paint at least one landscape in the country he loved so well. For years past he had thought of this, but the demand for his works becoming ever more and more pressing, he could rarely escape from town

Chill October, 1870, by John Everett Millais

before the middle of August, and most generally be back at his work again in October, just as Scotland was putting on its most attractive garb. His chance came at last. A subject that he greatly fancied was close at hand, and he could now find time to paint it.

Millais himself wrote on a piece of paper attached to the back of the canvas:

Chill October was painted from a backwater of the Tay just below Kinfauns, near Perth. The scene, simple as it is, had impressed me for years before I painted it. The traveller between Perth and Dundee passes the spot where I stood. Danger on either side—the tide, which once carried away my platform, and the trains, which threatened to blow my work into the river. . . I made no sketch for it, but painted every touch from Nature, on the canvas itself, under irritating trials of wind and rain.

Millais maintained his early decision to paint landscapes on the spot. He also enjoyed shooting, deer and grouse, and was an accomplished fisherman. These activities very much influenced his painting, for he filled his canvases with intimate scenes rather than breathtaking landscapes of mountain grandeur. Some of the best landscapes were painted on his shooting estate at Murthly, near Birnam, the tenancy of which he held for ten years. His son commented: 'he knew by heart, as one may say, every bit of the ground and every turn of the river, and his love of the place increased year by year.'

In the autumn of 1889, Millais painted *Dew-Drenched Furze* and once again we are indebted to his son, John:

. . . he went to the North, determined to go in for sport alone. He would not look at his paints, he said; and he stuck to his word until one fine day in November the potent voice of the wood spirits compelled him to

change his mind. In the early morning the long grass bearded with dew lay at his feet, and all around were firs, brackens, and gorse bushes, festooned with silver webs, that showed a myriad diamonds glittering in the sun. It was a fairy-land that met his eye whichever way he looked, and under its spell the soul of the painter was moved to immediate action.

SIR WALTER SCOTT AND SCOTLAND

Sir Walter Scott (1771–1832) said in his preface to the Waverley Novels that he had attempted to introduce 'Scotland's natives in a more favourable light than hitherto'. He undoubtedly succeeded in so doing, for his novels and poems caused thousands of admirers to go north of the Border to find the scenes of which he had written. His novels fostered a new enthusiasm for medieval and Elizabethan romance and were an important factor in the development of the Romantic movement all over Europe. A Highland mania began to spread south into England. Queen Victoria was to lose her heart to the Highlands. In 1848 she took the lease of an old house at Balmoral in Aberdeenshire, which Prince Albert soon replaced with a romantic granite castle designed by William Smith. It gave magnificent views over the River Dee. Red deer antlers were everywhere—they were even made into furniture—and tartans and cairngorm stones appeared all over England.

Walter Scott was born in Edinburgh, but he belonged to the countryside of the Border, and in particular the stretch between Kelso and Melrose. It was here at his grandfather's farmhouse at Sandy-Knowe that he spent much of his childhood. An illness, which may well have been poliomyelitis, left him lame, but he grew into a young man of considerable strength. Scott wrote: '. . . it is here at Sandy-Knowe that I have the first consciousness of existence.' His appreciation of Border lore

The Eildon Hills (*see* Scott)

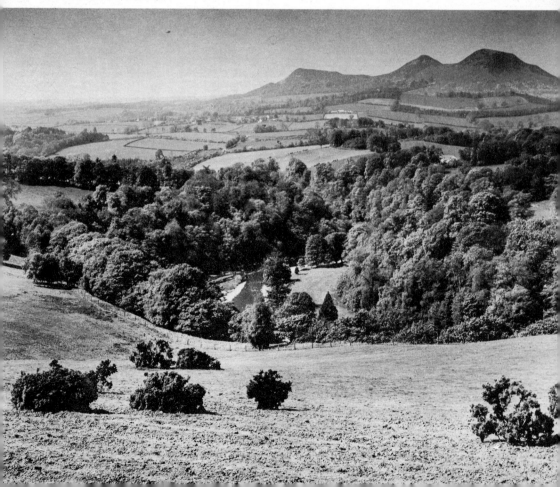

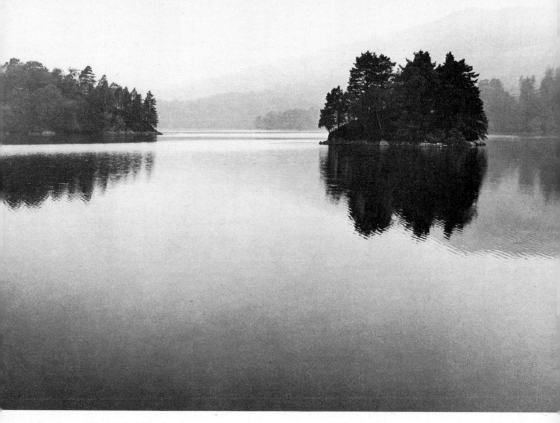

Loch Katrine and Ellen's Island (*see* Scott)

and people was awakened here. Another object of his early sympathy was the Jacobite cause, evoked by listening to the tales of farm-hands and shepherds who could recall the barbarous treatment meted out by the authorities to the prisoners taken in the 1745 uprising.

Scott collected the stories of days past, whenever he could find a storyteller. Such tales provided him with material for his three volumes of *The Minstrelsy of the Scottish Border*, published in 1802–3. Scott was well aware that many old tales and songs were already being lost.

The Border country and its wild history inspired many lines of Scott's great poem *Marmion* (1808), including:

> *And still I thought that shatter'd tower*
> *The mightest work of human power*

The reference is to Smailholm Tower, just up the hillside from Sandy-Knowe farm.

Kelso certainly excited Scott's imagination. He spent some time there in 1783, of which he wrote later: 'I began to feel distinctly the awaking of that delightful feeling for the beauties of natural objects which has never since deserted me. The neighbourhood of Kelso, the most beautiful, if not the most romantic village in Scotland, is eminently calculated to awaken these ideas. It presents objects, not only grand in themselves, but venerable from their association. The meeting of two superb rivers, the Tweed and the Teviot, both renowned in song. . .'

Scott had his first sight of the Perthshire Highlands in the late 1780s while dealing with legal matters for some of his father's clients. He rode into the Trossachs with an escort of a sergeant and six men, for 'the King's writ did not pass quite current in the Braes of Balquhidder'. He also saw Loch Katrine for the first time. The effect of this rugged country on his imagination is attested by his setting of the poem *The Lady of the Lake* (1810), and much of the novel *Rob Roy* (1817) here.

One result of such epics as *The Lady of the Lake* was to send tourists flocking to the Highlands. The publisher, Robert Cadell, wrote,

'The whole country rang with the praises of the poet. Crowds set off to the scenery of Loch Katrine, till then comparatively unknown; and as the book came out just before the season for excursions, every house and inn in that neighbourhood was crammed with a constant succession of visitors.' Today, Ellen's Isle on Loch Katrine is passed by the SS *Sir Walter Scott* on its way from Trossachs pier to Stronachlachar.

Scott made other journeys into the countryside with his friend Robert Shortreed. They enjoyed crossing the moorlands on horseback, and exploring the old peel towers of the Border counties from top to bottom.

With an inheritance from his uncle, he rented a house called Ashestiel in 1804. It was on the southern bank of the Tweed a few miles from Selkirk. It was here that he brought his wife Charlotte. Although the house is not open to the public, it may be viewed across the river where the A72 from Peebles turns northeast for Clovenfords. The Scotts remained in this house until 1812.

The Pentland Hills (*see* Stevenson)

The great house that Scott built replaced a small farm called Claty Hole. He spent many thousands of pounds buying surrounding lands and was constantly extending the house. He planted trees of all kinds. He loved the views of the River Tweed and the vista to the Eildon Hills. The countryside about Abbotsford is most certainly 'Scott Country'.

While *The Lady of the Lake* received scathing comment from some of Scott's contemporaries, and is not to everyone's liking today, there are passages linking verse and landscape in a most satisfactory manner. The following is an example:

> The stag at eve had drunk his fill,
> Where danced the moon on Monan's rill,
> And deep his midnight lair had made
> In lone Glenartney's hazel shade;
> But, when the sun his beacon red
> Had kindled on Benvoirlich's head,
> The deep-mouth'd bloodhound's heavy bay
> Resounded up the rocky way,
> And faint, from further distance borne,
> Were heard the clanging hoof and horn.

Bass Rock and Tantallion Castle (*see* Stevenson)

Looking westwards from the greens of the Gleaneagles Hotel, Glen Artney, and its forest, stretch away towards Ben Vorlich with such beauty as to send the beholder running for the poems.

Scott's world crumbled in 1826 with the collapse of publishing and printing firms with which he had been associated. Left with liabilities of well over £100,000 he wrote furiously to reduce the debt, with considerable success; but his efforts brought a breakdown in health, and he died at Abbotsford in the autumn of 1832, gazing from his window out to the River Tweed.

ROBERT LOUIS STEVENSON

Born in Edinburgh, Robert Louis Stevenson (1850–94) never lost his love for the city in spite of long travels abroad. He also used the Scottish landscape in several of his novels. From landscape Stevenson sought effects. He used it often to suggest evil, violence, or the threat of violence. He loved Scotland and returned from his journeys happy to be back, in spite of a climate that had always proved detrimental to his health. Some of the best descriptions of Scotland landscape appear in *The Master of Ballantrae* (1889), which he wrote abroad. Undoubtedly he would have preferred to live in Scotland; much of his reference to landscape came from youthful memories.

His imagination had been stirred as a child by his nanny who told him folk tales and stories from the Bible. As a visitor to his grandfather's house, Colinton Manse, just outside Edinburgh, he became well aware of the fact that the journey there took him past the churchyard. The steep trackway put the gravestones above head level, and he imagined the souls of the dead peering through the cracks in the churchyard wall; he called it 'the Witch's Walk'.

In 1867, his father rented Swanston Cottage on the northern slope of the Pentland Hills. R.L.S. was a man who banked his memories with interest; he collected many at this cottage, which stood in an old quarry and was surrounded by a thicket. He would live there with his dog for company, visiting the Holy Well of Halkerside, or walking with John Todd the local shepherd. R.L.S. describes the cottage in his novel *St Ives* (1897/8).

He gave his own fascinating account of how he came to write *The Master of Ballantrae*: 'Come said I to my engine, let us make a tale, a story of many years and countries . . . and while I was groping for the fable and the character required, behold I found them lying ready. . . Here, thinking of quite other things, I had stumbled on the solution . . . of a story conceived long before on the moors . . . conceived in Highland rain, in the blend of the smell of heather and bog-plants. . . So long ago, so far away it was, that I had first evoked the faces and the mutual tragic situation of the men of Durrisdeer. . .'

Stevenson owed his love of the sea to his father, who designed lighthouses. They visited lighthouses together, some of them on a wild shore, others requiring a journey by boat.

The story of *Treasure Island* (1883) had its seeds in family holidays spent at North Berwick looking out at the Firth of Forth. It was here that R.L.S. and his friends clambered into boats, played pirates and searched for gold. And out at sea was the great Bass Rock, where one day R.L.S. was to imprison David Balfour in *Kidnapped* (1886).

The North

In the early days of English Christianity, at Whitby Abbey in the 7th century, an unlettered herdsman named Cædmon miraculously received the power to put scriptural passages into English verse. According to Bede, he began with a song of the Creation. Cædmon is thus the Father of English sacred song, and his life reminds us of the depth of religion and art in the North. The later medieval Whitby Abbey is now a magnificent ruin looking out over the North Sea. Further north is Lindisfarne (Holy Island), once the home of the famous Lindisfarne Gospels and one of the places where Christianity first tiptoed into Anglo-Saxon England.

It is an exciting landscape, containing the astonishing Hadrian's Wall, built from the Solway to the Tyne and so forming the northern perimeter of the Roman Empire.

In the late 19th century groups of painters began to settle each summer in the villages and bays of the Yorkshire coastline. The favourite locations were Robin Hood's Bay, Runswick and Staithes, and they have continued their popularity with modern painters. Over in the Pennines, Frederick Delius often walked or rode over Rombalds Moor to Ilkley.

In the Peak, at Kinder Scout, a fight broke out between walkers and gamekeepers between the wars for the right to walk in the Pennines.

At Eyam, the plague village, doors are still marked with the names of victims who died. The vicar kept his congregation together, so as not to allow the Great Plague to spread.

On the western side of the region, the Lancashire Fells and the bird-filled flats of Morecambe Bay lead on up into the Lake District, the Solway Firth and Scotland.

Southwest of the steep-sided Wast Water is Muncaster Castle. The castle appears to grow from a spur of high ground that commands the whole panorama of Eskdale. It is as natural a position for the castle as it has proved to be for the mass of shrubs and trees that surround it. John Ruskin described Muncaster as 'the gateway to Paradise'.

The view from the nature reserve at Drigg Dunes, looking across the village of Ravenglass to Sca Fell, is unique.

The River Duddon runs through the wildest and most superb valley in the Lake District, from the Langdale Pikes to the village of Ulpha. Sheep climb here like mountain goats, and it is always a surprise suddenly to find that what you had noted as a boulder has stood up and walked away.

<center>❧◦⟨⟩◦❧◦⟨⟩◦❧</center>

THOMAS BEWICK

The wood engravings of Thomas Bewick (1753–1828) are unique in British art. A self-taught master of the art of the woodcut, Bewick was both artist and craftsman and, above all, a detailed observer of life around him. His home was at Cherryburn House close by the River Tyne at Ovingham, Northumberland. The house is still to be seen, a small building with stables and a byre, and a plaque now commemorates his name and year of birth. As a child he drew incessantly with chalk, on the family hearth, on the tombstones in Ovingham churchyard, and in the church porch itself. At school he filled his books '. . . with various kinds of devices or scenes I had met with'. He had not yet heard the word 'drawing' and the only paintings he knew of were '. . . the king's arms in the church, and the signs in Ovingham of the Black Bull, The White Horse, the Salmon, and the Hounds and Hare.'

Nature was Bewick's teacher, up on the fells, while fishing, and as a follower of most local field sports. In the evenings he liked nothing more than to sit at the fireside listening to tales of old Northumbrian heroes, and hearing from his father memories of folk long dead. This was the family atmosphere of his father's small farm, where he developed his own awareness of objects and wild creatures, and of the character of his fellow man.

Apprenticed to a Newcastle engraver at the age of 14, Thomas learned to engrave on metal, on the faces of grandfather clocks, and

PLATE IV.

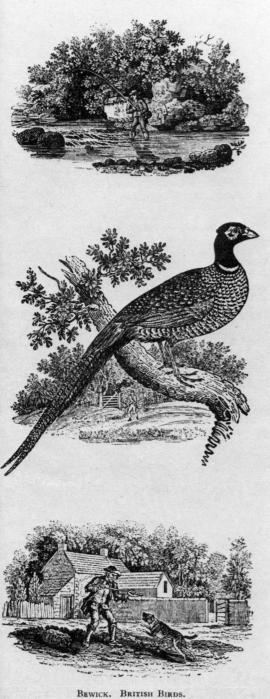

BEWICK. BRITISH BIRDS.
See No. 220.

Woodcut illustrations from Bewick's
History of British Birds

on coffin plates. He also revived the art of wood engraving after centuries of neglect. Bewick's technique was to cut his subjects on the end grain of the wood, instead of along the plank. He made white designs upon a black block to produce black designs upon white paper. The results were magnificent. He illustrated a number of children's books, and for his work on *Gay's Fables* (1779) the Society of Arts awarded him a prize of seven guineas.

With his apprenticeship over, he made a walking tour of the North before setting out for London; but the capital was not for him, and he yearned for the scenery of Tyneside. He lived on the edge of Newcastle for 42 years, bringing up a family and being the devoted son of his parents at Cherryburn.

Today, Bewick is remembered for his *General History of Quadrupeds* (1790) and the two-volume *History of British Birds* (1797, 1804). The woodcut illustrations of the birds and animals he knew so well from his own observations are nothing less than vibrant masterpieces. Yet the work that holds the imagination most are the woodcut vignettes he called 'tailpieces'. These little scenes that Bewick captured so enchantingly depict so much of the everyday life known to him. Drunken farmers, travellers on storm-drenched roads, the blind man saying grace while the cat steals his porridge, the fat man with a spouting beer barrel, too drunk to stop the flow. He catches for us the habits of his day, the cruelty of man and the humour. The tailpieces were not for the drawing room: they were too direct and to the point.

This tough old Tynesider was also a reflective man. His final tailpiece is of a coffin taken from Cherryburn down to the Tyne, where a ferryman waits for the body of Thomas Bewick. The personal landscape that Bewick has passed on to us through his art and craftmanship still lives on at Cherryburn and Ovingham.

RAYMOND BOOTH

Like many wildlife artists Raymond Booth (born 1929) is very much a solitary figure, totally committed to his way of life, and he has never sought publicity. His remarkable

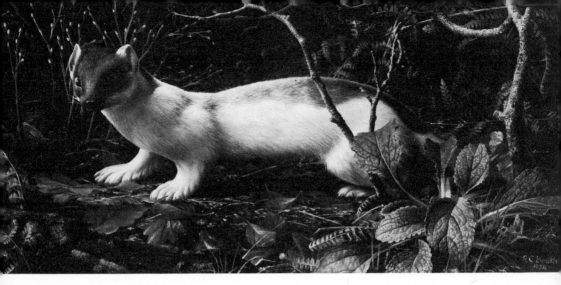

Stoat in Winter, by Raymond Booth

paintings are rich and accurate in their colouring in a way that demonstrates his intense power of observation. The textures of bark, leaf, flower and fungus fascinate him, so too do the birds and animals that inhabit his own very special landscape. A Yorkshireman, Raymond Booth lives in a bungalow on the outskirts of Leeds, and he seldom strays more than ten miles from it.

Much of his time is spent in Adel Woods learning from nature at first hand. He believes that gardening has done much to help him understand plants, which he always paints from life. On the other hand he is always looking out for dead animals which he can then study at leisure.

Booth developed tuberculosis as he was about to become an art teacher. It was a career that he had not been looking forward to, but while convalescing he found that he was able to sell some of his botanical drawings; the die was cast, and he became a professional artist.

An exhibition of Raymond Booth's work at The Fine Art Society, London, in 1982, awakened great interest in his work.

Two Hares in a Spring Landscape, by Raymond Booth

THE BRONTËS OF HAWORTH

Haworth Parsonage must surely be one of the most interesting houses in England. It is a Georgian house that has been added to since and turned into a museum. Coachloads of tourists now travel each summer to the small Yorkshire town of Haworth, and it is all a far cry from the days when the Reverend Patrick Brontë lived at the parsonage with his extraordinary family. It is not difficult to imagine the three sisters who survived childhood, gathered in their sitting room as the winds of winter came storming off the moors and battered at the house. There was little comfort at Haworth, for Mr Brontë was afraid of fire; no curtains masked the windows and few carpets warmed the floors. Yet it was here that the three girls, Charlotte (1816–55), Emily (1818–48), Anne (1820–49) and, of course, their brother Branwell (1817–48), produced their novels and poems. Someone once said that visiting the parsonage was like viewing a sale of the contents while the family had gone out onto the moors, which can only be a compliment to those who care for this very special house.

All three loved the moors, but none more so than Emily. When they left the parsonage it was seldom that they walked down into the town: invariably it was up into the purple-black of the countryside. Frequently they visited the waterfall, which is still to be seen. This was a time when the industrial revolution had made many inroads into the Pennine landscape. Charlotte wrote:

> The scenery of these hills is not grand, it is not romantic; it is scarcely striking. Long low moors, dark little heaths, shut in valleys where a stream waters here or there a fringe of stunted copse. Mills and scattered cottages chase romance from these valleys, it is only higher up, deep in amongst the ridges of the moors, that Imagination can find rest for the sole of his foot; and even if she finds it there she must be a solitude loving raven, no gentle dove.

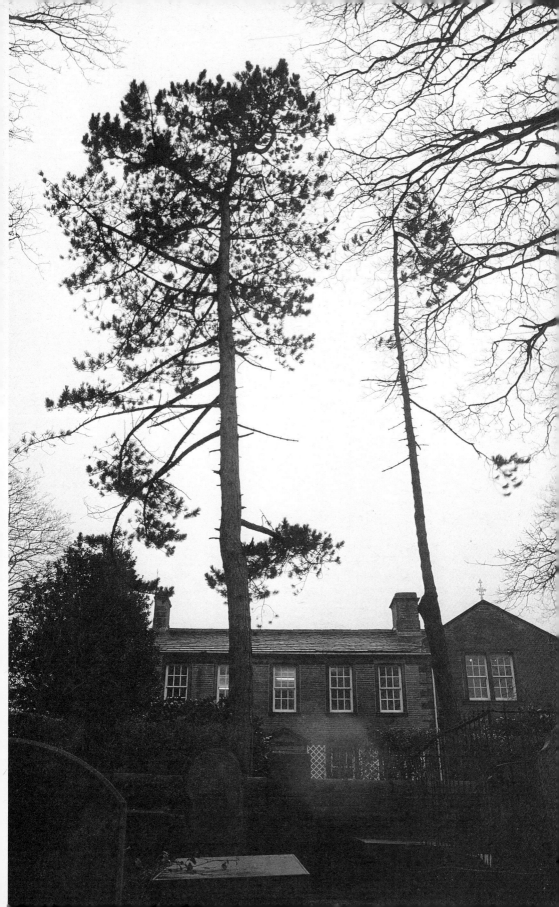

Haworth Moor (*see* the Brontës)

Haworth Moor is an undulating landscape creased and creviced with natural folds, with parts of it cut into geometric shapes by dry-stone walls. When the heather blooms the moor changes character and blazes with colour. Charlotte wrote:

Emily loved the moors. Flowers brighter than the rose bloomed in the blackness of the heath for her; out of a sullen hollow in a livid hill-side her mind could make an Eden. She found in the bleak solitude many and dear delights; and not the least and best loved was liberty.

At 16 Emily went to a school for some months. It was an experience she did not want to repeat, as Charlotte noted: 'Every morning, when she woke, the vision of home and the moors rushed on her. . . Nobody knew what ailed her but me.'

Emily's poems reveal best the joy she found in moorland as these two stanzas, each from different poems, make it abundantly clear.

Awaken, O'er all my dear moorland,
West-wind, in thy glory and pride!
Oh! call me from the valley and lowland
To walk by the hill-torrent's side!

Few hearts to mortals given,
On earth so wildly pine;
Yet few would ask a heaven
More like this earth than thine.

It has always been considered that the farm Top Withens, near Haworth, was used by Emily as the setting for *Wuthering Heights*. Its location completely fits the description that she gives in the early pages of her book:

'Wuthering' being the significant provincial adjective descriptive of the atmospheric tumult to which its station is exposed in stormy weather. Pure, bracing ventilation they must have up there at all times, indeed; one may guess the power of the north wind blowing over the edge by the excessive slant of a few stunted firs at the end of the house, and by a range of gaunt thorns all stretching their limbs one way, as if craving alms of the sun.

While the Brontë family kept dogs as pets, it was Emily who also tamed a merlin, that swift falcon of the moorland.

30

FREDERICK DELIUS

Fritz Theodor Albert Delius (1862–1934) was born in Bradford. His parents were of German origin and had established themselves in Yorkshire with a prosperous wool business. It was only after Fritz had married Jelka Rosen, the painter, in 1903 that he dropped the name 'Fritz' in favour of Frederick.

The music of Delius is both pictorial and impressionistic. It includes some extraordinarily beautiful music, most of it reflecting land- and seascapes. The problem, however, is what landscapes; for although so much of his work is frequently described as 'typically English', so little of it was written in England. In the Paris of the 1880s and 1890s he became the friend of many writers and Post-Impressionists. He stayed for a time at Ville d' Avray with its famous lake, where Corot had once lived and painted. The Norwegian composer Edvard Grieg was a close friend.

It should also be remembered that Delius's early career as a composer was pursued in the

Frederick Delius, 1929, by Ernest Procter

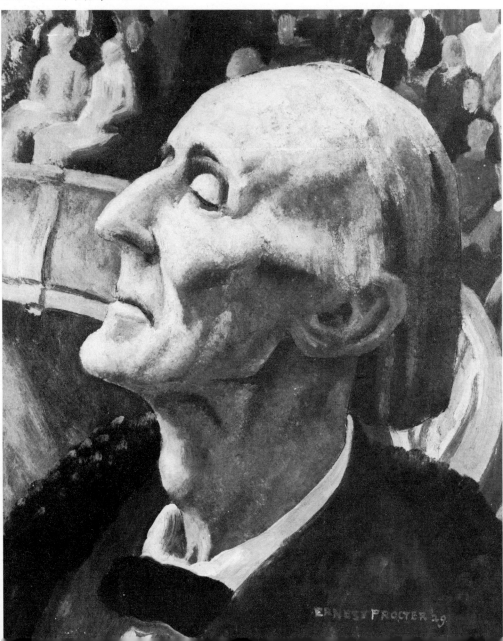

The Cow and Calf Rock, Ilkley (*see* Delius)

face of parental opposition. His father wanted him in the family business, which involved him in trips to Germany, Sweden and Norway. In Norway he was captivated by the mountain landscape, and he felt a close affinity with all high country. He also had a brief career as an orange grower on a plantation in Florida. This important period in his life was to shape his future; in Florida he wrote: '. . . through sitting and gazing at Nature', I gradually learnt the way in which I should eventually find myself . . .' At night he would listen to the Negroes singing with their subtle improvisations of harmony '. . . and, hearing their singing in such romantic surroundings, it was then and there that I first felt the urge to express myself in music.'

So it was that Delius belonged to many landscapes. In later life they were remembered landscapes, for he lost his sight. Eventually he and Jelka made their home in the village of Grez-sur-Loing, on a tributary of the Seine. It was quiet and unspoiled. Robert Louis Stevenson tells of the village bridge with its '. . . many arches choked with sedge; great fields of white and yellow water-lilies; poplars

and willows innumerable . . .' It all sounds rather English.

What is certain is that the Yorkshire moors made a lasting and vivid impression upon him for life. As a boy he loved to ride across the moor to Ilkley, and he looked forward to summers spent at Filey on the Yorkshire coast, which meant visits to the Cricket Festival at Scarborough. Delius himself played cricket at the villages of Gristhorpe and Hunmanby. He enjoyed the local horse fairs, sometimes he would cross Rombalds Moor to visit Skipton Castle. At one time he planned a musical treatment of *Wuthering Heights*.

Early in the century Thomas Beecham became an admirer of Delius, and in 1929 he organized and conducted a six-day festival of the composer's work. He claimed that Brigg Fair '. . . should be in the hands of students in every academy, as a text book on the art of

OPPOSITE ABOVE The village of Keswick, Cumbria (*see* Keats, p. 23)

OPPOSITE BELOW The waterfall at Haworth (*see* the Brontës of Haworth, p. 28)

32

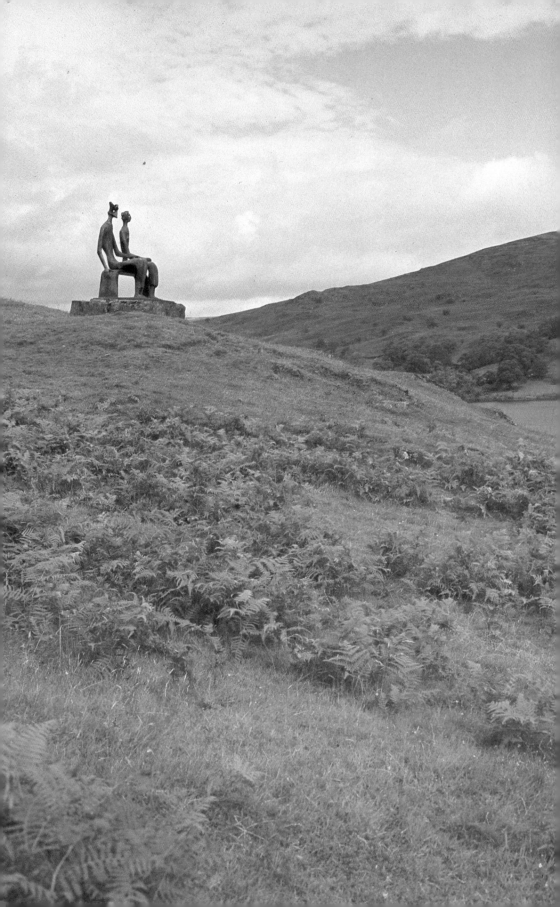

OPPOSITE *King and Queen*, the bronze figures by
Henry Moore overlooking Glenkiln Reservoir (*see* p. 35)

harmony in its most advanced stage of ingenious development.' In turn Delius admired Beecham, and once exclaimed: 'That is how I want my music to be played. Beecham is the only conductor who has got the hang of it.'

Delius's music pulsates with richness and imagination. Cecil Gray, the writer and composer who died in 1951, said of him: '. . . nothing could be more unmistakably English than such things as the Dance Rhapsody No. 1, or In a Summer Garden, or the two lovely pieces for small orchestra—in spite of the fact that the first of these two latter happens, quite irrelevantly, to be based on a Norwegian folk song. How magically, too, do the first few pages of Brigg Fair evoke the atmosphere of an early summer morning in the English country, with its suggestion of a faint mist veiling the horizon, and the fragrant scent of the dawn in the air!'

Sir Malcolm Sargent has written '. . . the refreshing cleanliness of his Nature worship, freed from the soiling of Humanity, is typically English, and, I feel, is expressed in the music of Delius with a clarity unknown in any other composer.'

Delius wrote 'Brigg Fair' in 1907, calling it an English Rhapsody, even though he had settled in France. Unlike so many English composers of the period, Delius never went out of his way to collect folk songs. For 'Brigg Fair' he was indebted to Percy Grainger, who was a close friend and very interested in folk songs. Grainger heard the Lincolnshire song sung by an old man, Joseph Taylor, in the village of Saxby All Saints, near Brigg. After Grainger had made his own choral setting of the song, he passed it on to Delius who then composed his English Rhapsody; Delius dedicated the work to Percy Grainger. The words of the original folk song are as follows:

It was on the fift' of August
The weather fine and fair
Unto Brigg Fair did I repair
For love I was inclined.
I rose up with the lark in the morning
With my heart so full of glee

Of thinking there to meet my dear
Long time I wished to see.
The green leaves they shall wither
And the branches they shall die
If ever I prove false to her
To the girl that loves me.

Delius was given the Freedom of Bradford in 1932, although due to illness he had to receive it in France, at his home in Grez. He said: 'I owe a great deal to Yorkshire. In my music much of my inspiration has come from the moors. I hope to get one more whiff of them before I die.'

He never lived to visit the moors again. The last music he asked to hear was a recording of his own 'In a Summer Garden'. Delius died on 10 June 1934. The BBC announcement of his death was followed by a passage from the 'Walk to the Paradise Garden'. Most fittingly, Bradford Council sent a wreath of heather with other moorland plants worked into it. The composer's body was later brought back to England and reinterred in the churchyard at Limpsfield in Surrey.

WILLIAM GILPIN

The Reverend William Gilpin (1724–1804) was born near Carlisle. In 1777 he was presented to the vicarage of Boldre in the New Forest for the remainder of his life. His major contribution to the 18th century was to awaken in people the idea of 'picturesque beauty', and to put forward the idea of looking at landscape as though it was a picture. It was an approach that met with great success and created a new sense of awareness among the travelling public.

The beauty of a distant mountain in a great measure, depends on the line it traces along the sky; which is generally of a lighter hue. The pyramidal shape, and easy flow of an irregular line, will be found in the mountain, as in other delineations, the truest source of beauty.
Indeed a continuity of line without a break, whether it be concave, straight or convex, will always displease, because it wants variety; unless indeed it be well contrasted with other forms. The effect also of a broken line is bad, if the breaks are regular.

PERCY GRAINGER

It was Frederick Delius who described Percy Grainger (1882–1961) as the only English composer 'who writes English music'. Delius knew of course that Grainger was an Australian, but his comment illuminates the robust old English quality of Grainger's work.

As a pianist Grainger studied in Melbourne, Frankfurt and Berlin; his first concert in London in 1900 was a great success. He toured widely in Britain and overseas, returning to London in 1906, where he met the Norwegian composer Edvard Grieg. They became friends and Grainger visited Grieg in Norway. Grieg's interest in and enthusiasm for Norwegian folk music had a profound influence upon Grainger. He never tired of seeking out folk songs in the British Isles, and he had a remarkable facility for capturing the vocal nuances of regional singers.

Percy Grainger became an active and important figure in the English folk music revival, and traditional tunes provided the composer with the foundations for many of his own works. Time and again his music conjures up the feel and the freshness of country air. As a composer he was self-taught. His début was in London in 1912, when he conducted his 'Mock Morris' for string orchestra.

The titles of very many of Grainger's compositions reflect his chosen field: 'Shepherd's Hey', 'Country Gardens', 'Over the Hills and Far Away', 'Ye Banks and Braes O' Bonnie Doon', 'Hill Songs', 'Irish Tune from County Derry', and 'Six Dukes went a-fishin'.

Percy Grainger was a man of great energy and with a sense of humour, a personality well suited to gathering tunes and words from among remote communities often wary of strangers. He once wrote: 'I regard the study of native music and close association with folksingers (peasants, sailors, etc.) as the most fruitful influence in my creative career.' The area of Britain he loved most was almost certainly Lincolnshire; the home of 'Brigg Fair', which he so generously passed on to his friend Frederick Delius. Percy Grainger became a naturalized citizen of the United States in 1919.

JOHN KEATS

A friend of John Keats, Joseph Severn, had long known of the poet's interest in landscape and feeling for nature. Many times they had walked across Hampstead Heath and on into the old Middlesex Forest at Highgate. Severn wrote:

> Nothing seemed to escape him, the song of a bird and the undernote response from covert or hedge, the rustle of some animal, the changing of the green and brown lights and furtive shadows, the motions of the wind— just how it took certain tall flowers and plants—and the wayfaring of the clouds.

Benjamin Haydon, the painter, remarked of Keats, 'The humming of a bee, the sight of a flower, the glitter of the sun, seemed to make his nature tremble!'

The poet and his friend Charles Brown were several times taken for pedlars as they hiked along the rough roads of the Lake District and on into Scotland. Keats had thought long and carefully over this six-week expedition they had begun in late June 1818. He did not see himself as a tourist or out for mere exercise: the journey was to be an important part of his poetic development. For much as Keats loved to dine and drink claret in the company of witty friends, he felt the need for a wider experience, something that could stretch his poetical horizons with new sights and physical challenge. With such thoughts he left his books behind him and turned his face and expectations to the high country of the north.

He was not disappointed, the lakes and mountains were more breathtaking and glorious than he had ever imagined. On seeing Lake Windermere he gasped to Brown, 'I can't believe it! Nothing can be so beautiful, but it is, and lovelier every minute.' The two men walked the shore of Windermere to Ambleside, where they dined on salmon trout. The following day they were up and away early to explore the local waterfalls.

Having missed the path leading to Stockghyll Force, they found their way to the famous Ambleside waterfall by following the sound of thundering water. It was another vital day for Keats and as he stood at the falls he saw far more than tumbling water. He

wrote: 'What astonishes me more than any-thing is the tone, the colouring, the slate, the stone, the moss, the rock-weed; or, if I may so say, the intellect, the countenance of such places . . . I shall learn poetry here.'

Later, Keats and Brown went on to Dove Cottage, Wordsworth's home, only to find that the poet was away, so Keats left a note to say that they had called. After staying at Keswick they climbed Skiddaw before walk-ing on into Scotland (see p. 11).

SEE ALSO PAGES 11, 154.

HENRY MOORE

Talking to Sir John Rothenstein, Henry Moore, O.M. (born 1898) once remarked on the relation between sculpture and drawing:

> . . . sculpture, involving a lifelong struggle to grasp reality in terms of three dimensions, is the most intellectually and imaginatively exacting pursuit, even Michelangelo, the greatest of the great, pressed on with it until the end of his life.
>
> But drawing enables a sculptor to get atmosphere round his figures—to give them an environment, above all a foreground.

Henry Moore has always been conscious of environment. Born at Castleford, Yorkshire, he remembers when a small boy feeling that the local slagheaps must be larger than the Pyramids. Later he described them as having: '. . . as big a monumentability as any mountain. Monumentability has always been important to me.' So important that he had the ambition to be a sculptor from the age of 10. In fact, after winning a scholarship to Castleford Grammar School, parental advice prevailed and he trained as a teacher and returned to the staff of his old elementary school. In 1917 he went to France and was gassed at Cambrai. An ex-Serviceman's grant took him to the Leeds School of Art. Moore studied for his diploma but longed to be free to explore the sculptures of ancient civilizations and develop his own style. He studied in the museums, and on the seashore, where he examined the working of the sea upon the stones. He liked the stones: '. . . hard tense stoniness'.

The Second World War brought other images: '. . . I found myself strangely excited by the bombed buildings . . . and life of the underground shelters. . . I began filling a note-book with drawings . . . static figures (asleep)— "reclining figures"—remained vivid in my mind.' This experience was to give a vital sense of humanity to his work. He had always liked working from life, his two loves being the landscape and the female figure. Tree stumps, old hedgerows and twisted roots excite his imagination; sheep are also a favourite subject, worked with ballpoint pen.

Moore draws his own hands, 'If you don't learn from your own body you learn from nothing!' His love of massive forms and the monumental realization of the human figure may well spring from his early life, when he would rub his mother's back to relieve her rheumatism.

Since the Second World War his monu-mental figures have peopled many landscapes. In Scotland his great bronzes of the 'King and Queen' look towards England. They sit on a hillside looking over Glenkiln Reservoir, which supplies Dumfries with its water.

The architect Chermayeff, having built a house for himself in Sussex, commissioned a sculpture from Moore, who decided upon a reclining figure that would harmonize with the horizontal lines of the long building. In a talk Henry Moore recorded for the British Council in 1955, he stated:

> It was then that I became aware of the neces-sity of giving outdoor sculpture a far-seeing gaze. My figure looked out across a great sweep of Downs, and her gaze gathered in the horizon. The sculpture had no specific relationship to the architecture. It has its own identity and did not need to be on Chermayeff's terrace, but it, so to speak, enjoyed being there, and I think it intro-duced a harmonizing element; it became a mediator between modern home and age-less land.

In recent years, as the work of Henry Moore has been exhibited in many parts of the world, it has been noticed how the large sculptures in particular appear to take on a new life and meaning among the fresh associations of each place. There are people, of course, who find

certain of his works difficult to understand as they look for instant recognition. A key may be found perhaps in an article that appeared in *The Listener* in August 1937, on the subject of holes in his sculpture:

A piece of stone can have a hole through it and not be weakened—if the hole is of studied size, shape and direction. On the principle of the arch, it can remain just as strong. The first hole made through a piece of stone is a revelation. The hole connects one side to the other, making it immediately more three-dimensional. A hole can itself have as much shape-meaning as a solid mass. Sculpture in air is possible, where the stone contains only one hole, which is the intended and considered form. The mystery of the hole—the mysterious fascination of caves in hillsides and cliffs.

BEATRIX POTTER IN LAKELAND

The tale of Beatrix Potter (1866–1943) must be as well known as the stories in her many books, the difference being that hers was the bitter-sweet story of real life. Her wealthy parents were typical of many Victorians who did not encourage ambition in their daughters. The annual summer holiday brought excitement and new horizons, for the Potters would stay with relatives, or in a boarding house, in either Scotland or the Lake District. It was through these excursions that Beatrix became conscious of wild and beautiful surroundings, and of plants and small creatures. She filled notebooks and painted detailed watercolours. Sir John Millais, a friend of the family, gave her encouragement; he once said to her 'Plenty of people can draw, but you have observation'. At that time she had no thought of writing books for children, but hoped that one day she might become a naturalist. In her early teens she invented a code alphabet which she then used for keeping her journal. For some ten years she studied fungi and painted specimens she found. This remarkable collection of watercolours was left to Armitt Library, at Ambleside, where they may be seen. Her nearest approach to becoming a professional naturalist was when her paper on germination

of spores was read at the Linnean Society of London in 1897.

For some years she had taken great pleasure in sending story letters to children she knew. These involved four rabbits, Flopsy, Mopsy, Cottontail and Peter, and the adventures of a squirrel by the name of Nutkin. She had the story of Peter Rabbit privately printed. She sent one of these volumes to the firm of Fredrick Warne, who published it in 1902 in an edition of 6000 copies. A whole series of titles followed. Beatrix formed a friendship with Norman Warne and they became engaged to be married. However, a few months later Norman Warne died suddenly. With royalties from the sales of *Peter Rabbit*, and a small legacy, she bought Hill Top Farm, at Sawrey, between Lake Windermere and Coniston Water. For Beatrix Potter Hill Top became home. With fine views reaching out to the fells around Coniston, the farm and its surroundings became the inspiration for her books for children. So many of the scenes she drew were details of Hill Top and its rooms. Her cottage was not yet completely home, for she was the occasional visitor still tied to her parents, but she knew that the Lake District was her country.

Beatrix married William Heelis in 1913. He was a solicitor who acted for her when buying Lake District property. Feeling that Hill Top was too small they moved to a farmhouse called Castle Cottage from which they could still see Hill Top farm, and for the first time she was able to pursue the life of a farmer. She died in the winter of 1943 and bequeathed to the National Trust her property in Sawrey and elsewhere, amounting to several thousand acres. Her books remain as popular as ever.

ARTHUR RANSOME

One of the most popular of all writers of books for children, Arthur Ransome (1884–1967) set most of his adventure stories in the English Lake District or among the waters of the Norfolk Broads. He cared deeply for landscape, and the natural details with which he liked to pack the settings for his exciting tales are loving and exact.

Arthur Ransome probably inherited his capacity for accurate description and writing

Eastwood Dunkeld
Sep 4th 93

My dear Noel,
 I don't know what to
write to you, so I shall tell you a story
about four little rabbits
 whose names were —

Flopsy, Mopsy Cottontail

and Peter

They lived with their mother in a
sand bank under the root of a
big fir tree.

Letter from Beatrix Potter which inspired *The Tale of Peter Rabbit*

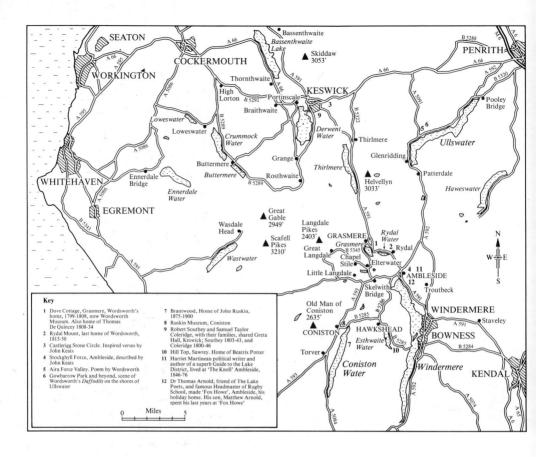

from his father, Professor Ransome, who wrote historical textbooks. His early career as a highly successful foreign correspondent for the *Manchester Guardian* developed his writing talents and gave him a taste for adventure; he witnessed the Russian Revolution in 1917 and later, after expulsion from Russia, married Trotsky's secretary.

He published his first book *A History of Story Telling*, when he was 25, but it was in 1930 that his most celebrated book, *Swallows and Amazons*, appeared. The idea for the story had come to him after watching two girls sailing a dinghy on the waters of Lake Windermere, although 'Wild Cat Island' in the story is Peel Island in Lake Coniston. Ransome included himself in the story in the character of Captain Flint. The famous houseboat illustrated in the book never existed; the author used the long-funnelled tourist steam launch *Gondola*, which cruised the lake, as his model. At that time he was living in the Lake

District after ill-health had forced him to retire from foreign travels and journalism. Many books followed, revealing his joy in tales of adventure, and his knowledge of and skill in fishing and sailing.

The first Carnegie Medal for children's writing was presented to Arthur Ransome in 1936. His philosophy of writing for children was a simple one: 'You write not for children, but for yourself, and if, by good fortune, children enjoy what you enjoy, why then you are a writer of children's books.'

SOME LAKE POETS (*see* map above)

William Wordsworth (1770–1850) will always be regarded as the leading figure among the poets who lived in the Lake District. He and his sister Dorothy (1771–1855) moved into Dove Cottage, Grasmere, in 1799. The cottage is now a Wordsworth museum. Their custom was to set off together on their delightful

Dove Cottage, Grasmere (*see* Lake Poets)

walks of local discovery. The journal that Dorothy Wordsworth kept for so long was important to her and also for her brother's poems, for some of his poetry certainly sprang from scenes and incidents recorded by his sister. On Thursday 15 April 1802, they visited the woods of Gowbarrow Park on the north shore of Ullswater:

> When we were in the woods beyond Gowbarrow Park, we saw a few daffodils close to the water-side. We fancied that the lake had floated the seeds ashore, and that the little colony had so sprang up. But as we went along there were more and yet more; and at last, under the boughs of the trees, we saw that there was a long belt of them along the shore, about the breadth of a country turnpike road. I never saw daffodils so beautiful. They grew among the mossy stones about and above them; some rested their heads upon these stones, as on a pillow, for weariness; and the rest tossed and reeled and danced, and seemed as if they verily laughed, with the wind that blew upon them over the lake; they looked so gay, ever glancing, ever changing.

Then, of course, Wordsworth wrote his famous poem but he did not call it 'Daffodils' —in fact he did not give it a title at all.

In 1802 Wordsworth married Mary Hutchinson. This produced a difficult situation, for William and Dorothy had been so close for so long. In 1808 it was time to move again. Wordsworth's family was growing, Coleridge often came to stay, and Thomas de Quincey, author of *The Confessions of an English Opium Eater*, took the lease of Dove Cottage.

The Wordsworths had moved on to Allan Bank, a house at the north end of Grasmere Lake. They moved again in 1811 to the

GUIDE
TO THE
ENGLISH LAKES
BY
HARRIET MARTINEAU.

Parsonage at Grasmere, where two of their children died. Then came their final home of Rydal Mount, Grasmere, where Wordsworth remained until his death in 1850. As Wordsworth became the grand old man of English poetry, honours came his way: he received a Civil List pension and became Poet Laureate.

Samuel Taylor Coleridge and Robert Southey lived at Greta Hall, Keswick, the two families sharing the house between them. Southey a man of prodigious industry who also gathered a library of some 15,000 books. He once said that 'to introduce Wordsworth into one's library is like letting a bear into a tulip garden.' Between Keswick and Grasmere the poets walked, talked and wrote their way into a unique period of English literary history. There were many satellites to the group: Hartley Coleridge, John Wilson, Harriet Martineau, and later John Ruskin.

Although Wordsworth approved of a guide to the Lake District, like the Duke of Welling-ton, he did not welcome mass mobility. Miss Martineau, however, the brilliant blue stocking, wrote an excellent *Guide to the English Lakes*, and not only encouraged the visitor but, in complete contrast to Wordsworth, welcomed the railway:

> In a generation or two, the dale-farms may yield wool that Yorkshire or Lancashire, and perhaps other countries may compete for; the cheese may find a market, and the butter may be in request. And at the same time, the residents may find their health improved by the greater wholesomeness of their food; and, before that, their minds will have become stirred and enlarged by inter-course with strangers who have, from

OPPOSITE The eastern Lake District Fells and Ullswater from Gowbarrow Park (*see* Lake Poets)

OVERLEAF Derwent Water, near Keswick (*see* Lake Poets)

ABOVE Robin Hood's Bay (*see* Senior) BELOW The harbour at Staithes Bay

ABOVE *A Bit of Old Runswick,* by Mark Senior

circumstances, more vivacity of faculty and a wider knowledge. The best as well as the last and greatest change in the Lake District is that which is arising from the introduction of the railroad.

MARK SENIOR

The fishing village of Staithes on the North Yorkshire coast also developed into an artists' colony during the late 19th century. They called themselves the Staithes Group, although they were scattered along the coast between Staithes and Robin Hood's Bay, south of Whitby.

Mark Senior (1864–1927) was a major force within the Staithes Group. He acted as a catalyst, drawing many other painters to sample the summer delights of the coastline, including Laura and Harold Knight, William Greaves, Frederick Jackson and Joseph Terry.

Most of the Staithes Group actually painted at Runswick Bay, by far the best of the bays in terms of light, where the red pantile-roofed cottages perched high up on the cliffside give superb views over the bay and inland to the heather-covered moors.

Mark Senior had a cottage at Runswick where he developed an Impressionist style and a fine understanding of colour. His blue is particularly brilliant and gives an added richness to his many sun-filled paintings. One of the cottages at Runswick still carries patches of blue paint on its walls, where Mark Senior cleaned his brushes. From 1891 he exhibited regularly at the Royal Academy.

WILLIAM WORDSWORTH: TRAVEL AND RAILWAYS

In the 18th century few people in Britain had explored many miles beyond their own birth-place. Soldiers and sailors had returned from their journeys with tales to tell of foreign climes, but few would have been able to relate the wonders of their own land. This began to change as roads improved, but it was not until 1763 that the stage coach was able to make

the journey across Shap Fell. It was also a time when, following the Jacobite Rebellion of 1745, the people of the South found themselves becoming increasingly interested in the North, and as relations with France became more difficult those who once would have travelled to the Continent now began to look elsewhere. The literary factor in these quests was to seek out the places of rare beauty described by poets and illustrated by the engravings of the publishers. Lakeland was to become the creative eyrie of many British poets, and the tourists followed hard on their heels.

In the 19th century William Wordsworth was deeply concerned at what he considered to be the inroads of tourism. Today the problem has grown far worse as mass mobility destroys the quiet beauty that the people come to seek. The poet's main worry was the expansion of the railway system. He voiced his concern over a long period, illustrated by this first public outburst:

SONNET ON THE PROJECTED KENDAL AND WINDERMERE RAILWAY

Is then no nook of English ground secure
From rash assault? Schemes of retirement sown
In youth, and 'mid the busy world kept pure
As when their earliest flowers of hope were blown,
Must perish;—how can they this blight endure?
And must he too the ruthless change bemoan
Who scorns a false utilitarian lure
'Mid his paternal fields at random thrown?
Baffle the threat, bright Scene, from Orrest-head
Given to the pausing traveller's rapturous glance:
Plead for thy peace, thou beautiful romance
Of nature; and, if human hearts be dead,
Speak, passing winds; ye torrents, with your
strong
And constant voice, protect against the wrong.

Rydal Mount,
 October 12th, 1844.

The degree and kind of attachment which many of the yeomanry feel to their small inheritances can scarcely be overrated. Near the house of one of them stands a magnificent tree, which a neighbour of the owner advised him to fell for proft's sake. 'Fell it,' exclaimed the yeoman, 'I had rather fall on my knees

Viaduct on the Lime Branch of the Lancaster and Carlisle Railways (*see* Wordsworth)

and worship it.' It happens, I believe, that the intended railway would pass through this little property, and I hope that an apology for the answer will not be thought necessary by one who enters into the strength of the feeling.

W.W.

Washing Day, 1912, by Augustus John

OPPOSITE A beach of the Aran group of islands (*see* Synge, p. 52)

Doolin, Co. Clare (*see* John)

John was in the company of Francis Macnamara, 'poet, philosopher and financial expert'! He lived in the fishing village of Doolin near Ennistimon. It was a wild barren landscape, torn and worried by great Atlantic winds. With horse and cart they explored the neighbourhood and made several crossings to the Aran Islands, occasionally by traditional currach rather than steamer.

Augustus John, like J. M. Synge, was fascinated by the islanders and their way of life. He wrote: 'The smoke of burning kelp rose from the shores, women and girls in black shawls in red or saffron skirts stood or moved in groups with a kind of nun-like uniformity and decorum. Upon the precipitous Atlantic verge some forgotten people had disputed a last foothold upon the rampart of more than one astounding fortress.' Like so many fine artists, Augustus John could paint a

scene equally well with words, so well illustrated in his autobiography *Chiaroscuro*. His later pictures occasionally depict a woman looking out over a lonely landscape. He may well have derived this composition from his days at Doolin when he noticed how women would be sent out to some vantage point to warn of the approach of the Civil Guard.

PAUL HENRY AND ACHILL ISLAND

Born in Belfast, the artist Paul Henry (1877–1958), studied art in Paris, at the Académie Julian, and at Whistler's studios. He is particularly acclaimed for his Irish paintings, yet his desire to return to Ireland came about by pure chance. Until 1912 he was a painter with a creative imagination that had yet to be fired. The necessary spark was applied by his

Morning in Donegal, by Paul Henry

friends Robert and Sylvia Lynd: 'When I next met Robert and Sylvia they were full of their visit to Ireland. They talked of Achill Island more than of any other place they had seen. Their enthusiasm thrilled me, and I decided to see this wonderful island for myself.'

Paul Henry was a man whose actions were largely governed by impulse, and he was looking forward to his fortnight's holiday on Ireland's Atlantic coast. His first glimpse of Achill Island in County Mayo excited him, but on arrival he stayed in the village of Dugort and, to his dismay, found it full of tourists. His shock was real, for during the journey he had begun to feel that his journey to Achill was not really a visit but a homecoming. He wished to be with the people of the country, and was directed southwest to the village of Keel. This was the place he felt he had been looking for: 'As I wandered round and

through the village, and out on the road that led through Pullough, and looked down on Dooagh and to the noble cliffs of Achill Head, I felt that here I must stay somehow or another.' He had neither money nor plans, so he tore up his return ticket to England, persuaded the village postmistress to give him a lodging, and remained on the island for the next seven years!

Paul Henry has described his desire to live in Achill and to be part of island life—to identify with it, and to study and paint it in all its moods—as an emotional one. He wanted really to know the people and be accepted by them, rather than be regarded as a migrant visitor. In this way Henry believed that he would discover and come to understand the true character of the landscape and its inhabitants. As among many remote communities there existed on Achill a distrust of being

Rainbow, the Aran Islands (*see* Synge)

drawn, painted or photographed, and it says much for Paul Henry that he was able to turn suspicion into friendship.

Sean O'Faolain wrote of Paul Henry: 'Sometimes people say that he is always painting the same thing—clouds, blue mountains and black bogs. He is always, indeed, painting the same thing—light caught in a flux, a moment's dazzling miracle.'

After six months on Achill he moved to the village of Pullough. From there one of his favourite walks 'was to Saddle Head where I could lie on the turf and look out over Blacksod Bay to Belmullet and the "Stags of Broad Haven" and beyond that to the loneliest part of Ireland.'

To help ease financial pressures, which always seemed to be with him, he applied for the post of Paymaster for the Congested Districts Board. His duties were by no means heavy and they gave him the opportunity of exploring the Erris Peninsula. He writes: 'I was able to sit down whenever I wanted to and make drawings on the way . . . my wanderings in Mayo took me into many outlying areas and it is in these places that one finds a richness of life that is not found in the more sophisticated parts of the county.'

The west of Ireland held him spellbound: 'the intensity of the emotion I get from a purely Irish landscape always puzzled and disturbed me. . . Is this only some trick of the imagination, or do the horns of Elfland sound more distinctly there?' Whatever the reason Paul Henry broke the spell and left Achill in 1919 before becoming completely bewitched.

J. M. SYNGE AND THE ARAN ISLANDS

It was W. B. Yeats who, during a chance meeting in Paris in 1896, suggested to John Millington Synge (1871–1909) that he should go to the Aran Islands and 'live as one of the people themselves, express a life that has never found expression'. Two years passed before the budding playwright actually took the advice and travelled to the island of Inishmore (also known as Aranmore), where he studied Gaelic with Martin Conelly.

Synge then moved on to the island of Inishmaan, but left the Islands during the summer of 1898. Even from this comparatively short stay it was clear that Synge already felt a kinship with the people, the islands themselves and their history. He

returned to the islands for several weeks each summer and autumn until 1902.

The notes Synge made on these visits he reworked and eventually published under the title *The Aran Islands* (1907), with illustrations by Jack Yeats. It was a faithful and moving account of life on the islands; the playwright developed what can only be described as an emotional attachment to them. He wrote, 'with this limestone Inishmaan I am in love, and hear with galling jealousy of the various priests and scholars who have lived here before me. They have grown to me as the former lovers of one's mistress, horrible existences haunting with dreamed kisses the lips she presses to your own.' Here he saw what he regarded as the last and vanishing relics of an ancient civilization. 'Every article on these Islands', he wrote, 'has an almost personal character, which gives this simple life, where all art is unknown, something of the artistic beauty of medieval life.'

On these islands Synge believed himself to be 'beyond the dwelling place of man' with a 'world of inarticulate power'. The islanders' endless struggle with the elements, and their understanding of the natural forces about them, appeared to give them a deeper insight into life itself, which was reflected in their ancient stories.

For a playwright such as Synge it was like manna from heaven. His imagination clutched at stories ancient and modern, which often provided him with inspirational kernels for future plays.

The megalithic fortification of Dun Conor on Inishmaan had been used by islanders to hide a man who was wanted for the murder of his father. Synge wrote, '. . . it is within a stone's throw of my cottage, and I often stroll up there after a dinner of eggs or salt pork, to smoke drowsily on the stones.' It was at this place that he began to contemplate what was to become his most celebrated work, *The Playboy of the Western World* (1907).

On the island of Inishmore he was taken to the ruined church of The Four Beautiful Persons. A well close by was said to be a holy well, for its waters had once cured a boy of blindness. From this visit Synge conceived *The Well of the Saints* (1905). News that the unidentified body of a man had been washed

Photograph of the lake at Coole Park, by George Bernard Shaw (*see* Yeats)

ashore in Donegal prompted *Riders to the Sea* (1905). The plot of *In the Shadow of the Glen*, first performed in 1903, also grew from a story told by an islander, although Synge actually set the play in County Wicklow.

Travel to the Aran Islands is now much easier than it was in Synge's day as there are daily flights from Galway and Rossaveal.

W. B. YEATS AND COOLE PARK

Coole Park, County Galway, was the home of Lady Gregory, a woman deeply interested in books, paintings and architecture. She was a devoted friend of William Butler Yeats (1865–1939) and did all within her power to encourage his poetry. For many years Yeats stayed at Coole for long periods. This heavily wooded estate with its lake and wild swans has great beauty. A copper beech still stands bearing the carved initials of Yeats, Synge, Augustus John, John Masefield, Sean O' Casey, and others. The River Cloon flows past the wood and disappears underground to re-emerge in Galway Bay twenty miles to the west. The estate is overshadowed by the *dun* or barrow of the legendary King Guaire.

Yeats liked to work in a room on the west side of the house looking towards the lake.

He wrote, '. . . at last what I have been seeking always, a life of order, and of labour, where all outward things were the image of an inward life.' In 1902 he wrote the sonnet 'In The Seven Woods', based on his intimate knowledge of Coole. The wild swans on the lake are also a recurring theme and an important image in his poems, as in 'The Wild Swans at Coole' (1917):

> *The bell-beat of their wings above my head,*
> *Trod with a lighter tread . . .,*
> *By what lake's edge or pool*
> *Delight men's eyes when I wake some day*
> *To find that they have flown away?*

In 'The Trembling of the Veil' Yeats writes: '. . . the woods at Coole, though they do not come into my dream, are so much knitted to my thought that when I am dead they will have, I am persuaded, my longest visit.'

His poem 'Coole Park', written in 1929, predicts the fate of the house at Coole.

> *I meditate upon a swallow's flight,*
> *Upon an aged woman and her house,*
>
> . . .
>
> *Here, traveller, scholar, poet, take your stand*
> *When all these rooms and passages are gone,*
> *When nettles wave upon a shapeless mound*
> *And saplings root among the broken stone. . .*

Coole Park (now demolished)

Lake Isle of Innisfree, Lough Gill, Co. Sligo (*see* Yeats)

When Lady Gregory died in 1932 it was a very heavy blow to Yeats, for she had been a dear friend for so many years. He grieved again when the house began to be dismantled. It was finally pulled down in 1941. Today its foundations still form patterns in the grass; but best of all wild swans still inhabit the lake and a haunting beauty remains. As ever, Yeats was to find the right words:

> *Man shifts about—all that great glory spent—*
> *Like some poor Arab tribesman and his tent.*

The grounds of Coole are now cared for by the Irish Forestry and Wild Life Service.
SEE ALSO PAGE 184

W. B. YEATS AND COUNTY SLIGO

As a boy, W. B. Yeats (1865–1939) lived with his grandparents in the town of Sligo and, even when his family moved to London, he would return to spend summer holidays there. Both his grandparents' houses have been demolished, but housing estates named after them preserve the memory.

In 1965, the anniversary of the poet's birth, the Yeats Society and the Sligo Chamber of Commerce were looking forward to the day when Sligo would be to Yeats what Stratford-upon-Avon is to Shakespeare. With the passing of each year the importance of Yeats as a poet becomes increasingly apparent and appreciated, and the numbers of students and pilgrims to Sligo increase. The great poet received the Nobel Prize for his writing and was a founding senator of the Irish Free State.

The Sligo landscape is indeed beautiful, a land of lakes, woodland and hills looking out to Sligo Bay. On some maps the area is already shown as 'Yeats Country'. The enthusiasm for Yeats is not, of course, confined to Sligo. Travel south to Galway and people will tell how it was there that Yeats did his best work.

OVERLEAF Ben Bulben, Co. Sligo (*see* Yeats)

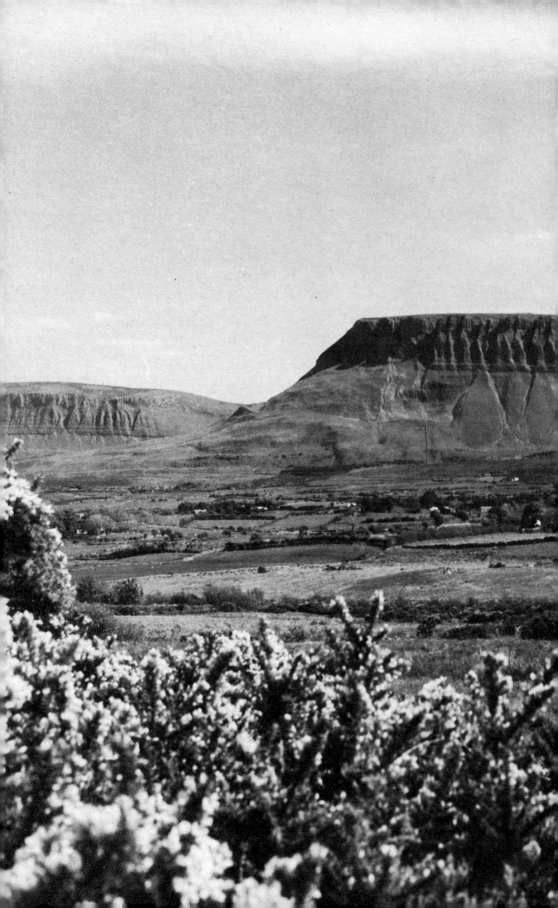

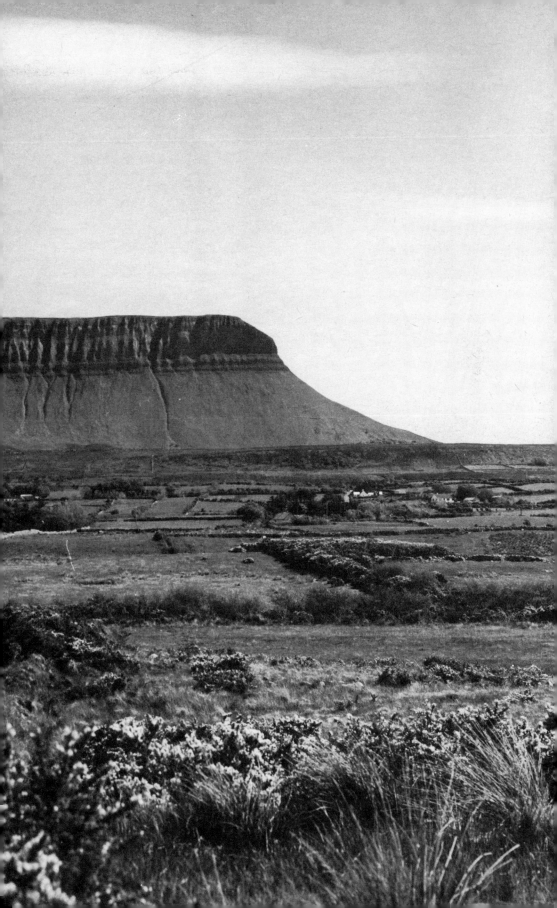

The Sligo countryside had a profound effect upon Yeats and his poetry; he also found there a deeply rooted love of the Irish people, and their old heroes and legends. In later years he believed it enabled him to form a purely Irish style of writing. As a youth in London and homesick for Ireland, he found that he '. . . longed for a sod of earth from some field I knew, something of Sligo to hold in my hand. It was some old race instinct like that of a savage. . .'

His mother instilled in her family the belief that Sligo was more beautiful than other places, and she was always ready to tell stories of her girlhood and of the fishing people of Rosses Point. Through his mother Yeats became interested in the county's history. The woods above Dooney Rock and those beyond the waterfall at Ben Bulben and Knocknarea, five miles west of Sligo, are highly important in his work and are men-

tioned a number of times. 'Under Ben Bulben' is obviously the most famous poem associated with the mountain; its closing lines, 'cast a cold eye on life, on death. Horseman, pass by!' form the epitaph on Yeats's grave. He died in the south of France but lies buried at Drumcliff in view of the mountain, in the graveyard of the Protestant church, where his grandfather had once been rector.

A poem that must be mentioned is 'The Lake Isle of Innisfree'. This tiny island on Lough Gill came to mind when Yeats read *Walden* by Henry Thoreau, the American poet and philosopher. Yeats wrote his poem in London when he saw and heard a fountain of water in a shop window and it reminded him of lake water. He wrote: 'From the sudden remembrance came my poem, my first lyric with anything in its rhythm of my own music.'

SEE ALSO PAGE 184

Wales

The Welsh poets have sung for centuries in praise of Wales, and to a man they all have the voice for it.

As Huw Menai wrote in his poem 'Cwm farm near Capel Curig':

The Cymric speech; the very mountains brood
O'er consonants that, rugged streamlets, flow
Into deep vowel lakes . . . and by this wood,
Where Prince Llewelyn might himself have stood,
Forget-me-nots in wild profusion grow!

Wales is a land of hills and mountains, white water and salmon, and a people who know the history of their country and its folk lore, and have not only retained their language, but are proud to see its use rapidly grow. On the River Teify, in Cardiganshire, a few coracles of Ancient British type are still used

Caernarvon Castle, by Paul Sandby (1725–1809). Sandby travelled widely and is generally recognized as one of the finest 18th-century watercolourists.

for fishing, and on the hill farms a hard living is still won from raising sheep.

As with all mountain landscapes, the mood may change by the hour or the minute according to weather and season.

Denbighshire and Caernarvonshire attract many tourists. Betws-y-Coed and Snowdon have long been popular; so too are the castles of North Wales, and the Festiniog Railway. Some of the best walking country is to be found among the Brecon Beacons, or going north from Penderyn to seek out the hidden waterfalls.

In Central Wales the Dovey Valley has much to commend it. It is a fine place for the birdwatcher. Another good centre for exploring Wales is Llangollen, where the River Dee sings its way down into England. The canal at Llangollen is a remarkable piece of engineering—not the canal itself but the Pont Cysylte

aqueduct that carries the water of the canal across the Vale of Llangollen for a distance of 1000 feet and at a height of 127 feet. It is Thomas Telford's masterpiece of British engineering. Crossing the aqueduct in a small boat provides the most dramatic of all views over the River Dee and Vale of Llangollen.

In South Wales it was the blue of Swansea Bay that gave the poet Landor 'more pleasure than the Bay of Naples'. This same quality of blue was recognized by Clement Scott in his poem 'The Women of Mumbles Head':

Maybe you have travelled in Wales, sir, and
 know it north and south;
Maybe you are friends with the 'natives' that
 dwell at Oystermouth;
It happens, no doubt, that from Bristol you've
 crossed in a casual way,
And have sailed your yacht in the summer in the
 blue of Swansea Bay.

Today the traveller might well come from Bristol, but it is most unlikely that he would take a boat—more likely a flying swoop by car across the magnificent Severn Bridge.

❧⸙❦⸙❧

W. H. DAVIES

Born of Welsh parents at Newport, South Wales, William Henry Davies (1871–1940) was to become one of the most picturesque figures of British literature. After a brief and abortive apprenticeship to a frame maker, he turned his eyes to America where he led the rough life of a hobo. He was a fighter who enjoyed life to the full and the company of all men, and women. The only things he feared were rats and 'educated ladies'.

While train jumping in the United States, he slipped and lost a foot. He returned to this country a cripple and earned a living peddling bootlaces and singing in the street. Davies had inherited the useful sum of 10 shillings (50p) a week from his grandmother, and this he carefully saved while living in dosshouses. At his own expense he published a collection of poems under the title The Soul's Destroyer. A copy sent to Bernard Shaw resulted in recognition and fame.

W. H. Davies could never be described as an intellectual poet, nor would he have wished to be. He dealt in the simple themes of nature and treated them with gentle lyricism:

As butterflies are but winged flowers,
Half sorry for their change, who fain,
So still and long they lie on leaves,
Would be thought flowers again.

E'en so my thoughts, that should expand,
And grow to higher themes above,
Return like butterflies to lie
On the old things I love.

Of all Davies's poems, the one that really gave him lasting joy was called 'Sweet Stay-at-Home', which has appeared in many anthologies. His Autobiography of a Supertramp has become a classic. He wrote the book at Stidolph's Cottage in Eggpie Lane at Sevenoaks Weald, Kent. The cottage was tenanted by the poet Edward Thomas, who also rented Else's Farm nearby. Davies broke his wooden leg there, and a replacement was made to Thomas's design. The shape, however, clearly puzzled the local carpenter, for he prepared a bill for 'a curiosity cricket bat'.

As well as writing of robins and nightingales, Davies wrote poems about tramps, prostitutes and drunks. He made his final home at Nailsworth, Gloucestershire, so that he could be: '. . . near to Wales but . . . not haunted by any sort of trail from my past.' Yet he clearly thought of:

DAYS THAT HAVE BEEN

Can I forget the sweet days that have been,
When poetry first began to warm my blood;
When from the hills of Gwent I saw the earth
Burned into two by Severn's silver flood;

When I would go alone at night to see
The moonlight, like a big white butterfly,
Dreaming on that old castle near Caerleon,
While at its side the Usk went softly by:

When I would stare at lovely clouds in Heaven,
Or watch them when reported by deep streams;
When feeling pressed like thunder, but would not
Break into that grand music of my dreams?

Can I forget the sweet days that have been,
The villages so green I have been in;
Llantarnam, Magor, Malpas, and Llanwern,
Liswery, old Caerleon, and Alteryn?

Can I forget the banks of Malpas Brook,
Or Ebbw's voice in such wild delight,
As on he dashed with pebbles in his throat,
Gurgling towards the sea with all his might?

Ah, when I see a leafy village now,
I sigh and ask it for Llantarnam's green;
I ask each river where is Ebbw's voice—
In memory of the sweet days that have been.

ERIC GILL AND CAPEL-Y-FFIN

Artist, craftsman, designer and writer, Arthur Eric Rowton Gill (1882–1940) was a man with an astonishing range of talents, and he used them all, as may be judged from his prolific output. He was a man who loved the country-side and simple delights; totally opposed to

Crucifixion, 1910, by Eric Gill

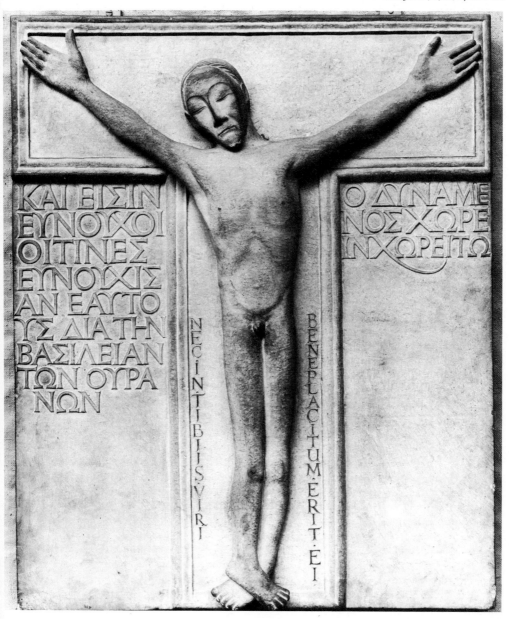

the growth of an industrial society, he constantly expressed his views, in essays and pamphlets on the relationship between art, life and society. In 1924, Gill established a community of artists and craftsmen at Capel-y-ffin, among the Black Mountains in Wales; the events that led up to its formation are interesting.

After early tuition at Chichester Technical and Art School, where he developed a passionate interest in decorative lettering, Gill was apprenticed in 1899 to W. D. Caroe, architect to the Ecclesiastical Commissioners at Westminster. In London he also attended the LCC Central School of Arts and Crafts, where he was able to study lettering under the great calligrapher Edward Johnston. Following the advice of his teachers he also acquired the skills of masonry and stone-carving. The late Sir Charles Wheeler, first sculptor President of the Royal Academy, once described Gill's letter cutting as the finest since the Renaissance. Others have claimed it the best since the Romans.

In 1903 Gill became a self-employed craftsman, and five years later moved to Ditchling in Sussex. In 1913 he was received into the Roman Catholic Church. Many other artists and craftsmen followed him to Ditchling, including Edward Johnston, Desmond Chute, Hilary Pepler and David Jones.

This remarkable Ditchling group formed itself into the Craft Guild of St Joseph and St Dominic, with the aim of being a religious community dedicated to making things by hand. In 1916 Hilary Pepler founded the St Dominic's Press at Ditchling. He was interested in good printing using a hand press and hand-made paper. These books are now sought after by collectors of private press books throughout the Western world. Gill's woodblock engravings and decorations embellished many of the books and, very soon, the famous Golden Cockerel Press was knocking at Gill's door. When he completed the Stations of the Cross at Westminster Cathedral he was also acclaimed as a sculptor. As a type designer he created the now celebrated typefaces of Gill Sans-serif and Perpetua.

In 1924 disagreements with Pepler led to Gill's resignation from the Guild; it was inevitable, as Gill wrote later: 'if 2 persons

were playing a game and after a bit they discover they're playing a different game. There's no harm done. They seperate, that's all.' Both men felt the separation deeply.

The Benedictine monks on Caldy Island, near Tenby in South Wales, were the owners of the disused monastery at Capel-y-ffin, and they proved willing to let the group from Ditchling have the tenancy. The monastery had been partly built in the 1860s by an Anglican preacher, Father Ignatius. Gill decided that it was very necessary to view the property before committing himself further, but his first impressions almost caused him to abandon the enterprise. In his autobiography, a great deal of which he wrote at Capel-y-ffin shortly before his death, he says: 'We arrived about midnight in deep snow having with great difficulty hired a motor car at Abergavenny fifteen miles away. . . For miles and miles we had been driving slowly and dangerously up a narrow and very rough mountain lane and then we arrived at that dark and almost uninhabited and uninhabitable place.'

Next day, as so often happens, things no longer appeared so discouraging. A quadrangle formed by Victorian Gothic buildings looked ideal, mountain streams tumbled with fresh water and the views were magnificent: 'the mountains above and around and confronting the monastery at Capel-y-ffin are as good to look at as any in the world', wrote Gill. The reconnaissance over, three families duly said farewell to the downland of Sussex for the mountains of Wales. '. . . three fathers, three mothers, seven children (of whom the eldest was nineteen and the youngest five years old) one pony, chickens, cats, dogs, goats, ducks, and geese, two magpies and the luggage. We hired a lorry at Pandy, twelve miles away (the nearest station at which the pony could be detrained) and arrived at Capel about tea time in a typical steady Welsh downpour.'

The members of the community did their own milking and brewing, butter and bread making, and farmed 20 acres. It also began a new and exciting period of creativity for all of them, including Laurence Cribb, Rene Hague, Donald Attwater, Philip Hagreen, and of course David Jones. Eric Gill continued with his wood engraving, particularly for the

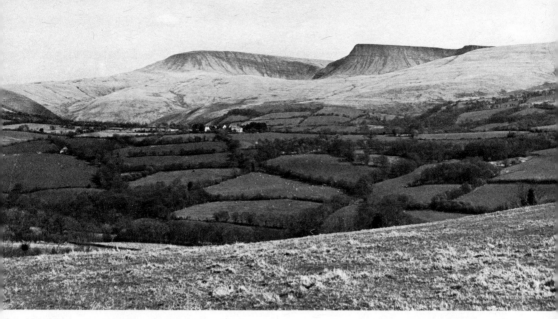

The Black Mountains (*see* Gill)

Golden Cockerel Press. The four years spent in the Black Mountains were important for all of them, '2000 feet of mountain wall on both sides and to the north of it—no outlet but to the south'. It was a quiet life, uninterrupted by outsiders, apart from the visitors who came to ask if they could 'have a look at a monk'. Long after Gill, his family and companions had left Capel-y-ffin, he wrote:

> It is still the same paradise and it is possible that it will long remain so. For by the mercy of geographical accident all the valleys are cul-de-sacs. Let industrial-capitalist disease do its worst—the Black Mountains of Brecon will remain untouched and their green valleys lead nowhere. God help them! I hope I am right.

DAVID JONES AT CAPEL-Y-FFIN

When John Rothenstein made a visit to Capel-y-ffin in 1926, he asked Eric Gill who the shy man was who wore 'anonymous' clothes. 'That', said Gill, 'was David Jones. He's been learning carpentry but he's not much good at it. But he's a jolly good artist; a lot will be heard of him before long.' Gill's confidence in David Jones (1895–1974) was to

be amply justified, and by his achievements as poet and writer as well as in painting.

In 1952, in a letter to Desmond Chute, Jones warmly admitted his enormous debt to Gill: 'What an inimitable man he was. There was a late 15th-century Welsh poet who wrote a couplet which being translated runs—"it was difficult for me to part with one whose like did not live". I think any of us who knew Eric must feel like that about him.'

Gill certainly encouraged David Jones, and had him assist him with many lettering tasks. These only involved the painting-in of Gill's own letters, but resulted in the development of Jones's own individual lettering style. There is no doubt that of all Gill's pupils and followers, it was David Jones whose talents were to bear the richest harvest of creativity.

At Capel-y-ffin his drawings and water-colours became deeply influenced by the mountain landscape; the rhythms of hills and streams gave his style more freedom, as in *Hill Pastures* and *Twmpa, Nant Honddu*. This period in Wales saw his work mature, a fact that Jones recognized: 'I began to have some idea of what I would personally ask a painting to be, and I think that from 1926 onwards there has been a fairly recognizable direction in my work.'

It was also at about this time that he was writing *In Parenthesis*, an epic in experimental

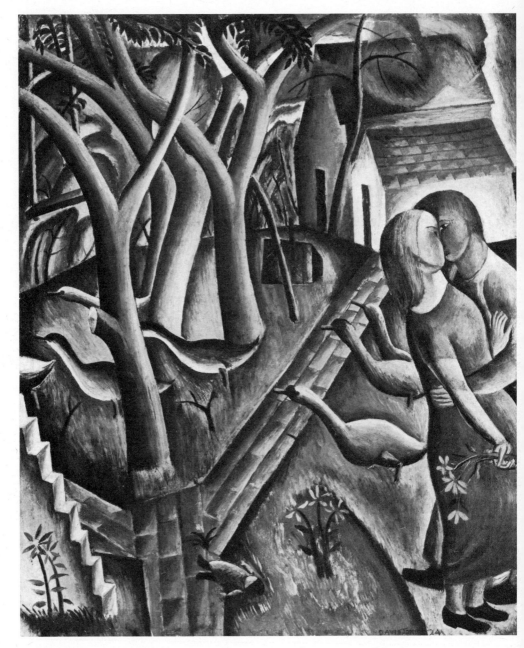

ABOVE *The Garden Enclosed*, by David Jones
OPPOSITE Capel-y-Ffin (*see* David Jones)
OVERLEAF LEFT Llanthony Priory (*see* Landor, p. 67)
OVERLEAF RIGHT ABOVE *Snowdon*, by John Varley
(1778–1842). Varley was an early 19th-century
watercolourist who achieved remarkable atmospheric
effects.
OVERLEAF RIGHT BELOW The home of Dylan Thomas
overlooking the Laugharne Estuary.

form, combining prose and free verse. When it first appeared many readers considered it 'strange and difficult'. However, its accomplished power was duly acknowledged when it won the Hawthornden Prize in 1938.

The experience of the First World War had a profound and lasting effect on David Jones,

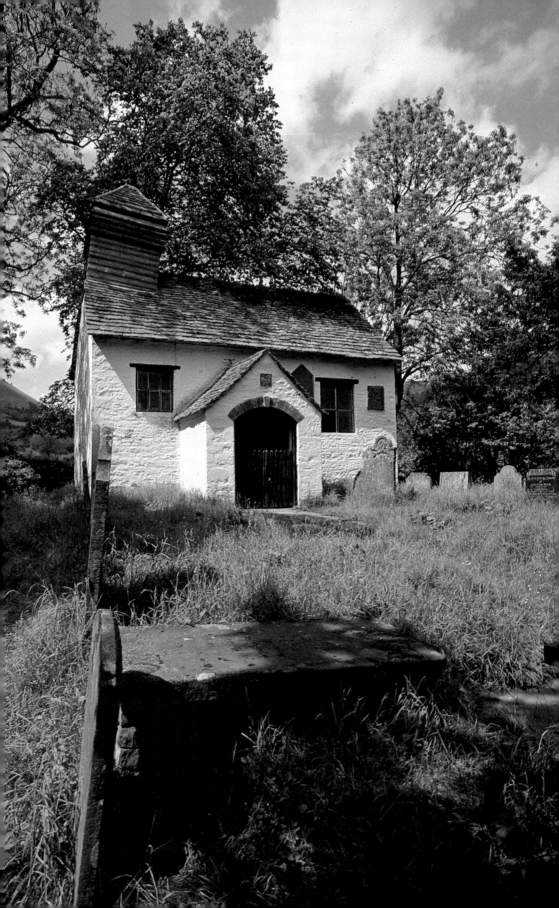

as on so many others. Early in 1915 he had joined the Royal Welch Fusiliers. He chose the title *In Parenthesis* because what had happened in the trenches was so far removed from normal life. His description of events is astonishingly evocative. When Private John Ball faces heavy gunfire, we share it with him: 'Out of the vortex, rifling the air it came-bright, brass-shod Pandoran; with all filling screaming the howling crescendos up piling snapt. Behind 'E' battery, fifty yards down the road, a great many mangolds up-rooted, pulped, congealed with chemical earth, spattered and made slippery the rigid boards leading to the emplacement. The sap of vegetables slobbered the spotless breech-block of No. 3 gun.'

This extraordinary work also makes references to Wales: 'The water in the trench-drain ran as fast as the stream in Nant Honddu in the early months, when you get milk from Pen-y-maes.'

David Jones found his creative springs in landscape, the Bible, liturgy, Welsh legend, and the Arthurian tales of Malory. Boyhood visits to North Wales, Strata Florida, and later to Caldy Island and the Black Mountains, gave him his spiritual home. He was born at Brockley, in Kent, and most of his life was spent in or near London. James Jones, his father, had come from Holywell, North Wales, and his wife was of an English family who had built ships on the Thames. Their son was a Celtic-Londoner, fascinated by his parentage, and the landscape of the Romans, Celts and Christians, and the marks they had all left upon the land, which David Jones peopled with mythological subjects of the past and present in paintings and prose. His awareness of past and present, cause and effect, is best illustrated by this extract from a broadcast talk he gave for BBC Wales in 1954:

About eight hundred years ago a prince of Aberffraw defeated his Welsh and English enemies at Coleshill between Flint Sands and Halkin Mountain. Holywell, where my father James Jones, was born, is about three miles northwest of the battle site. The birth

of a son to John Jones, Plastrwr, Treffynnon, in 1860 would indeed seem a matter having no apparent connection with the battle won by the great Owain Gwynedd in 1149. But however unapparent, the connection is real enough; for that victory symbolized the recovery of a tract of Britain that had been in English possession for well over three centuries. Had that 12th-century recovery not occurred the area around Holywell would have remained within the Mercian zone of influence. In which case its inhabitants would, centuries since, have become wholly English in tradition, nomenclature and feeling. Had local history taken that course, it follows that I should not now be speaking to you at the invitation of the Welsh BBC, as an artist of Welsh affinities. You see by what close shave some of us are what we are, and you see how accidents of long past history can be of importance to us in the most intimate sense, and can determine integral things about us.

FRANCIS KILVERT AND CADER IDRIS

Just over the Welsh border from Hay on Wye is the village of Clyro where the Reverend Robert Francis Kilvert (1840–79) was curate from 1865 to 1872. It was a border he crossed and recrossed. After 1872 he left for Wiltshire, but returned to the living of Rhayader in 1876. The following year he was finally appointed vicar of Bredwardine in Hereford-shire. This extraordinary man, who maintained a fascinating diary for many years, has handed on to us a unique glimpse of Victorian Wales; of people, places and events. A powerful man, he walked many miles across wild countryside to visit his parishioners.

Kilvert also took time off to see the beauty of Wales. One such occasion was his ascent of Cader Idris, a mountain that has been the inspiration of many works of art. His description of the climb is a graphic one:

As we sloped up the mountain side we had beautiful views of the Harlech mountains opposite, blue Cardigan Bay and dim Snowdon. The zig-zag path was steep in

OPPOSITE Pennard Cliffs (*see* Vernon Watkins)

parts and a great wind blew over the mountain so that I had to sit down in a sheltered place and tie the band of my hat to my button-hole with the old guide's neckerchief, for, said the old man, 'Many hats have been lost on this ridge.' We aimed for a great stone on the top of the first ridge. After this the climbing was not so severe. The old man came up very slowly. Soon after we passed the great stone we passed through a gateway the posts of which were large basaltic pillars. Here we saw a mountain standing apparently close by waiting upon Cader Idris. It was Plynlimmon. Here we passed round over the back of the mountain and began ascending the summit from the S. We came to a little round pool, or rather hole, full of water. The old man pulled a little tumbler out of his pocket, rinsed it, and gave me a glass of the clear bright water. It was delicious. Then he drank himself. He said the pool was the head water or spring of the Dysyni River. He had never known it dry in the driest summers. We saw from the spring the winding gleam of the Dysyni wandering down a desolate valley to join the Dyfi, its sister stream.

About this time the wind changed and flew suddenly round into the S. The head of the Idris, which had been cowled in cloud, had cleared for a while, but now an impenetrable dark cloud settled down upon it and the mist came creeping down the mcuntain. The sky looked black and threatened rain. Now there lay before us vast tracts and belts of large stones lying so close together that no turf could be seen and no grass could grow between them. It was broken basalt, and huge lengths of basalt, angled, and some hexagonal, lay about or jutted from the mountain side like enormous balks of timber and with an unknown length buried in the mountain. We passed quarries where some of the great columns had been dug out to be drawn down the mountain on sledges. Cader Idris is the stoniest, dreariest, most desolate mountain I was ever on. . .

The sun was shining on the hills below, but the mist crawled down and wrapped us as if in a shroud, blotting out everything. The mists and the clouds began to sweep by us in white thin ghostly sheets as if some great dread Presences and Powers were going past, and we could only see the skirts of their white garments. The air grew damp and chill, the cloud broke on the mountain top and it began to rain. Now and then we could discern the black sharp peak which forms the summit looming large and dark through the cloud and rain and white wild driving mist, and it was hidden again. It is an awful place in a storm. I thought of Moses on Sinai. . .

It is said that if one spends a night alone on the top of Cader Idris he will be found in the morning either dead or a madman or a poet gifted with the highest degree of inspiration. Hence Mrs Hemans' fine song 'A night upon Cader Idris'. The same thing is said of the top of Snowdon and of a great stone at the foot of Snowdon. Old Pugh says the fairies used to dance near the top of the mountain and he knows people who have seen them.

Down, down, and out of the cloud into sunshine, all the hills below and the valleys were bathed in glorious sunshine—a wonderful and dazzling sight. Above and hanging overhead the vast black precipices towered and loomed through the clouds, and fast as we went down the mist followed faster and presently all the lovely sunny landscape was shrouded in a white winding sheet of rain. The path was all loose shale and stone and so steep that planting our alpenstocks from behind and leaning back upon them Alpine fashion we glissaded with a general land-slip, rush and rattle of shale and shingle down to the shore of the Foxes' Lake. The parsley fern grew in sheets of brilliant green among the grey shale and in the descent we passed the largest basaltic columns of all protruding from the mountain side. In the clefts and angles of the huge grey tower columns grew beautiful tufts and bunches of parsley fern. We passed another lake, and after some rough scrambling walking over broken ground at the mountain foot, we came back into the turnpike road at the lake that we had passed in

Cader Idris (*see* Kilvert)

the morning. As we entered Dolgelly the old man said, 'You're a splendid walker, Sir,' a compliment which procured him a glass of brandy and water.

WALTER SAVAGE LANDOR AT LLANTHONY

Four miles down the valley from Capel-y-ffin, and some ten miles north of Abergavenny, are the village of Llanthony and the remains of Llanthony Priory. The priory dates from the 12th century and is in the care of the Department of the Environment. The building suffered badly during the revolt of Owain Glyndwr. Ruinous or not, it was an estate that appealed very much to the wealthy and extravagant poet and writer, Walter Savage Landor (1775–1864). He planned to restore the priory and make his home in a building on the west side that is now a hotel. Landor bought the property in 1807, and as well as restoring the priory, he intended to cover the estate with merino sheep and cedars of Lebanon! It was to be the home and grounds of a gentleman.

Unfortunately for Landor his temperament was his undoing. His ungovernable temper was the cause of constant quarrels and violent prejudices. After six years of conflict and litigation with the local authorities and country people, he abandoned Llanthony to his mother and left for the Continent. Yet Llanthony itself was never erased from his memory or affections, and in Italy, while producing some of his best work, he wrote:

> Llanthony! an ungenial clime,
> And the broad wing of restless Time,
> Have rudely swept thy mossy walls
> And rockt thy abbots in their palls.
> I loved thee by thy streams of yore,
> By distant streams I love thee more;
> For never is the heart so true
> As bidding what we love adieu.

GRAHAM SUTHERLAND

The roots of the artist Graham Sutherland (1903–80) lie deep in nature and imagination. He was born in London and, after a false start as an apprentice with the Midland Railway

67

Entrance to a Lane, 1939, by Graham Sutherland

Works at Derby, he became a student at the Goldsmiths' School of Art. He concentrated on engraving, producing some excellent landscape etchings. However, by the end of the 1920s etchings were fast going out of fashion so he switched to painting. His early work had been much influenced by Samuel Palmer (see p. 164), but Sutherland was soon to develop a very personal style of landscape painting. The favourite areas in which he liked to paint were Cornwall, and Pembrokeshire (now part of Dyfed) in southwest Wales. His first visit to

Pembrokeshire—he particularly enjoyed its celebrated coastline—took place in 1934, and the following year he became fully committed to the life of a professional painter.

Graham Sutherland began to make a reputation almost immediately, and in 1943 Edward Sackville-West, with brilliant percipience, linked Sutherland and Henry Moore as 'two of the most significant artists of our time'. Sutherland was attracted and deeply inspired by the 'mood' of a landscape, and he used it with a sense of drama, poetic expression, and mystery. His colours were often 'unrealistic', and many of his canvases portray scenes that are semi-abstract and abandon perspective. There is also a Surrealist element in his work: he participated in the International Surrealist Exhibition in London in 1936. His portraits of trees and hills, roots, leaves and thorns are very much his own; he described a thornbush as 'pricking air', and by foreshortening, he could turn some commonplace natural object into a monster growth of compulsive power.

Lanes and paths attracted him and they form the subjects of several paintings taken from drawings he made in Pembrokeshire in the summer of 1939. Just as Henry Moore saw the fascination of a hole or cave so too did Graham Sutherland; the tunnel-like wooded entrance leading nowhere greatly appealed to his imagination. His first one-man exhibition, mainly composed of Welsh landscapes, took place at the Paul Rosen and Helft Gallery in 1938.

During the Second World War Sutherland worked as an official war artist. Later he was to design the massive tapestry of Christ in Majesty, for the new Coventry Cathedral. He also painted many portraits, including Somerset Maugham, Lord Beaverbrook, Madame Rubinstein, and Sir Winston Churchill—a work that became the subject of much controversy and was destroyed on the instructions of Lady Churchill.

DYLAN THOMAS

The radio play *Under Milk Wood* has been translated into a score of languages and more. For most of the population of Laugharne in South Wales it all came as something of a shock. It was as though some mole in their midst had recorded the daily tittle-tattle of the town and broadcast it unblushingly to the

The Laugharne Estuary (*see* Thomas)

Dylan Thomas, 1938, by Mervin Levy

area. In a letter to Vernon Watkins in July 1944, he described how 'Aeroplanes grazed the roofs . . . there were fairies at the bottom of my garden, with bayonets . . . and Canadians in the bushes, and Americans in the hair; it was a damned banned area altogether.' In the same letter he looks forward again to living in Laugharne.

Vernon Watkins described Laugharne as having '. . . peace and beauty . . . this small sea-town beyond Carmarthen, a fishing village at the end of the world.' It was Richard Hughes, author of *A High Wind in Jamaica*, who first encouraged Dylan and Caitlin Thomas to go to Laugharne. The poet later remarked, 'Its literary values are firmly established: Richard Hughes lives in a castle at the top of the hill; I live in a shed at the bottom.'

In June 1949 he was wondering if back in Wales he was still the same person, 'watching the herons walk like women poets'. When, so little time ago he had been '. . . under the blaring lights, to the tune of cabhorns'. Was this the same man who wrote 'Fern Hill' (Llangain, Carmarthenshire)

> Now as I was young and easy under the apple
> boughs
> About the lilting house and happy as the grass
> was green.

When Dylan Thomas died in New York in the November of 1953, his body was brought back to the churchyard at Laugharne, where a plain white wooden cross marks the poet's grave. His funeral brought admirers from afar and Brown's Hotel was filled to the doors. It was agreed that, 'Dylan had a good send-off, what he would have liked.'

C. F. TUNNICLIFFE

The artistic skills of Charles Tunnicliffe (1901–79) make him one of the outstanding wildlife illustrators of the 20th century. He was a master of his crafts, a supreme engraver, etcher, watercolourist and book illustrator. He loved all wild creatures, observed them obsessively, delineated them delightfully. His piles of sketchbooks, etchings and woodcuts reveal the strata of years of endeavour and accomplishments. Tunnicliffe was probably the finest in his field since Thomas Bewick.

world. There can be little doubt that the Thomas town of 'Llaregyb' is Laugharne, although the late Vernon Watkins always considered that there might have been a little of New Quay, Cardiganshire, for added spice. Each year visitors come in thousands to look at the town and the celebrated boathouse, with its breathtaking view of the estuary, where in a small blue shed under the cliff, Dylan had woven his now famous words.

Dylan Thomas (1914–53) was born in Swansea, and his first slim volume, *Eighteen Poems*, was published in 1934. It was Edith Sitwell who first recognized and hailed this fresh poet's voice, and when his second book, a further *Twenty-five Poems*, appeared in 1936, she lavished praise on the work in the review columns of *The Sunday Times*. Dylan ventured to London and soon became an easily recognized figure in Chelsea. He enjoyed city life and never really lost the taste for it.

For part of the war years he lived at Old Bosham, one of the finger-like creeks that grope inland from the Solent and link Hampshire with Sussex, and at that time a banned

Shoveler Ducks, by C. F. Tunnicliffe

Tunnicliffe's illustrations for Henry Williamson's *Tarka the Otter* (1932) (see p. 109) and *Salar the Salmon* (1935) made him famous. Many authors had good reason to thank him for enhancing the pages of their works, including H. E. Bates, Richard Church, and Ernest Hemingway.

The artist was born in Cheshire of a farming family who, in due course, were able to see that his future lay in art rather than on the land.

After obtaining a scholarship to Macclesfield Art School, he went on to the Royal College of Art, and was later admitted to the Royal Academy, where he had exhibited over a long period.

Much of Tunnicliffe's early work was done in the countryside around Macclesfield, and it was a landscape that he continued to visit and keep in touch with in later years. In 1947 he made his home at Malltraeth on the island of Anglesey, North Wales. The house was situated on the southern shore of the island, the window of his studio looked out on the wading birds following the tide.

The finest introduction to his work may be obtained in *A Sketchbook of Birds* published in 1979, although he did not live to see its publication. The sketches in the book range in period from 1934 to 1962. The magnificent collection of drawings, watercolours and sketches, valued at more than £1 million, was purchased by the Isle of Anglesey Borough Council for £400,000 in 1981. Charles Tunnicliffe's work will eventually be exhibited on Anglesey.

VERNON WATKINS

When Vernon Watkins (1906–67) died his friends, and there were many, were shocked for it was all so unexpected. He died in the United States, at Seattle, while playing tennis, the game he liked most. He had been invited to lecture on modern poetry; the choice could not have been better.

Vernon Watkins was a fine poet whose work will undoubtedly live. Born in the town of Maesteg, Glamorgan, he was already composing verse at the age of 8. Later he was to describe himself as 'a Welsh poet writing in English'; he did not speak Welsh, although his parents did, and he found that the English language satisfied him. His poems here are full of images, great depths and rhythms, the sort of poems that slip quietly into an expectant mind refreshed by nature.

His personal landscape was the Gower Peninsula. Following service with the RAF, he married and settled at The Garth, Pennard Cliffs. Vernon worked at Lloyds Bank in Swansea, but there was not an inch of the Gower he had not seen, climbed or sat on.

As R. S. Thomas has written:

The Bank Clerk

It was not the shillings he heard
But the clinking of the waves
In the gullies and rocks of
Pwll Du. Turning them over

To the customers at the counter
He offered them the rich change
Of his mind, the real coinage
Of language for their dry cheques.

Vernon Watkins astonished visitors with his agility and surefootedness. He knew the sheep paths down the cliffs as well as the pools left by the tide, and the nesting places of cormorants.

As well as writing poetry, he collected the letters sent to him by Dylan Thomas. The book *Letters to Vernon Watkins* is now famous. The two men had become friends at their first meeting, and the letters are rich and warm. In his introduction Vernon wrote: 'Just before the war I stayed with Dylan frequently in Laugharne. The peace and beauty of this small sea-town beyond Carmarthen, a fishing village at the end of the world, represented for him the last refuge of life and sanity in a nightmare world, the last irregular protest against the regularity and symmetry of madness.'

A letter from Dylan Thomas, the envelope dated 5 June 1940 refers to an incident when '. . . you nearly caught us napping on the Worm . . .' An editorial note by Vernon Watkins explains:

The worm in the middle of the first paragraph of the letter refers to Worm's Head at the end of the Gower Peninsula, jutting out to sea from the six-mile long Rhossili beach. We had almost been cut off by the tide which comes in very quickly between the rocky coast and the beginning of Worm's Head; we had just reached the land by wading knee-deep. . . He had once been cut off on the Worm; it was before I knew him. He said how cold it had been, and how he had kept warm by running and clapping his hands during his six hours' wait for the sea.

OPPOSITE Three Cliffs Bay beloved by Vernon Watkins

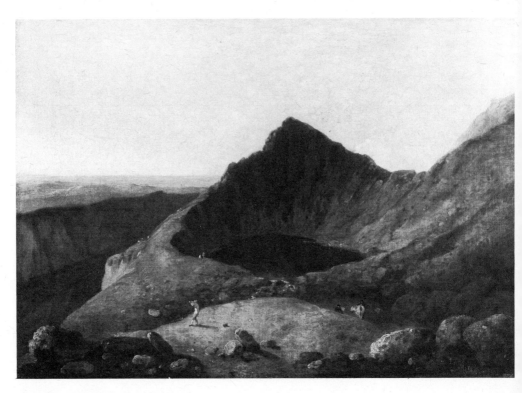

Cader Idris, 1713/14, by Richard Wilson

One of Vernon Watkins finest poems is 'Taliesin in Gower'; these few lines tell the quality of the poet and the man:

I have seen the curlew's triangular print, I know
* every inch of his way.*
I have gone through the door of the foundered
* ship, I have slept in the winch of the cave*
With pine-log and unicorn-spiral shell secreting
* the colours of day:*
I have been taught the script of the stones, and I
* know the tongue of the wave.*

RICHARD WILSON
AND WELSH MOUNTAINS

The son of a Welsh clergyman, Richard Wilson (1714–82) was born in Penegoes, Monmouthshire. After a classical education he arrived in London to study painting and to practise as a portraitist. Later he travelled to Italy and changed over to landscape painting. Sir George Beaumont, the great art connoisseur of the late 18th and early 19th centuries, declared that in his opinion the work of Wilson represented 'the Sublime', and Gainsborough 'the Beautiful'.

Even so, the work of Richard Wilson was never fully appreciated during his lifetime, probably because after seven years in Italy his glimpses of the English landscape bathed in Roman light were depreciated by many, including Reynolds, even though Wilson was a founder member of the Royal Academy.

He painted some memorable works in his native Wales, and two outstanding pictures are his *Snowdon seen from Llyn Nantlle* and *Cader Idris*. Today, Wilson is regarded as one of the leading landscape painters of the 18th century, and the largest collection of his work is to be found at the National Museum of Wales, Cardiff.

Central

William Shakespeare always gets to the very heart of things:

This precious stone set in the silver sea,
Which serves it in the office of a wall,
Or as a moat defensive to a house,
Against the envy of less happier lands;
This blessed plot, this earth, this realm, this
England.

There can be no doubt that England is a small country in the physical sense, but the strength of England lies in the passionate sense of local pride that people have in the village or town where they live. It manifests itself in many ways, in field names, or in styles and materials for building: the villages of the Cotswolds are an excellent example. Even in areas of heavy industry the countryside is not far distant, and in England the countryside can change in character in the space of half a day's walk.

The River Wye, Ledbury, the Malvern Hills, Wenlock Edge, Banbury and Olney are all places in this central region that have contributed to the literature and music of England. So have the parish churches: is there any ancient English church without architectural interest?

We have only to look and there will hardly be a place not associated with a literary person or literary event. At Worcester, Mrs Henry Wood wrote the novel *East Lynne*; Mrs Craik, who wrote *John Halifax, Gentleman*, was born at Stoke-on-Trent; and Bredon Hill is the place of A. E. Housman's poem 'In Summertime on Bredon' from *A Shropshire Lad*. In the Worcestershire countryside J. R. R. Tolkien developed his great fantasy of *The Lord of The Rings* making the Vale of Evesham the land of the Hobbits.

Hay-on-Wye, Worcester & Hereford, by David Cox (1783–1859). The Cox family were great exponents of the watercolour technique and painted widely in Britain.

75

What is left of Sherwood Forest still makes the old ballads of Robin Hood live in the imagination:

> To se the dove draw to the dale,
> And leve the hilles hae,
> And shadow hem in the leves grene,
> Under the grene-wode tre.

D. H. Lawrence drew on his knowledge of the countryside around Eastwood for several of his novels. It was the landscape he called 'the country of my heart'. The very best sense of Midlands country, however, is to be found in George Eliot's great Victorian novel, *Middlemarch*. George Eliot—her real name was Mary Ann Evans—had a talent for descriptive writing that sparkles:

> ... a pretty bit of midland landscape, almost all meadows and pastures, with hedgerows still allowed to grow in bushy beauty and to spread out coral fruit for the birds. Little details gave each field a particular physiognomy, dear to the eyes that have looked on them from childhood: the pool in the corner where the grasses were dank and trees leaned whisperingly; the great oak shadowing a bare place in mid-pasture; the high bank where the ash-trees grew; the sudden slope of the old marl-pit making a red background for the burdock; the huddled roofs and ricks of the homestead without a traceable way of approach; the grey gate and fences against the depths of the bordering wood; and the stray hovel, its old, old thatch full of mossy hills and valleys with wonderous modulations of light and shadow such as we travel far to see in later life, and see larger, but not more beautiful. These are the things that make the gamut of joy in landscape to midland-bred souls—the things they toddled among or perhaps learned by heart standing between their father's knees while he drove leisurely.

❦❦❦❦

H. E. BATES

The personal landscapes of H. E. Bates (1905–74) extend from Rushden, his birthplace in Northamptonshire, to the Far East. His stories of English country life are full of delight. He closely observed the landscape and its creatures, but unlike so many writers for whom landscape is important, he was also an observer of people.

While he was at Kettering Grammar School during the First World War, a wounded officer arrived at the school as a teacher. H. E. Bates was so enthralled by the ex-soldier's reading of Stephen Crane's *The Red Badge of Courage* that he decided above all to be a writer. He joined a local newspaper at 16, and at 20 he had published his first book.

The short stories of H. E. Bates reached an ever-growing audience of discerning readers, but the outbreak of war in 1939 brought an abrupt change of direction in his writing. He was commissioned into the Royal Air Force and saw service in India and Burma. He wrote stories of service life under the pseudonym 'Flying Officer X'. After the war his novels *The Purple Plain* and *The Jacaranda Tree* brought him an international reputation.

His books are always very English in their outlook. What better title than *The Darling Buds of May* for the first of his Larkin family novels? The Nene Valley that he knew so well in boyhood provides a setting for several works. Among his later writings is the short story 'The Simple Life'; the following extract provides the measure of his evocative skill:

> 'You're not looking in the right direction.' He stood close by her, holding her right arm just below the elbow. 'No, not that way. Overhead. More overhead.'
>
> She stared into the sky with eyes screwed up, again seeing nothing.
>
> 'I said your eyes were keener than mine.'
>
> 'It's farther up than you're looking, Mrs Bartholomew. Look further up.'
>
> She laughed. 'I'm looking a million miles up now.'
>
> 'Perhaps you're looking too much against the sun.'
>
> 'I'm just plain stupid, that's what.'
>
> Suddenly she gave a cry. In a moment of unexpected revelation both sound and sight of the lark, from a height that seemed to her impossibly distant, merged together. She became conscious of a moment of great, simple, exquisite pleasure and in the unremitting thrill of it she actually threw up both hands.

Newstead Abbey, Nottinghamshire (*see* Byron)

'It's the most beautiful thing in the world,' she said, 'it's the most beautiful sound I ever heard.'

The village of Little Chart, near Ashford, Kent, was his home from 1931 until his death in 1974.

BYRON AND NEWSTEAD ABBEY

George Gordon, sixth Lord Byron (1788–1824), claimed his ancestral home of Newstead Abbey, in Sherwood Forest, in 1798.

It was a great shattered ruin full of Gothic atmosphere and drama. As the young Byron stood gazing at it with his mother, he had already fallen in love with the old mansion. His great-uncle, known as the 'Wicked Lord Byron' had been the last to live there, in the kitchen quarters.

Byron was at Harrow until 1805, and then went to Trinity College Cambridge. In the meantime Newstead Abbey, which in fact had been a priory, never an abbey, had been leased to Lord Grey in order to assist its upkeep. At Cambridge, Byron got into debt and began to publish his verses. He eventually

went to live at Newstead Abbey in 1808. He took with him a tame bear; he also seized the opportunity of lavishly entertaining his friends from Cambridge. Byron did not handle the estate well. It was not long before he was thinking of Continental climes, and in 1809 he left for Greece. On his return in 1812, the first two cantos of *Childe Harold* were published and, as he put it, he awoke one morning and found himself famous, his table a mass of visiting cards and invitations.

In 1817 Byron sold Newstead Abbey, and continued his travels in Italy and Greece. Among his early poems are the following lines from 'On Leaving Newstead Abbey':

Through thy battlements, Newstead, the
 hollow winds whistle:
Thou, the hall of my fathers, art gone to
 decay;
In thy once smiling garden, the hemlock and
 thistle
Have choak'd up the rose which late
 bloom'd in the way.

Of the mail-cover'd Barons, who, proudly, to
 battle,
Led their vassals from Europe to Palestine's
 plain
The escutcheon and shield, which with ev'ry
 blast rattle,
Are the only sad vestiges now that remain.

The Abbey is now in the care of Nottingham Corporation.

JOHN CLARE

Between Ermine Street and Deeping Fen, and Stamford and Peterborough, is the village of Helpston, the birthplace of John Clare (1793–1864). As a small boy he tended the sheep and geese on Helpston Heath. The family were so poor that his father received parish relief. What changed Clare's life—or rather his outlook, for he remained in poverty throughout his life—was the discovery of a copy of James Thomson's *Seasons* which he eventually purchased. It was then that he began to write verses of his own.

'Birds, bees, trees, flowers all talked to me incessantly, louder than the busy hum of men, and who was so wise as nature out of doors on the green grass by woods and streams under the beautiful sunny sky.'

He followed the River Welland to the Fenlands, which he saw as:

A mighty flat, undwarfed by bush and tree,
Spread its faint shadow of immensity.

Clare admitted to '. . . forsaking the church-going bell and seeking the religion of the fields'. It revealed much that previously had been concealed to him; suddenly the familiar sights of boyhood were structured into verse:

The crow goes flopping on from wood to wood,
The wild duck wherries to the distant flood;
Whizz goes the pewit o'er the ploughman's team,
With many a mew and whirl and sudden scream.

His first book of poems was *Poems Descriptive of Rural Life and Scenery, by John Clare, a Northamptonshire peasant,* published in 1820. The poems were recited at Covent Garden, and Rossini set one of them to music. The later books, *The Village Minstrel and other Poems* (1821) and *The Shepherd's Calendar* (1827) were commercial failures.

Looking back to childhood he remembered:

The old house stooped just like a cave,
Thatched o'er with mosses green;
Winter around the walls would rave,
But all was calm within;
The trees we have all green again
Here bees the flowers still kiss,
But flowers and trees seemed sweeter then:
My early home was this!

From 1835 Clare began to show signs of mental instability. The condition grew worse and he was removed to a private asylum in Epping Forest, where he continued to write verse and take walks. Later he was sent to the county lunatic asylum at Northampton.

John Clare is buried on the south side of Helpston churchyard, which was contrary to his wishes. It would seem that his 'Memorandum' concerning his burial had not been read, for he stated: 'I wish to lye on the North side of the Churchyard, just about the middle of the ground where the Morning and Evening Sun can linger longest on my Grave.'

The Malvern Hills from the British Camp (*see* Elgar)

EDWARD ELGAR AND THE MALVERN HILLS

The celebrated English composer Sir Edward Elgar (1857–1934; see also p. 146) was the son of a piano tuner and violinist who ran a music shop in the cathedral city of Worcester. He was born in a small but double-fronted red-brick house in the village of Broadheath. Like his father, he in due course became a musician with the Three Choirs Festival Orchestra. Elgar learned piano and violin. He also loved the countryside, and throughout his life remained deeply attached to his native county. At the age of 7 he was found sitting on the banks of the River Severn clutching pencil and paper 'trying to write down what the reeds were saying'. Swaying reeds and trees fascinated him and they found their way into his later music.

Although he tended to be a pessimist, he had a fine sense of humour. He enjoyed simple things, galloping on horseback across the Malvern Hills as a boy, flying kites; and bicycle rides gave him pleasure for much of his life. The sounds and visual impressions of his landscape made indelible marks on his musical memory.

He went through all the trials that beset so many young people. After school he worked in a solicitor's office, tried composition, helped in the music shop, and accepted any casual employment as a musician. In Malvern and Worcester he taught music, although he disliked teaching intensely.

His mother was a profound influence upon his life. She knew and loved great poetry, and was sympathetic and encouraging towards him in his efforts at composition.

In 1899 Elgar married, and his wife, Caroline Alice, encouraged him to move to London, but he was again defeated by publishers who were not interested in his work. It was his mother who encouraged Elgar to study the Iron Age hill fort on the Malverns, also called the British Camp or Herefordshire Beacon. She begged him to write about it and, although he appeared to decline any interest in such a proposal, an idea soon began to form in Elgar's mind: it was Caractacus. In the months and years that followed, from the Enigma Variations to the Dream of Gerontius, Elgar's music bloomed gloriously; yet without the inspiration of the Malvern landscape such music might never have been composed.

Elgar rented a cottage called Birchwood Lodge, tucked away in woodland near Stor-

ridge. He worked best among familiar and beautiful landscapes and quiet; he found all of this at Birchwood.

In a letter to Sir Sidney Colvin in 1921 Elgar comments: 'I am still at heart the dreamy child who used to be found in the reeds by Severn side with a sheet of paper trying to fix the sounds and longing for something very great.'

SEE ALSO PAGE 146

GEORGE ELIOT

The pseudonym George Eliot was chosen for Mary Ann Evans (1819–80) by the man who first recognized her genius for fiction, George Henry Lewes. Instantly attracted to one another, they lived together until his death; he was separated from his wife but unable to remarry. Such was the problem that weighed heavily upon their devoted union. With the support of a few loyal friends they faced the years of social ostracism.

George Eliot's deep love of Warwickshire and her understanding of country people developed through her father, who was the agent for a landowner with an estate on the edge of the Forest of Arden. She understood the pleasure and satisfaction, as well as the toil, that could be won from the land. As Caleb says, in *Middlemarch*:

> It's a fine thing to come to a man when he's seen into the nature of business; to have a chance of getting a bit of country into good fettle, as they say, and putting men into the right way with their farming, and getting a bit of good contriving and solid building done—that those who are living and those who come after will be the better for it. I'd sooner have it than a fortune. I hold it the most honourable work that is.

George Eliot again demonstrates her insight into the lives and the minds of country people, in the early pages of *Silas Marner*:

> ...No one knew where wandering men had their homes or their origin; and how was a man to be explained unless you at least knew somebody who knew his father and mother? To the peasants of old times, the world outside their own direct experience was a region of vagueness and mystery: to their untravelled thought a state of wandering was a conception as dim as the winter life of the swallows that come back with the spring; and even a settler, if he came from distant parts, hardly ever ceased to be viewed with a remnant of distrust.

IVOR GURNEY

Poet, composer, and First World War soldier, Ivor Gurney (1890–1937) was born in Gloucester. He became a choirboy at the cathedral; he also became remote and introspective, brooding on poetry and music. His particular joy was to walk the hills of Gloucester—Cleeve Hill and Churchdown were very special places for him. The composer Herbert Howells, who died in 1983, dedicated his early Piano Quartet to 'the hill at Chosen and Ivor Gurney who knows it'—'Chosen' was a name given to Churchdown Hill.

Gurney succeeded in joining the army in 1915; he had tried earlier but had been rejected. While among the horror of trench warfare he continued writing poetry and songs. When he returned from the war, wounded and gassed, it was clear, at least to his family, that his life had been changed. In the words of Ursula Vaughan Williams, Ivor Gurney had '... suffered physical and spiritual mutilation'. For a time he studied composition under Ralph Vaughan Williams at the Royal College of Music, but Ivor Gurney was rapidly becoming mentally unstable. There were periods when he would go into the countryside for days on end, sleeping rough and having hallucinations; yet at the same time he continued to write poetry and songs. He was desperately trying to cling to sanity. The very fact that he had survived the war made him

OPPOSITE ABOVE Cleeve Hill, Gloucestershire (*see* Gurney)

OPPOSITE BELOW 'Lady Chatterley's Cottage' (*see* D. H. Lawrence, p. 81)

OVERLEAF LEFT Willows, Moorgreen Reservoir (*see* D. H. Lawrence, p. 81)

OVERLEAF RIGHT Eastwood, 'The Country of My Heart' (*see* D. H. Lawrence, p. 81)

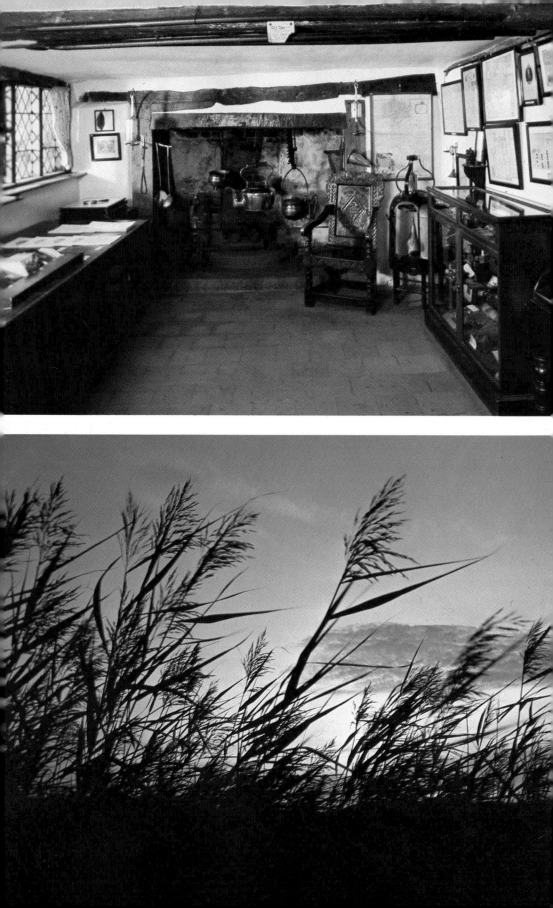

feel that he had betrayed those of his comrades who had not returned. In 1922 he entered a private asylum in Gloucestershire, but was later transferred to the City of London Mental Hospital at Dartford. Earlier he had tried to obtain a revolver, intent on shooting himself. The loss of his freedom he found intolerable, but he had many friends. Ralph Vaughan Williams and Herbert Howells were regular visitors and kept him supplied with books. At times yet another fine poem would manifest itself, but so much of what he wrote was incoherent.

Far better to dwell instead upon the landscape that Ivor Gurney loved:

The high hills have a bitterness
Now they are not known
And memory is poor enough consolation
For the soul helpless gone.
Up in the air there beech tangles wildly in
 the wind
That I can imagine
But the speed, the swiftness, walking into
 clarity,
Like last year's bryony are gone.

D. H. LAWRENCE: 'THE COUNTRY OF MY HEART'

The landscape that D. H. Lawrence (1885–1930) knew well lies between Nottingham and Chesterfield, Derby and Ollerton. But it is the more parochial area about his home town of Eastwood that he loved best of all. Nor far away is Newstead Abbey, inherited by Lord Byron in 1798, although financial problems caused him to dispose of the property in 1816. D. H. Lawrence's father used to sing in the Newstead Abbey choir as a boy.

Lawrence was born in Victoria Street, Eastwood, in a typical modest terrace house of a colliery town, which now bears a plaque over the front door. Eastwood is an industrial town but, a short walk away, there lies a country landscape that did much to inspire *Lady Chatterley's Lover, The White Peacock,*

OPPOSITE ABOVE The kitchen at Milton's cottage, Chalfont St Giles, Buckinghamshire (*see* Milton, p. 85)

OPPOSITE BELOW Fen country, near Southwold, Norfolk (*see* Vaughan Williams, p. 92)

Women in Love, Sons and Lovers and *Love Among the Haystacks.* This stretch of country is cut through by the MI motorway. Between Eastwood and the motorway lies Moorgreen reservoir: the Nethermere of *Sons and Lovers* and *The White Peacock*; it is also the 'Willey Water' of *Women in Love.* This was Lawrence's favourite walking area, past Beauvale House, Hoggs Farm, and Felley Mill and beyond to Annesley Hall.

Lawrence describes the area well in a letter to his friend Rolf Gardiner that he wrote in December 1926:

Some of my happiest days I've spent haymaking in the fields just opposite the S. side of Greasley church—bottom of Watnall Hill—adjoining the vicarage: Miriam's father hired these fields. If you're in those parts again, go to Eastwood, where I was born, and lived for my first 21 years. Go to Walker St—and stand in front of the third house—and look across at the Crich on the left, Underwood in front—High Park woods and Annesley on the right: I lived in that house from the age of 6 to 18, and I know that view better than any in the world. Then walk down the fields to the Breach, and in the corner house facing the stile I lived from 1 to 6. And walk up Engine Lane, over the level-crossing at Moorgreen pit, along till you come to the highway (the Alfreton Rd)—turn to the left, towards Underwood, and go till you come to the lodge gate by the reservoir—go through the gate, and up the drive to the next gate, and continue on the footpath just below the drive on the left—on through the wood to Felley Mill (the White Peacock farm). When you've crossed the brook, turn to the right through Felley Mill gate, and go up the footpath to Annesley. Or better still, turn to the right, uphill, before you descend to the brook, and go on uphill, up the rough deserted pasture—on past Annesley Kennels—long empty—on to Annesley again. That's the country of my heart. From the hills, you look across at Underwood, you'll see a tiny red farm on the edge of the wood. That was Miriam's farm —where I got my first incentive to write. I'll go with you there some day.

Laurie Lee's cottage, Slad, Gloucestershire

LAURIE LEE

The area around Slad, near Stroud in Gloucestershire, must by now be one of the most famous English valleys in literary history. It is the home of Laurie Lee, so magnificently described in his classic work *Cider with Rosie*.

The village to which our family had come was a scattering of some twenty to thirty houses down the south-east slope of a valley. The valley was narrow, steep, and almost entirely cut off; it was also a funnel for winds, a channel for the floods, and a jungly, bird crammed, insect hopping suntrap whenever there happened to be any sun.

There are places like this in many parts of Britain; what gives Laurie Lee's valley its impact is the intensity with which childhood memory is re-created as fresh as ever in later life, for him and for us. How lovingly he describes his home and its sense of mystery handed on by time:

Our house was seventeenth-century Cotswold, and was handsome as they go. It was built of stone, had hand-carved windows, golden surfaces, moss-flaked tiles, and walls so thick they kept a damp chill inside them whatever the season or weather. Its attics and passages were full of walled-up doors which our fingers longed to open—doors that led to certain echoing chambers now sealed off from us for ever. . . The house was shaped like a T, and we lived in the down-stroke. The top-stroke—which bore into the side of the bank like a rusty expended shell—was divided separately among two old ladies, one's portion lying above the other's.

The image of the old Cotswold stone house could not be more succinct, and it is this sense of place, the very identity of this region of Britain, that permits the reader to savour the story all the more.

Above all, Laurie Lee is a poet, and his eye and understanding frequently opens doors long walled up.

St Michael and All Angels, Ledbury (*see* Masefield)

JOHN MASEFIELD

Born in Ledbury, Herefordshire, John Mase-
field (1878–1967) became one of the literary
giants of the 20th century. He knew many of
the writers of his day and he enjoyed regal
royalties. His collected poems alone have been
reprinted at least two dozen times; and he
wrote more than a hundred volumes of verse

and prose. His final collection of verse
appeared in his 87th year!

Masefield wrote much about the sea, and
his experience of it was won at first hand. The
early death of his father plunged him into a
hard world. He was educated and disciplined
on the training ship *Conway*, a school for the

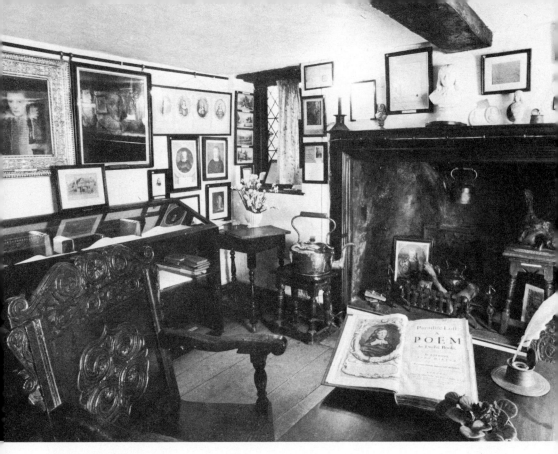

Milton memorabilia

British merchant service, and when he went to sea it was to serve before the mast. Later, in New York, he worked in a bar and in a carpet factory.

Masefield had already made up his mind to be a writer, and a book of *Salt-Water Ballads* appeared in 1902 when he was 27. Journalism and a host of books followed. Much of his work will certainly survive. His verse has made great impact and had wide appeal. The great navigator and solo yachtsman, Francis Chichester, published his autobiography in 1964 under the title *The Lonely Sea and The Sky*. This, of course, comes from Masefield's poem 'Sea Fever' which begins:

I must go down to the seas again, to the lonely
 sea and the sky,
And all I ask is a tall ship and a star to steer
 her by.

In the preamble to his book Francis Chichester describes 'Sea Fever' as 'that great poem . . . because it gives in only twelve lines the key to my lifetime search for romance and adventure.' He concluded with the words: 'With thanks to the greatest of sea-poets, John Masefield, the Poet Laureate.'

Besides sea poems like 'Sea Fever' and the equally celebrated 'Cargoes', John Masefield also wrote of his early and formative landscape with such lines as:

Then hey for covert and woodland, and ash and
 elm and oak,
Tewkesbury inns, and Malvern roofs, and
 Worcester chimney smoke,
The apple trees in the orchard, the cattle in the
 byre,
And all the land from Ludlow town to Bredon
 church's spire.

Masefield always maintained that his verse owed everything to Ledbury, and the church of St Michael and All Angels was his joy and fascination.

I wish I'd seen . . .
The many towns this town has been.

He revelled in the church bells, the view from the tower, and the set of its gilded weather-cock, 'Lofting as any clipper's skysail truck.'

A golden vane surveying half the shire
A weather-cock serene in the assails
Of tree-upsetting, ship-destroying gales.
Pinnacled, plumey, lovely there he shone,
Swinging to shifts, but never moving on.

JOHN MILTON

The great poet of his times, John Milton (1608–74) in the opinion of most stands second in English poetry only to Shakespeare. He was also a Parliamentarian, and when Cromwell triumphed in 1648, Milton became involved in a great deal of political activity. In the month following the execution of Charles I, Milton published his 'Tenure of Kings and Magistrates', which defended the people's right to remove unjust governors. He was also appointed Secretary for Foreign Tongues to the Council of State. It meant publishing works in Latin, aimed at a European audience, in defence of the policy of the Government and the Reformation.

This great scholar and poet, who had still to write *Paradise Lost* and *Paradise Regained*, feared for his life with the Restoration of Charles II in 1660: he was, after all, the leading defender of the regicides. Charles, however, was a tolerant monarch, and although two of his anti-Royalist books were burned by the public hangman, Milton was allowed to survive.

During the plague of 1665 Milton and his family were living in what was then the outskirts of London at Bunhill Fields. They decided to move yet further from the capital as increasing numbers of mass graves were being dug in the area. With the help of the Quaker Thomas Ellwood, a former pupil of Milton, they settled themselves in a cottage at Chalfont St Giles, Buckinghamshire. Of the houses Milton lived in this is the only one to have survived to the present day.

Milton was now blind.

Milton's cottage, Chalfont St Giles, Buckinghamshire

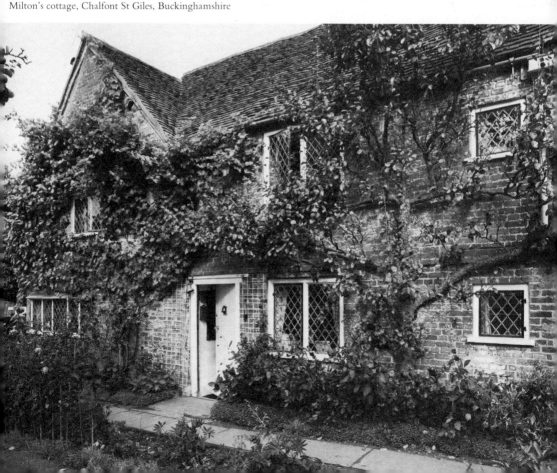

Seasons return, but not to me returns
Day, or the sweet approach of even or morn,
Or sight of vernal bloom, or summer's rose.

This delightful cottage, which forms such a precious and tangible link with the scholar-poet, is now preserved as a Milton museum. The conservation of the cottage and its garden has been undertaken by the Milton Cottage Trust. There are many interesting books and period relics in the house, including a lock of Milton's hair taken at the opening of his coffin in London at the end of the 18th century. John Keats wrote 'Lines on Seeing a Lock of Milton's Hair', but that was a different snippet and is, apparently, lost.

Paradise Lost was finished at the cottage, and Milton showed it first to Thomas Ellwood, who was excited by the poem and praised it highly. It was Ellwood who asked what Milton now had to say of Paradise Found? When Milton felt it safe to return to London, 'when the city was well cleansed', he wrote *Paradise Regained*.

SHAKESPEARE COUNTRY

In so many ways William Shakespeare (1564–1616) has remained the greatest of all writers, and a man of mystery. But there would seem to be little doubt that he was born in the half-timbered house in Henley Street, Stratford-upon-Avon. In the Bard's day it was a quiet country town. Now it is a centre of pilgrimage for much of the world; a place of tourism, theatre and culture.

The birthplace was the home of John Shakespeare, landowner, master glover and alderman; William was his third child. Today the Shakespeare Birthplace Trust maintains the house as it would have been in Elizabethan times, as a home with country furniture and effects of the period. The cottage of Anne Hathaway, originally known as Hewlands Farm, is at Shottery, a mile from Stratford; Mary Arden, Shakespeare's mother lived at Wilmcote. This house has also been carefully preserved together with its dovehouse, and the other outbuildings display a collection of agricultural bygones.

Shakespeare would now have to look hard to recognize his Warwickshire. In his day it was certainly more wooded, oxen would have ploughed the fields and the root crops would be unknown to him. When he left Stratford for London it was most likely in the company of strolling players, but we do not know. As Matthew Arnold wrote: 'We ask and ask—Thou smilest and art still'.

It is, however, possible for us still to find Shakespeare in the countryside, for he was undoubtedly a country boy who closely observed birds and loved wild flowers. When he writes in Macbeth 'A falcon, towering in her pride of place, was by a mousing owl hawk'd at and killed', it is a line that well demonstrates the eye of Shakespeare for nature, and because of the unusual nature of such an occurrence, he may well have seen it happen. His passion for wild flowers is revealed many times in his writings, and he seems to have found particular pleasure in the cowslip. Only someone who is looking closely at such a flower would know that 'in their gold coats spots you see', a line spoken by the fairy in *A Midsummer Night's Dream*. The spots are honey guides enabling insects to identify a flower with nectar, and like all countrymen of his day he would have been aware of the practical use of plants at a time when every man was his own physician.

What more beautiful and imaginative than the words of Ariel spoken in *The Tempest*.

Where the bee sucks, there suck I:
In a cowslip's bell I lie;
There I couch, when owls do cry.
On the bat's back I do fly
After summer merrily:
Merrily, merrily shall I live now
Under the blossom that hangs on the bough.

When Shakespeare wrote 'I know a bank whereon the wild thyme blows' his thoughts may well have been among the winding lanes of Warwickshire. The house where Shakespeare died was pulled down by the Reverend Gastrell in the 18th century, driven to senseless anger by tourists. It is undoubtedly good to visit the Stratford-upon-Avon houses of his family, and the inns of the period, but the pilgrim will never be closer to Shakespeare than in some Warwickshire spinney in early summer.

Mary Arden's cottage (*see* Shakespeare Country)

Under the greenwood tree
Who loves to lie with me,
And turn his merry note
Unto the sweet bird's throat
Come hither, come hither, come hither:
Here shall he see
No enemy
But winter and rough weather.

GEORGE BERNARD SHAW

The village of Ayot St Lawrence is tucked away in the Hertfordshire countryside off the AI—to the northwest of Welwyn Garden City. An attractive and quiet village with many delightful houses and cottages, it was the home of G.B.S. (1856–1950) from 1906 until his death.

Shaw did not like crowds and hated autograph hunters. His house at Ayot was the perfect retreat for a celebrated playwright, and he called it Shaw's Corner. It is a Victorian villa built in 1898 and was the former rectory. Although spacious and typical of its period, it is certainly not among the beauties of Ayot St Lawrence architecture. The garden is a delight, and was very close to the heart of G.B.S. His study in the house is interesting enough, but when the sun shone or fresh air beckoned, Shaw would reach out for hat and walking stick and set out across the lawns to his revolving garden hut, small but congenial, and as he was to write later:

In shattering sunlight here's the shelter
Where I write dramas helter skelter.

Those lines come from Shaw's last completed work, which he called *Bernard Shaw's Rhyming Picture Guide to Ayot Saint Lawrence.*

Now let me take you for a walk
And shew you with a rhyming talk
What our dear village has to shew
And tell you all you need to know.

There are nearly 300 lines of such rhyming couplets, illustrated with 59 photographs. Photography was Shaw's hobby for half his long life, but his pictures are always the work of the stumbling amateur and yet, because of it, they have a compulsive air of innocence.

Shaw's Corner contains a portrait by Augustus John, and photographs of such world figures as Ibsen, Gandhi, and Lenin; others depict his native Dublin. This great dramatist and critic could never be described as a true countryman, although landscape, trees and cloudscapes were a passion with him. He was, however, undoubtedly a villager. His wife

Charlotte much preferred their London apartment but for G.B.S. home was Ayot St Lawrence. A former licensee of Ayot's only public house declared: 'Bernard Shaw was either "Mr Shaw" or "Bernard" or even "Bernie"—but never plain "George". Bernard Shaw was one of us.' He presented a shilling to every child in the village on his birthday, tried to be present at all village council meetings, and would give talks and read plays at the Women's Institute. G.B.S. was a man of great humour and wit, always ready to listen to a fellow villager who wished to pass the time of day, a quip or a tale of woe. As he grew older so he turned more to his garden, his vegetables and his beehives. There can be no doubt that G.B.S. drew much material and strength from the quiet of Ayot St Lawrence and its people.

Shaw's Corner, Hertfordshire (*see* Shaw)

Since 1950, Shaw's Corner has been the property of the National Trust, and the rooms in which he lived and worked for such a large part of his life are virtually as he left them. His ashes were scattered in the garden, as were those of his wife.

ALFRED TENNYSON IN LINCOLNSHIRE

The great Victorian poet Alfred Tennyson (1809–92) was born at his father's rectory at Somersby, a hamlet on the lower slopes of the Lincolnshire Wolds, between Horncastle and Spilsby.

His earliest attempt at poetry came at the age of 8, when he remembered covering two sides of a slate with Thomsonian blank verse in praise of flowers. Before he could read, he said, 'I was in the habit on a stormy day of spreading my arms to the wind, and crying out "I hear a voice that's speaking in the wind", and the words "far, far away" had always a strange charm for me.'

Tennyson, like his father, had a passion for the sea. Dr and Mrs Tennyson took their family in the summer to a cottage at Mablethorpe, where they enjoyed the sometimes wild weather of the North Sea. Here the young Tennyson liked to stand on a sand ridge and '. . . think that it was the spine-bone of the world'.

He wrote a poetic fragment about Mablethorpe.

Here often when a child I lay reclined.
I took delight in this fair strand and free;
Here stood the infant Ilion of the mind,
And here the Grecian ships all seem'd to be.
And here again I come, and only find
The drain-cut level of the marshy lea,
Gray sand-banks, and pale sunsets, dreary wind,
Dim shores, dense rains, and heavy-clouded sea.

Alfred Tennyson never forgot the scenes of his boyhood; he recalled the 'Dim mystic sympathies with tree and hill reaching far back. . . A known landskip is to me an old friend, that continually talks to me of my own youth and half forgotten things, and indeed does more for me than many an old friend that I know.'

FLORA THOMPSON

The Oxfordshire hamlet of Juniper Hill was where Flora Thompson (1876–1947) was born. Her books *Lark Rise, Over to Candleford* and *Candleford Green* were written in Devon and published between 1937 and 1943; in 1945 the three volumes were published together as *Lark Rise to Candleford*. The result is one of the finest country books of the century. Flora, or 'Laura' as she calls herself in these autobiographical works, has given us a superbly detailed account of the life of men labouring on the land, and of their families, when Queen Victoria still reigned. It was a time when what country folk ate they grew themselves, and poverty pressed upon them all—a hard life lived by firm, tried and trusted values.

The writings of Flora Thompson are a quarry for the social historian, but they are so much more than that. Here are the lives of real people, their hopes, fears, superstitions, and their compromises. Such a compromise was the slaughter of the pig that 'Laura' had known all her life, whose back she had scratched, and for whom she had saved titbits:

> There was fried liver and fat for supper and when Laura said, 'No thank you', her mother looked at her rather surprisingly, then said: 'Well, perhaps better not, just going to bed and all, but here's a nice bit of sweetbread. I was saving it for Daddy, but you have it. You'll like that.' And Laura ate the sweetbread and dipped her bread in the thick, rich gravy and refused to think about the poor pig in the pantry, for, although only five years old, she was learning to live in the world of compromises.

Flora had educated herself, reading books from libraries and second-hand shops. She worked as a Post Office assistant at Grayshott, in Hampshire, until her marriage to John Thompson, also a Post Office clerk, in 1900. She was clearly a woman of considerable insight and with a true literary gift. Flora was always part of the community, yet able to stand back from it and become its observer.

OVERLEAF Lincolnshire Wolds (*see* Tennyson, p. 89)

The landscape of Flora Thompson will always be the corner of Oxfordshire that borders with Northamptonshire; she knew it and wrote of it in detail:

All around, from every quarter, the stiff, clayey soil of the arable fields crept up; bare, brown and windswept for eight months out of the twelve. Spring brought a flush of green wheat and there were violets under the hedges and pussy-willows out beside the brook at the bottom of the 'Hundred Acres': but only for a few weeks in late summer had the landscape real beauty. Then the ripened cornfields rippled up to the doorsteps of the cottages and the hamlet became an island in a sea of dark gold.

RALPH VAUGHAN WILLIAMS

The music of Vaughan Williams (1872–1958) is unashamedly English to the core—so much of it sought out during folk-song hunting expeditions, so much of it inspired by the poetry and the pastoral atmosphere of the landscape of his homeland. Above all, the composer had an intuitive feel for landscape that his compositions, without recourse to any specific location, were able to conjure images in the mind of the individual listener to match his own particular source of English Arcady. For example, most people who know the English countryside are likely to have in mind a landscape that will recall or accommodate such music as 'The Lark Ascending'.

The music critic Hubert Foss once wrote, 'Only a small part of Vaughan Williams's music could be called "descriptive", and not much more of it even "illustrative" . . . the Pastoral Symphony does not qualify even for the illustrative class, for we are given no clue save the vaguely comprehensive title to what the music is intended to illustrate. . .'

'Yet', declares Foss, 'all the time, the English landscape forms the background of his dreams.' Vaughan Williams certainly kept his creative landscapes to himself; but, given the fact that his music is so comprehensively English in quality, it may be that, had he been more specific, something of its universal power and appeal might have been lost. The music is gentle and contemplative, catching sombre moods, light and colour, in the manner of the many generations of England's poets of the countryside.

His journeyings in search of folk songs did, lead directly to 'The Norfolk Rhapsodies' and 'In The Fen Country'; these followed his visit to Norfolk in the early years of the century (see also George Butterworth, p. 100).

Vaughan Williams began collecting folk songs in the field in 1904. He visited Essex, around Brentwood; Sussex and Surrey near Leith Hill; and he collected during holidays in Yorkshire and Wiltshire. Between 1908 and 1909 he also collected on the Norfolk Broads near Lowestoft, and in Hampshire and Herefordshire.

The musical harvest that he gathered from folk songs appeared years later in such works as 'Six Studies in English Folk Song' (1927) and 'Suite on Sussex Folk Songs' (1930). Vaughan Williams's 'Fantasia on a Theme' by Thomas Tallis' was first heard in Gloucester Cathedral in 1910 at the Three Choirs Festival.

The setting of poems formed a very important part of Vaughan Williams's work. 'Linden Lea' was based on a poem in Dorset dialect by William Barnes. 'Whither must I Wander' sprang from the verse of Robert Louis Stevenson, and 'Willow Wood' from the poems of Dante Gabriel Rossetti. The most celebrated instance is 'On Wenlock Edge' based on A. E. Housman's *A Shropshire Lad*.

Wenlock Edge, on the north approach to Ludlow, is the very heart of Housman country. There have been a number of compositions inspired by *A Shropshire Lad*, although most people would almost certainly declare Vaughan Williams's work the most important. A. E. Housman himself did not care for such musical attentions. Nevertheless, 'On Wenlock Edge' is haunting in its beauty and beloved of many.

Ralph Vaughan Williams was born at Down Ampney, Gloucestershire, where his father was vicar. His mother was a Wedgwood, and on the death of her husband she took her young son to Leith Hill Place, her old family home. In later years Ralph Vaughan Williams became very fond of Leith Hill in its beautiful countryside setting with magnificent views into Sussex.

Wenlock Edge, near Shipton, Shropshire (*see* Vaughan Williams)

Shortly before his death Ralph Vaughan Williams was to take what was to be his exciting last look at the English landscape. Together with his wife, he visited Dorset and saw the Cerne Abbas giant, the figure cut into the turf of the hillside. Moving on to the Berkshire Downs they looked at Wayland's Smithy, the name from mythology given to the famous Neolithic long barrow, much renowned in story and song. They picnicked near the Uffington White Horse, another spirited, chalk-cut prehistoric figure, with a view over Oxfordshire and Berkshire. In Wiltshire the lasting images were of Old Sarum, Stonehenge, and a floodlit Salisbury cathedral turned to gold.

As Ursula Vaughan Williams wrote in her biography of her husband: 'We had seen England in its most typical beauty of a cool, wet summer, with enough sunshine to ripen the corn and to fill the hedges and road verges with Ralph's favourite wild flowers, late summer's profusion of yellow and white and lilac colours.'

JOSEPH WRIGHT OF DERBY

What is so interesting about the paintings of Joseph Wright (1734–97) is that they have the power of surprise. He is celebrated for his candle-lit scenes and the glowing forges of the rapidly developing Industrial Revolution. Wright was fascinated by the effects of illumination and his skill is seen at its best in *An Experiment with the Air Pump*, where candlelight splashes the area of activity and the moon is glimpsed through the window.

Joseph Wright was born in Derby and, although he trained in London under Thomas Hudson as a portrait painter and did much excellent work as a portraitist, he also painted some remarkable landscapes. He was one of the few British painters to paint moonlight scenes.

The River Derwent was the source of much inspiration for Wright. Certain places, such as

The Earthstopper on the Banks of the Derwent, by Joseph Wright of Derby

Matlock Tor on the Derwent, he painted several times, by daylight and by moonlight. Dale Abbey was another favourite subject. One of his finest landscapes by moonlight is *The Earthstopper on the Banks of the Derwent*. A lantern makes its own pool of light beneath the river bank as the earthstopper fills the holes to prevent the fox from going to ground on the following day, when the hunt will take place. The moon appears from behind heavy cloud as though peering at some secret activity, which indeed it is.

Wright travelled to Italy, and for a time he worked in Bath in the hope of taking the place of Gainsborough. But, thankfully, he always remained a provincial painter, otherwise the subject matter for which he is now regarded would never have been painted.

East Anglia

The popular image of East Anglia is that of the Norfolk Broads, but there is so much more than that. Norfolk and Suffolk are counties that do not give up their secrets easily— theirs tends to be a landscape that people think they know. In fact it is a land that is unknown to most, because you do not pass through it on the way to somewhere else.

Although modern, mechanized farming has opened 'prairie' fields for ease of sowing and harvesting, there is no difficulty in finding the picturesque. This is still the landscape that Constable and Gainsborough knew; indeed there is so much that has barely changed at all. Were Constable to return he would have no difficulty in recognizing his father's mill or the homes of his friends.

The Aldeburgh Festival begun by Benjamin Britten here has also succeeded in introducing people to the landscape, and a great affinity exists between his music and the broad skies and mudflats that are to be seen at Snape.

The Norwich School of Painters portrayed their landscape lovingly, and in the Norwich Castle Museum is a magnificent collection of their work. They painted nature and people at work and play. Theirs was not a metropolitan art, but their collective response to the landscape in which they lived is magnificent and moving.

John Constable, of course, was very much out of step with fashionable painting; he broke the rules of men who worked in studios and leapt into Nature itself. Like Thomas Hardy, he was a man who noticed things, a quality that has now made him Britain's best-loved painter.

The places painted in the past continue to attract the painters of today, amateur and professional. St Benet's Abbey was greatly favoured by the painters of the 18th and 19th centuries. It is curious how certain minor groups of ruins throughout Britain seem to have caught the imagination of artists over a long period. The ruins of Netley Abbey, near Southampton, are a further example.

The great houses and estates of East Anglia obviously have an important impact on landscape. Felbrigg Hall, near Cromer, is a fine example of a 17th-century house providing a punctuation mark in the landscape. Felbrigg was delightfully drawn by Humphrey Repton, and we owe so many fine vistas to the eye and understanding of such men. Capability Brown even changed the course of rivers to suit his landscapes.

Beyond the Great Wood at Felbrigg stretches the North Sea, which has always had such influence upon East Anglia, its climate, wildlife, and its people.

❧

ROBERT BLOOMFIELD

During the late 18th and early 19th centuries several ploughman and shoemaker poets made their appearance, had work published, and created considerable interest at the time. Robert Bloomfield (1766–1823) was one of them; among others were Stephen Duck, John Clare (see p. 78), and Charles Crocker.

Bloomfield was born at Honington in Suffolk where his mother kept the village school. At the age of 11 he went to live with his mother's brother-in-law, who was a farmer in the village of Sapiston. Unfortunately Bloomfield lacked the strength and physique required for farmwork and proved to be of very little help with animals or on the land. He did, however, take an interest in the farming year and the work that was done through the seasons.

His older brother, a tailor and a shoemaker, agreed to look after him in London. His interest in reading led him by chance to copies of *Paradise Lost* and James Thomson's *Seasons*. While working with other shoemakers in a London garret he composed his best-known work, *The Farmer's Boy*. He composed this poem, based on his own farming childhood, committing the lines to memory until able to put them on paper.

With the help of a Suffolk patron, *Farmer's Boy* was published in a fine edition, with illustrations by Thomas Bewick (see p. 25) in

March 1800, and 26,000 copies were sold in three years, plus foreign translations. He published other poems but never with the success of his first volume.

The public at this time were interested to see the verse of peasant poets, but curiosity once satisfied, interest invariably faded.

Neither Bloomfield nor Duck were the equal of John Clare, who had the individual voice of a true poet showing personal insights into country life.

Yet *The Farmer's Boy*, filled with the imagery of his childhood landscape around Sapiston, is not to be dismissed. After all, it was a copy of this book that W. H. Hudson (see p. 122) found years later in a bookshop in Buenos Aires, and it created an ambition in the naturalist to see the English countryside for himself. That alone is sufficient to warrant the remembrance of Robert Bloomfield and *The Farmer's Boy*.

GEORGE BORROW

Four books and the memories of people who knew George Borrow (1803–81) tell us all we know of this extraordinary man. People who met Borrow never forgot him. He stood 6 feet 3 inches tall, was handsome and impressive, a man of great physical strength and courage. Borrow was also one of the great pedestrians of the 19th century. To keep an appointment with the secretary of the British and Foreign Bible Society, he once walked 112 miles in 27 hours. A fine horseman, he was wary of trains: 'I am fond of the beauties of nature; now it is impossible to see much of the beauties of nature unless you walk. I am likewise fond of poetry, and take special delight in inspecting the birthplaces and haunts of poets.'

Although he enjoyed nature, he understood little of natural history. Borrow was a born traveller, an English gypsy who sang and declaimed verses like incantations as he strode through the countryside; children shouted after him 'gypsy' or 'witch'. His real joy lay in overcoming the elements and talking with people he met on the road. He was self-sufficient, a spinner of tales, and enjoyed living with gypsies. All these things are the yeast of his writing. Borrow is not a great writer, but his works contain experience and enchantment not to be found elsewhere.

Borrow was born at East Dereham, Norfolk. His father was a soldier who came from Cornwall, his mother the daughter of a local farmer. For many years they had no fixed home as they followed the regiment in England, Scotland and Ireland. When the regiment was disbanded in 1816, Captain Borrow retired on full pay and settled at Norwich.

George Borrow did not care for school, but he discovered that he had a gift for languages. He learned Romany from gypsies camped on Mousehold Heath. A firm of Norwich solicitors took Borrow on as an articled clerk, but he pursued his interest in languages instead of law. He could speak Welsh and had a basic proficiency in a score of other languages.

The British and Foreign Bible Society later sent him to Russia and Spain. It was *The Bible in Spain* (1843) that made his literary reputation, and this was followed by *The Romany Rye* (1857) and *Wild Wales* (1862).

Throughout his writings Borrow himself is always the central character and his own hero, even in his poems:

A lad who twenty tongues can talk,
And sixty miles a day can walk;
Drink at a draught a pint of rum,
And then be neither sick nor dumb;
Can tune a song, and make a verse,
And deeds of northern kings rehearse;
Who never will forsake his friend,
While he his bony fist can bend;
And though averse to brawl and strife,
Will fight a Dutchman with a knife.
O that is just the lad for me,
And such is honest six-foot three.

OPPOSITE ABOVE A house once lived in by George Borrow

OPPOSITE BELOW Oulton Broad, near Lowestoft, Suffolk (*see* Borrow)

OVERLEAF LEFT ABOVE The Alde Estuary from Snape Warren (*see* Britten, p. 97)

OVERLEAF LEFT BELOW Benjamin Britten's Maltings concert hall at Snape, centrepiece of the Aldeburgh Festival

OVERLEAF RIGHT ABOVE The Alde Estuary, landscape much beloved by Benjamin Britten

OVERLEAF RIGHT BELOW Wicken Fen (*see* Clare, p. 78)

Borrow described landscape well, as in this passage from *Wild Wales*:

> ... the scenery to the south on the farther side of the river became surprisingly beautiful. On that side noble mountains met the view, green fields and majestic woods, the latter brown it is true, for their leaves were gone, but not the least majestic for being brown. Here and there were white farmhouses; one of them, which I was told was Pen y Glas, was a truly lovely little place.

In 1840, Borrow married a Mrs Clarke, a widow with a daughter, who Borrow had known for some years. She owned a cottage at Oulton Broad near Lowestoft, and it was there that they made their home. He wrote his books in a summer house at the edge of the Broad. Later they moved to Yarmouth, and then to London.

When his wife died in 1869, Borrow remained in London for a few years and then returned to the cottage at Oulton. He still took walks to Mousehold Heath to talk with the gypsies, but his strength was waning. The man who had ranged over Britain and Europe could barely reach the garden gate. George Borrow died on 26 July 1881. His body was taken to Brompton Cemetery, London, and buried next to his wife.

BENJAMIN BRITTEN

The magnificent and original musical gift of Benjamin Britten (1913–76) searches the soul with the astonishing richness of its imagination. He became the most celebrated English composer since Elgar, and the first to achieve truly international recognition within his own lifetime. Britten was very much a composer of his time, travelling the world and establishing his lines of musical communication, which ranged through opera and symphony to the Young Person's Guide to the Orchestra. Yet, throughout his extraordinarily prolific life, Britten nourished his gifts through his English roots, the deepest of which lay in the

OPPOSITE ABOVE The Old Vicarage, Grantchester, Cambridgeshire (*see* Rupert Brooke, p. 98)

OPPOSITE BELOW The Granta at Grantchester (*see* Rupert Brooke, p. 98)

countryside of East Anglia, the place of his birth.

Britten's recognition of the East Anglian coast as his spiritual home was not immediate. He was born in the fishing port of Lowestoft, in Suffolk, and the ever-changing sea, in terms of light and character, always fascinated him. He loved the Suffolk landscape and the sense of history given to it through its ancient churches. Often he would go by car on what he termed 'church crawls'; later the artist John Piper frequently accompanied him on such expeditions. Some churches held special interest for him, such as Orford, where much of his music, and that of other composers, has been performed since the beginning of the now celebrated Aldeburgh Festival, which he founded in 1948. Britten also had an acute ear for natural sounds. He was prepared to spend hours among the Suffolk woods in order to hear the song of a nightingale.

During the 1930s the poet W. H. Auden began to attract Britten to poetry. This new interest was to become of great importance to the composer, encouraging his awareness of the need to give words their full value in musical settings. W. H. Auden, in company with Christopher Isherwood, left Britain for America in January 1939, and six months later they were followed by Benjamin Britten and his lifelong companion Peter Pears, the celebrated tenor. Britten, Pears and Auden were guests of Dr and Mrs Mayer at their home in Amityville, Long Island, New York. Mrs Mayer had a natural flair for encouraging the work of creative artists, and her home was a centre of much talent during the 1930s and 1940s. Britten's stay in America was important in terms of work and experience, although the opera *Paul Bunyan*, for which he wrote the music and Auden the libretto, was not a success. Auden ascribed the failure to himself and declared his sorrow that '... some lovely music of Britten's went down the drain'.

In 1942 Britten and Pears decided to return to England and put down permanent roots. The realization of this need had come to Britten the previous year in an unexpected way, as important matters so often do. He had picked up by chance a copy of the BBC periodical *The Listener* of 29 May 1941. In it

Benjamin Britten and Peter Pears

he discovered a talk that had been broadcast by E. M. Forster on the poetry of a fellow East Anglian, George Crabbe (1754–1832). Forster's description of Aldeburgh made Britten yearn for home. Then, in a Los Angeles bookshop, he found a copy of *The Poetical Works of George Crabbe*. This included a poem called 'The Borough', part of which told the story of the Aldeburgh fisherman, Peter Grimes.

The idea for the great opera of that name was born, and the Koussevitzky Music Foundation provided $1000 towards the costs. It was composed at the *Old Mill*, at Snape, and was completed early in 1945. The first performance of the opera was given on 7 June 1945, just a month after war had ended in Europe.

The works that followed, *War Requiem, Billy Budd, Noyes Fludde, The Burning Fiery Furnace, Death in Venice*, indeed, the entire canon of his work, provide testimony to one of the most creative and experimental musical minds of modern times.

In 1964, Britten was presented with the first Aspen Award, at Aspen, Colorado. Part of the citation reads: '... To Benjamin Britten, who, as a brilliant composer, performer, and interpreter through music of human feelings,

moods and thoughts, has truly inspired man to understand, clarify and appreciate more fully his own nature, purpose and destiny'. In responding to the Award, Britten spoke of his debt to the poems of Crabbe, which had been so instrumental in reminding him of where he belonged, and the importance of place. He said:

I have lived since then in the same small corner of East Anglia, near where I was born—I want my music to be of use to people—I do not write for posterity—I write music, now, in Aldeburgh, for people living there and further afield, indeed for anyone who cares to play it or listen—my music now has its roots, in where I live and work. And I only came to realize that in California in 1941.

All who attend the Aldeburgh Festival, or visit the place at any season, will see about them the landscape that Benjamin Britten loved. The river and the reeds, the creeks and the wildlife, the sea, churches and cornfields, and above them the wide East Anglian skies—all of which, in sound, colour and composition, filled and overflowed in the work of Benjamin Britten, endowing him with a personal powerhouse of inspiration.

RUPERT BROOKE

The village of Grantchester is situated on the banks of the Granta some three miles south of Cambridge between the A10 and the M11. It is a place that will be associated always with Rupert Brooke (1887–1915). Walking to Grantchester and back on Sunday afternoons was an acknowledged activity among Cambridge undergraduates, who called it the 'Grantchester Grind'. The river was deep enough for bathing and there were tea gardens close by, the most favoured of these being at The Orchard, a riverside cottage.

When Brooke returned to Cambridge in June 1909, he decided to take rooms at The Orchard. He had a sitting room that gave a view to the church, a bedroom, the use of the river garden, and all meals for 30 shillings (£1.50) a week. In a letter to Hugh Dalton (later Chancellor of the Exchequer) he described the situation as 'a divine spot', and recommended 'an admirable ruin near, with a sundial and no drains'. This is the first reference that he makes to the house next door, the Old Vicarage; and it was not long before Brooke was to carry his books from The Orchard and become a lodger with Mr and Mrs Neeve who lived in the Old Vicarage. Three rooms were put at Brooke's disposal for which he once again paid 30 shillings a week. Bees were kept in the large garden, the hives hidden in the bushes, and Mr Neeve sold the honey on the combe at sixpence a portion.

'Ten to three', Grantchester (*see* Rupert Brooke)

The Old Vicarage itself was a red-brick house of three floors, not in good condition. There was a verandah at the rear smothered with Virginia creeper. Scores of frogs inhabited the garden which delighted Rupert Brooke and he always showed interest and concern for them. Time keeping was another concern, for the church clock was wildly inaccurate. Brooke wallowed in the lush overgrown surroundings of the Old Vicarage garden. Here he read and wrote to his heart's content, entertained his friends to tea, declaimed poetry and bathed nude.

While in Germany in 1912 his letters to friends in England show fond memories of Grantchester. 'I envy you. . . That river and the chestnuts . . . tea on the lawn.' In the May of that year, while sitting by his favourite window at the Café des Westens, Berlin, he wrote the delightful poem 'The Old Vicarage, Grantchester'. Although often made an object of gentle fun, the poem is both lyrical and sincere, and who does not recall its closing lines?

> Deep meadows yet, for to forget
> The lies, and truths, and pain? . . . oh! yet
> Stands the Church clock at ten to three?
> And is there honey still for tea?

Rupert Brooke was a brilliant young man who was to become surrounded by legend. If the closing lines of 'The Old Vicarage, Grantchester' are celebrated, then the opening lines of 'The Soldier' are equally famed:

> If I should die, think only this of me:
> That there's some corner of a foreign field
> That is for ever England. There shall be
> In that rich earth a richer dust concealed.

'The Soldier' owes its existence to Brooke's reading in 1912 of The Four Men by Hilaire Belloc. This classic of Sussex literature describing a journey across that county attracted Brooke so much that he knew it almost by heart. In the closing passages of the book as he stands above the Arun Valley, Belloc reflects '. . . if a man is part of and is rooted in one steadfast piece of earth, which has nourished him and given him his being, and if he can on his own side lend it glory and do it service, it will be a friend to him for ever, and he has outflanked Death in a way.' A few lines later Belloc writes:

> He does not die, but still remains
> Substantiate with his darling plains.

This clearly provided the inspiration for 'The Soldier'. The Four Men also reflects Brooke's own love of walking and the countryside.

Rupert Brooke became a sub-lieutenant in the Royal Navy in September 1914 and took part in the Antwerp expedition. While serving in the Mediterranean he contracted blood poisoning. He died on 23 April 1915, and was buried on the island of Skyros in the Aegean Sea. The tributes and obituaries, spoken and written when the news of Brooke's death reached Britain, used him as a symbol of golden youth, sacrifice—and possibly propaganda. There were some people who even wished the church clock at Grantchester to be set permanently at ten to three.

GEORGE BUTTERWORTH

The music of George Butterworth (1885–1916) is as delicate as a watercolour sketch; it catches the ear with simple melodies of a gentle beauty born of the English folk-song tradition. Butterworth was a man of extraordinary complexity, a gentle man and a warrior. He revelled in English music and, as Ralph Vaughan Williams noted, he had a quality rare among composers: '. . . a wonderful power of criticism of other men's work, and insight into their ideas and motives'.

Butterworth originally intended to make the Law his profession. At Oxford, however, he became increasingly involved in musical circles and found himself president of the University Musical Club. He met Ralph Vaughan Williams, Adrian Boult and Cecil Sharp. An intimate and productive friendship developed between Butterworth and Vaughan Williams. Both men were interested in English folk song and dance, and composition was their common aim.

During December 1911, Butterworth and Vaughan Williams set out on a brief folk song collecting trip to the Norfolk Broads. They travelled on bicycles, spending the evenings listening to singers and songs in a number of Norfolk pubs.

George Butterworth was devoted to the

Willy Lot's cottage, Flatford (*see* Constable)

unspoiled English landscape, from the Fens to the hill country. His music constantly reflects his ability to catch and portray what he saw and felt in warm musical colour. 'Firle Beacon' is a beautiful but little-known piano piece; 'The Banks of Green Willow', his six songs for 'A Shropshire Lad' and the songs for 'Bredon Hill' are his masterpieces.

This brilliant young man destroyed much of his output, considering it not worthy. With the outbreak of the First World War he enlisted as a private and was later commissioned in the Durham Light Infantry. In the summer of 1916 he was awarded the Military Cross for his gallant defence of a trench which was later named after him; shortly afterwards he was killed during the Battle of the Somme.

JOHN CONSTABLE

'The world is wide, no two days are alike, or even two hours, neither were there ever two leaves of a tree alike since the creation of the world, and the genuine productions of art, like those of nature, are all distinct from each other.'

The words of John Constable (1776–1837) constantly illuminate his approach to life and his painting. Son of a mill owner, he had been trained from boyhood to observe nature in all its moods. This was essential experience for a wind-miller and no less for a landscape painter. Changing cloud formations foretold wind strength and weather, while his painter's eye watched how a darkening cloud enhanced vivid greens and yellows.

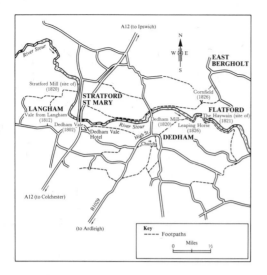

part of England that will be for ever remembered as 'Constable Country'. No name could be more fitting, for it was here that he produced so many superb drawings and paintings. Towards the end of his life, Constable was returning by coach one day from Suffolk to London, when an incident occurred that pleased him greatly. In a letter to his friend David Lucas, who engraved a fine series of Constable's works, he wrote: 'In the coach . . . were two gentlemen and myself, all strangers to each other. In passing the vale of Dedham, one of them remarked, on my saying it was beautiful, "Yes, sir, this is Constable's country." I then told them who I was, lest he should spoil it.'

Today, Constable is the most famous of all English landscape painters, and Dedham Vale, the heart of 'Constable Country' has become a place of pilgrimage. Prints of paintings, books and pamphlets, guides and maps abound to show the visitor the original scenes that caught the imagination of Constable. Astonishingly, very little has changed over two hundred

Constable was born in East Bergholt, a village that overlooks the lush and fertile valley of the River Stour, which separates the counties of Suffolk and Essex. The Stour Valley and Dedham Vale in particular form a

The Hay Wain, 1821, by John Constable

years. To look from the Stour across verdant fields to Dedham Church is still to see England as it was. Flatford Mill no longer grinds grain —it is now a Field Study Centre for naturalists and artists—yet if you stand at its door and look across the millpond, you see the landscape of *The Hay Wain*: only the wagon and horses are missing. The cottage of Willy Lot has barely changed at all; it stands by the millpond as though remembering the past.

Such scenes of his childhood always gave Constable pleasure, for he was a painter who felt the world to be at his own doorstep. He had not chosen an easy path—his father had first wished to make him a clergyman, then a miller, but John's inclinations towards painting proved too strong. His mother encouraged him to follow his own chosen career, so too did the connoisseur Sir George Beaumont, who showed him a painting by Claude and some watercolours of Thomas Girtin, described by Sir George as 'examples of great breadth and truth'.

Writing to his friend John Dunthorne, a painter and glazier by trade, with whom he had often painted and sketched in Dedham Vale, Constable, now aged 26, set out a testament of faith:

> I have not endeavoured to represent Nature with the same elevation of mind with which I set out, but have rather tried to make my performances look like the work of other men . . . I shall return to Bergholt, where I shall endeavour to get a pure and unaffected manner of representing the scenes that may employ me. . . There is room enough for a natural painter. . . The great vice of the present day is bravura, an attempt to do something beyond the truth. Fashion always had, and will have, its day; but truth in all things only will last, and can only have just claims on posterity.

Instead of following the fashion for classical ruins, castles and Italian views, Constable now concentrated upon the ordinary English pastoral landscape, which he realized was far from being ordinary. Not for him the heavy browns and tints of the past masters who appeared to paint through distant and dusty windows. Constable leapt straight into the natural foreground and caught at light and colour with both hands. He painted true to nature just as he had promised, full of freshness, joy and dew. Constable paid a price for doing this: he was not made a full member of the Royal Academy until 1829, long after his work had begun to influence new directions in painting at home and abroad.

SEE ALSO PAGE 116

JOHN SELL COTMAN

The watercolour is a medium ideally suited to the British landscape and its exponents have been many, the leading among them being J. M. W. Turner, Thomas Girtin and John Sell Cotman (1782–1842). In fact there is no watercolourist quite like Cotman. Laurence Binyon described Cotman's painting of Greta Bridge in Yorkshire as 'the most perfect example of pure watercolour ever made in Europe'. Indeed, the relationships he achieves with colours and shapes are breathtaking. Cotman's art cannot be confined to his own times, for in his watercolours can be seen clear hints of art to come, of Impressionism, abstract art, and at times Surrealism.

Cotman was born in Norwich. He knew the painters of the Norwich School (see p. 107) and it was from their works that he imbibed a freshness of approach to landscape. Painters like Richard Wilson (see p. 74) had already provided evidence that superb scenery was to be found in Britain, and that there was really no need to pursue further the academic tradition of Italianate classicism. Painters in Britain were turning to nature. For Cotman it was an ideal climate for a fresh approach. He painted in Yorkshire, Durham and Wales and the results are magnificent. Yet he did not paint in a 'natural' style that would have been recognized as such by John Constable. Cotman certainly caught the look of nature, the way the trees grew, the way a field was ploughed, but he simplified the images into his own patterns. Some of his work has flatness, similar to that of a Japanese print.

The paintings Cotman made on the banks of the Greta are his statement of intent; he was never happier, it was a state of unlaboured mastery and he revelled in it.

At the same time, this son of a Norwich hairdresser was open to self-doubt, and was

Greta Bridge, 1810, by John Sell Cotman

saddened by his lack of recognition. He actually saw his work sold for mere shillings. Dawson Turner, a Yarmouth banker, was a patron of Cotman, and the artist completed many antiquarian and architectural drawings for him; he also gave drawing lessons to Dawson Turner's family.

From 1824 until his death in 1842, Cotman was Art Master to King's College, London. It was J. M. W. Turner who, recognizing Cotman's skill, championed his appointment.

Today the watercolours of John Sell Cotman are among the most prized and appreciated, and his reputation has become international.

THOMAS GAINSBOROUGH

Unlike so many other painters of the 18th century, Gainsborough (1727–88) was never out of work or out of funds. Although his first love was the painting of landscapes, he is also celebrated for his portraits. Gainsborough had the ability to capture the living likeness of his sitters, and because of it he was forever in demand. Some of the portraits are masterpieces, others less so but, as he said, 'the portraits kept the pot boiling'. So it seems that

we get the word 'pot-boiler' from Gainsborough. It is a term that could never be applied to his own painting.

Gainsborough was born in Sudbury, a market town in Suffolk where his father was a cloth merchant. It was at Sudbury as a boy that he began to take an interest in drawing, and his parents sent him to London for training. He became a pupil and assistant to a French artist, Hubert Gravelot. When Gravelot returned to France in 1745, Gainsborough tried to establish a studio of his own, but within the year he had returned home to Sudbury and was married shortly afterwards. An authority writing in 1829 states that Gainsborough first met his wife to be while he was sketching in a wood.

Like so many painters from East Anglia, Gainsborough was very much influenced by Dutch painting and, in his case, by French painting as well. He used colour and imagination sensitively, and painted beautifully. However, the demand for landscape paintings was extremely limited; they were simply not fashionable. Unlike Constable, who went into the fields to capture nature on his canvas, painters of this earlier period worked indoors. Gainsborough sought for a poetic or romantic

view of nature. Many painters of his day were still deeply involved in historical or classical scenes, so Gainsborough was something of a pioneer in his approach. His trees have sometimes been called 'bunches of parsley and celery stalks', but Sir Joshua Reynolds said of Gainsborough that 'nature was his teacher and the woods of Suffolk his academy'.

Some of his romantic landscapes, such as *The Cottage Door with Children Playing*, are delightful enough scenes but quite unrealistic. On the other hand Gainsborough's *Forest* is

The Market Cart, by Thomas Gainsborough

St Benet's Abbey, by John Sell Cotman, painted many times by the Norwich School of Painters

handled with far more care, and it is a painting that later had great influence on Constable, who was interested in its light effects.

Many of his landscapes are merely fanciful, but the detail of such pictures is invariably well observed. Gnarled oak stumps, and burdock leaves, which he loved to draw, were frequently worked into such compositions; one painting of this style shows horses pulling a grain drill that had been invented by his elder brother!

The delight of painting landscapes never left Gainsborough. Even in his portrait work, landscape and woodland settings are frequently used as important backgrounds. The landscapes that he painted later in life show the artist at his best: *The Market Cart* is a superb example.

Portraits continued to be demanded of him and he could never seem to give them up, although he once stated his ambition as being to 'take my viola di gamba and walk off to some sweet village where I can paint landskips and enjoy the fag-end of life in quietness and ease'—but he never did.

Constable lived only twelve miles from Gainsborough's birthplace and said of Gainsborough's paintings: 'On looking at them we find tears in our eyes, and know not what brings them.'

For Gainsborough the time had not come when landscape artists would set up their easels in the fields; as Sir Joshua Reynolds stated after Gainsborough's death:

'From the fields he brought into his painting room stumps of trees, weeds, and animals of various kinds and designed them, not from memory, but immediately from the objects. He even framed a kind of model from landscapes on his table; composed of broken stones, dried herbs and pieces of looking glass, which he magnified and improved into rocks, trees and water.'

Gainsborough's impressionistic landscapes looked forward to future trends, but in so doing failed to capture the sense of place that he felt and knew existed for him at Sudbury and in the surrounding countryside.

THE NORWICH SCHOOL OF PAINTERS

Eighteenth-century Norwich cared about painting and drawing; city merchants required portraits that demonstrated their prosperity—still-life painting reflected laden tables, and drawing was taught in most schools. A local painter, Joseph Brown, was producing pleasant, well-painted pictures in classical style by the third quarter of the century. Brown died in 1800 and was acclaimed the Norwich Claude. It was against this background of artistic fertility that the landscape painters of the Norwich School developed.

It was Joseph Crome (1768–1821), a painter and etcher, who founded what he termed the Norwich Society of Artists, now universally known as the Norwich School. Crome was very much a country boy and for years after serving his apprenticeship he worked as a housepainter. However, whenever possible he sketched the surrounding picturesque landscape in company with his friend Robert Ladbrooke (1769–1842).

A certain Thomas Harvey became interested in Crome. He provided him with several useful introductions, including one to Sir William Beechey who gave Crome much practical advice, after which Crome's work improved rapidly. Thomas Harvey also permitted him to examine his small collection of Dutch and Flemish paintings. It was upon such examples that Crome established his art. From the 17th century there had been close links between East Anglia and Holland—in many ways they possessed a similar landscape—and Crome became a devoted admirer of the work of Ruysdael and Hobbema. There are many similarities between the Dutch painters and the Norwich School, not least in their choice of subject matter and the care taken to depict nature as she is.

Woody Landscape, by James Stark (*see* Norwich School of Painters)

Mousehold Heath, by John Crome (*see* Norwich School of Painters)

Crome founded his fraternity of artists in 1803, for the purpose of holding an annual exhibition and fortnightly meetings. It was all very much a local affair. Crome's pictures sold for very small sums, and a mere handful of his works were exhibited in London.

What all the members realized—just as Constable discovered in Dedham Vale—was that their own local landscape was more than worthy of their art. Now the work of the Norwich School is acknowledged and appreciated throughout the Western world. One of the watercolourists among them, John Sell Cotman (1782–1842), stands supreme. As the 20th century approaches its close so the everlasting 'modernity' of Cotman has given him international stature.

Even though they travelled in other parts of Britain, the members of the Norwich School seldom lifted a paintbrush outside their own county, although John Sell Cotman proved very much an exception to that rule. The Norfolk landscape then contained more variety

and scenes of picturesque quality than it does today. Certain places, like Benets Abbey, a strange grouping of ruins with the remains of a windmill springing up from them, were painted by Cotman, Henry Bright and others as though they were compulsory exercises. However, the pictures that have survived reveal nothing mechanical, only delight in the subject.

The finest collection of works by the Norwich School is to be seen, appropriately, in the Norwich Castle Museum.

It is always interesting to read the comments of such painters in respect of their art. John Wodderspoon told how, 'Meeting Crome in a remote spot of healthy verdure with a troupe of young persons, and remarking, "Why, I thought I had left you in the city engaged in your school!" "I am in my school," replied Crome, "and teaching my scholars from the only true examples. Do you think," pointing to a lovely distance, "that either you or I can do better than that?" '

On 17 October 1841, John Sell Cotman wrote to Dawson Turner: 'I have been sketching on our River, and at Hanworth, Cromer and Sheringham, the wilderness of Norfolk ... judge for yourself my happiness on finding your Norfolk flints capable of once more creating a blaze in my heart.'

Again to Dawson Turner, 20 October 1841, describing the river journey from Yarmouth to Norwich:

'On the return journey the deck of the steamer opened up to me scenes that I must never hope to witness again. All was desolation and dreariness. It was sublime. It was a day to be remembered, entirely and especially by an artist, for it gave a power to wildness that I never before ever imagined.'

And writing to Dawson Turner, 20 November 1841: 'Oh! rare and beautiful Norfolk.'

The most important members of the Norwich School were, besides John Crome and John Sell Cotman, James Stark, George Vincent, John Bernay Crome (Crome's eldest son), William Henry Crome (Crome's third son), Robert Ladbrooke, Henry and John Berney Ladbrooke (Robert's second and third sons), John Thirtle, Robert Dixon, Charles and David Hodgson, Henry Ninham, Joseph and Alfred Stannard, Miles Edmund Cotman (Cotman's eldest son), Joseph John Cotman (another son), Thomas Lound, John Middleton, Henry Bright, the Reverend James Bulwer, James Sillett and Edwin Cooper.

These painters produced their extraordinary output of hundreds of oil paintings, watercolours and drawings from this one corner of England during the first half of the 19th century. It has provided posterity with a whole panorama of life and landscape that is unequalled anywhere; a creative landscape indeed, and one that remains so.

HENRY WILLIAMSON

Between 1937 and 1945, Henry Williamson farmed the 240-acre Old Hall Farm at Stiffkey in Norfolk. The farm was almost derelict then and employed only two men, but by 1941 there were seven. Old pastures and rough land were ploughed, and before the war ended Henry Williamson was recording that the Home Hills, never before ploughed, were 'golden-brown with a thick and sturdy crop of oats; and in the summer following the oats were even stronger, with gold-greasy heads and dark brown stems.'

Why had Williamson left his beloved Devon to farm against the North Sea coast, where freezing winds streamed in from the Baltic region? The author of *Tarka the Otter* had a simple answer: 'My work in the West Country is finished. Otter, salmon, stag, falcon, village, moorland, estuary—all I know of them is in my books.'

The River Stiffkey flowing through the village soon became a constant source of inspiration for his writing; so too did the farm itself. From the main coast road (the A149) curving round the meadows half a mile east of Stiffkey can be seen the whole setting for *The Story of a Norfolk Farm* and *The Phasian Bird*. Later novels in *The Chronicle of Ancient Sunlight* also draw on the landscape and experiences here. In these novels his Old Hall Farm becomes 'the Norfolk Farm'; Stiffkey becomes 'Stewkey' (in fact this is the local pronunciation of the name); Wells becomes 'Whelke'; and Morston, 'Durston'.

Henry Williamson's colophon, or trademark, of an owl with his initials H.W. is still to be seen at The Old Hall Farm.

Stiffkey lies between Blakeney and Wells-next-the-Sea, on the A149 road. Seaward are the sands that Henry Williamson called 'the Great Barrier Sands'; at their eastern edge is Blakeney Point, rich in bird life. It was a landscape that gripped the creative mind of Henry Williamson as the final sentence of *The Phasian Bird* shows: 'In the sky wild geese were passing, flying for the Great Barrier Sand where they rested by day, flying with slow flaps of wings one beside and above the other, crying their music of ice-pack and midnight sun, of seas where the great whales blew, of summer upon the flowery coast of far Spitsbergen.'

SEE ALSO PAGE 132

South West

Between Dorset and Land's End extends a magnificent coastline on both the north and south sides of the peninsula. It embraces Exmoor and *Lorna Doon*, and Dartmoor and *The Hound of the Baskervilles*, the Wessex novels of Thomas Hardy and the Cornish romances of Daphne du Maurier. It is a coastline that is alternately caressed or battered, according to the mood of the waves that roll across three thousand miles of Atlantic Ocean.

The stone circles at Avebury, Stonehenge, and Silbury Hill, the largest man-made mound in Europe, all mark the baffling and mysterious life and rituals of early man. The Arthurian legend is also held to belong here. At Tintagel Head on the Atlantic coast are the ruins of a castle said by tradition to be the birthplace of King Arthur; although excavation has not confirmed such detail.

The lands of the South West have seen history made and altered. William of Orange landed at Torbay in 1688 to receive the throne of England. Three years before the Duke of Monmouth had landed at Lyme Regis and was defeated by James II's forces at Sedgemoor. It was a battle in which hundreds of local men died; their burial pits still remain. The battlefield is near Bridgwater, and is easily reached just north of Westonzoyland. Now it is a quiet place of gentle beauty, but it does have a haunted feel.

Many painters have lived in the South West, making their explorations in light and colour. Many of them have been members of the artist communities that have sprung up from time to time, and of which the St Ives School is the classic example.

The rivers have created many special landscapes. In Devon, Henry Williamson explored in detail the Taw and Torridge: the land of the two rivers that saw the life and death of *Tarka the Otter*.

The Helford River will always be linked with Daphne du Maurier; and the River Fal with Harold Spring, who lived by the river from 1939 until his death in 1965 and is buried in Mylor churchyard.

For the walker—and surely the only way to explore is on foot—the coastal footpaths are a joy. Most important is the Cornwall coastal path, but there are so many others. In North Devon it is sheer pleasure to walk the banks of the River Lyn, where almost certainly you will see that beautiful bird the dipper, walking beneath the water on the stony river bed.

There are many wild places of great beauty in the South West, but it is always well for walkers to remember that on its moorlands, a change in weather can result in their becoming lost.

⋙⚬⋘⬦⋙⚬⋘

WILLIAM BARNES

William Barnes (1800–86), the dialect poet of Dorset, was one of the county's most loved characters. Thomas Hardy knew him well:

> Few figures were more familiar to the eye in the county town of Dorset on a market day then an aged man, quaintly attired in capel cloak, knee breeches, and buckled shoes, with a leather satchel slung over his shoulders and a stout staff in his hand. . . Every Saturday morning he might be seen trudging up the narrow South Street of Dorchester . . . till he could reach the four crossways. Halting here opposite the public clock, he would pull his old-fashioned watch from its deep fob and set it with great precision to London time.

After being a solicitor's clerk and a schoolmaster, William Barnes entered the Church. He published his first dialect poems in 1844. He possessed an exquisite feeling for local scenery:

> *Or in the day, a-vleen drough*
> *The leafy trees, the whorse gookoo*
> *Do zing to mowers that do zet*
> *Their zives on end, an' stan' to whet.*
>
> *An I do zee the frisken lams*
> *Wi' swingen tails an' wooly lags*
> *A-playen roun' their veeden dams*
> *Ar' pullen o' their milky bags.*

Church of St Enodoc, the Camel Estuary, Cornwall
(*see* Betjeman)

JOHN BETJEMAN AND CORNWALL

Sir John Betjeman, born in 1906, has been the Poet Laureate since 1972 and is the best-known English poet living. He is undoubtedly very much a poet of place, aware of his surroundings and reacting quickly to what he can see and to what he senses. For some fifty years he has written widely, and wisely, on architecture in a way that has had much influence on public taste, and he is the founder of the Victorian Society. His collected poems form a unique social history of our time.

Brought up in North London, Betjeman has always had an eye for suburbia and social behaviour, for English churches and their architectural detail; much of this finds a place in his poetry. This eye for detail reaches far back into his childhood, and the summer holidays he spent on the north Cornish coast.

He has returned there many times and his feeling for Cornwall pulsates through his Cornish poems. He is never a nature poet, but his eye for landscape and his ear for its sounds are faultless, as in 'Trebetherick':

> We used to picnic where the thrift
> Grew deep and tufted to the edge;
> We saw the yellow foam-flakes drift
> In trembling sponges on the ledge
> Below us, till the wind would lift
> Them up the cliff and o'er the hedge.
> Sand in the sandwiches, wasps in the tea,
> Sun on our bathing-dresses heavy with the wet
> Squelch of the bladder-wrack waiting for the sea
> Fleas round the tamerisk, an early cigarette.

Later in the poem Betjeman senses something darker in the landscape:

> Thick with sloe and blackberry, uneven in the
> light,
> Lonely ran the hedge, the heavy meadow was
> remote,
> The oldest part of Cornwall was the wood as
> black as night,
> And the pheasant and the rabbit lay torn open at
> the throat.

Betjeman has written and edited several books on Cornwall, but it is his poems that most beautifully encapsulate the essential warmth of his feeling for this landscape and his remembrance of it. Such poems as 'Cornish Cliffs', 'Tregardock', 'Old Friends', and the magnificent 'Sunday Afternoon Service in St Enodoc Church, Cornwall'.

It is against the Cornish seascape that the poet has discovered that:

> Here where the cliffs alone prevail
> I stand exultant, neutral, free,
> And from the cushion of the gale
> Behold a huge consoling sea.

R. D. BLACKMORE AND EXMOOR

Lorna Doone was published in 1869, a remarkably powerful romantic novel that successive generations of readers have found compulsive. The author, R. D. Blackmore (1825–1900), blended his literary ingredients to perfection: a pinch of historical research, a handful of

legend and fancy, love and passion, the beautiful Lorna, and strong and handsome John Ridd, a battle against hate and sheer villainy; all set among the glorious landscapes of Exmoor. Blackmore, it was said, did for Exmoor what Scott had done for the Highlands.

Although Blackmore loved Exmoor and had acquired a detailed knowledge of it while still a boy, he was born at Longworth in Berkshire where his father was vicar. An outbreak of typhoid fever almost wiped out the family and their friends. Only father and son survived. The Reverend Blackmore took the living at Culmstock, near Tiverton. When his son reached the age of 11 he was sent to Blundell's School, Tiverton, where he later placed his hero John Ridd.

The landscape of Lorna Doone is to be found in the neighbourhood of the village of Oare. It was here that Blackmore set the marriage of Lorna to John Ridd in Oare church. A tablet in the church commemorates the centenary of Blackmore's birth.

From Malmsmead, near Brendon, just south of the A39 between Lynton and Porlock, is Badgworthy Water which here forms the border between Devon and Somerset. A footpath leads south from Malmsmead, where there is another memorial to Blackmore beside Badgworthy Water. On the west bank is the entrance to Hoccombe Combe, known to thousands of walkers as the Doone Valley.

Blackmore was a barrister and a teacher as well as a novelist. Lorna Doone and most of his other novels were written at his house at Teddington, where he relaxed by growing fruit and flowers.

OPPOSITE ABOVE *Dolgelley*, by John Sell Cotman (*see* p. 103)

OPPOSITE BELOW *Salisbury Cathedral from the Meadows*, 1831, by John Constable (*see* p. 101)

OVERLEAF LEFT *Dedham Church* (*see* Constable, p. 101)

OVERLEAF RIGHT St Ives, Cornwall (*see* The St Ives School, p. 124)

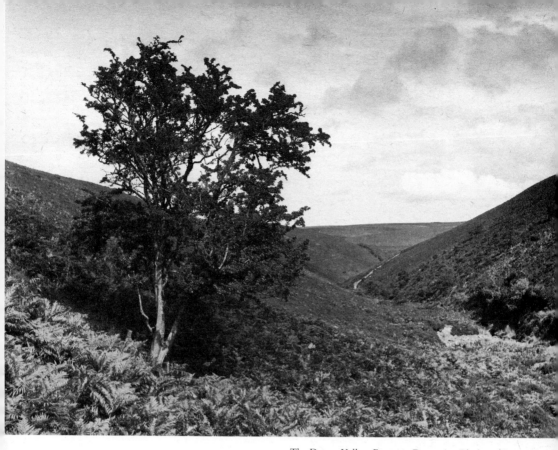

The Doone Valley, Exmoor, Devon (*see* Blackmore)

JACK CLEMO

Born at Goonamaris near St Austell, the Cornish poet Jack Clemo is blind and deaf. His father worked in the china clay industry in the drying kilns, but was killed in the First World War. Jack Clemo, born in 1916, began to lose his sight at the age of five, and while still in his teens his hearing began to fail. He was educated at Trethosa village school and he once described himself in these words: 'A dreamer and social misfit, I had already spent five years as an unemployable hermit mystic before partial deafness increased my isolation.'

This extraordinary man, who has refused to learn braille, has lived a life of constant challenge, meeting his disabilities head-on, creating a personal religious philosophy and an erotic mysticism in some of his writing. It is no unspoiled landscape that he remembers

and writes of best, but the clay pits of Corn-wall, the dumps and the quarries. The excava-tions and scars created in the search for china clay provided him with a symbolism he used to great effect in his first book of verse *The Clay Verge*. Clay occurs in other titles such as 'The Map of Clay' and 'Clay Phoenix'.

It was the loss of his sight that originally caused Jack Clemo to turn to verse, and as the years have passed so the scope of his work has widened, particularly since his marriage in 1968. He has stated: 'I write entirely on spiritual inspiration and do not consciously choose either the subject or the style of my poems.' Jack Clemo acknowledges and accepts that his physical handicaps have restricted his output, but the personal statements and attitudes of this landscape poet have been firmly expressed.

OPPOSITE Coate Water, Swindon, Wiltshire (*see* Williamson, p. 132)

OVERLEAF China clay quarries near St Anstell (*see* Clemo)

S. T. COLERIDGE AND THE WORDSWORTHS IN SOMERSET

Samuel Taylor Coleridge (1772–1834) and his family became tenants in 1797 of a cottage in what is now the main street of Nether Stowey, in Somerset. It so happened that William Wordsworth and his sister Dorothy were staying near by. While walking in the Quantock Hills the two poets developed the idea of a ballad, to be called 'The Rime of The Ancient Mariner'. In fact the ballad was entirely the composition of Coleridge, for Wordsworth realized that their styles were not compatible. Coleridge completed several poems at Nether Stowey, the most important being 'Kubla Khan'. It is possible that this poem was completed under the effects of opium. The drug certainly began to affect and dominate Coleridge's life shortly afterwards. Several Exmoor farms have been suggested as the place where 'Kubla Khan' was written.

In July 1797 Coleridge brought the Wordsworths up from Dorset and took them to Alfoxden House in Somerset, where they took the lease. William spoke of its 'enchanting beauty', and Dorothy declared it to be 'that dear and beautiful place'. Red deer from the Quantocks 'roared' near the house. The year at Alfoxden was a vital one for Wordsworth; he was able to set the course of his poetical development and take advice from Coleridge, in whose criticism he had great confidence.

JOHN CONSTABLE AND SALISBURY

In the autumn of 1811 John Constable (see p. 101) made his first visit to Salisbury to meet the Bishop, who had once been Rector of Langham, not far from East Bergholt in Suffolk. He also met John Fisher, the Bishop of Salisbury's nephew, who was to become his closest friend. John Fisher introduced Constable to a landscape that the painter immediately felt he could paint with the kind of intimacy and enthusiasm he had known for so long on the borders of Suffolk and Essex. The *View of Salisbury* that resulted was well received when Constable exhibited the painting at the Royal Academy in 1812. He asked the President, Sir Benjamin West, whether

the work was the right preparation for future excellence. The reply was, 'Sir, I consider that you have attained it.' This painting is now in the Louvre in Paris. Benjamin West liked Constable and had once given him most valuable advice, 'Always remember, Sir, that light and shadow never stand still.'

Constable was very much out of step with his contemporaries who, in the main, were slavishly following old and well-worn paths. His freshness, and his accurate observation of landscape, cloud and colour, did not please everyone. As Constable said of his own work: 'It flatters none by "imitation" and "courts" none by smoothness and "tickles" none by petitness, and is without "fallal" or "fiddle deedee".' Constable considered that 'The great vice of the present day is bravura, an attempt at something beyond the truth.' He waited long to be made a full member of the Royal Academy. When his election was achieved it came as a surprise: he fully expected that once again the council would prefer the 'shaggy posteriors of a Satyr to the moral feeling of a landscape'.

In 1816 Constable married Maria Bicknell. John Fisher conducted the service. Later he made sketches at Netley Abbey, an obligatory exercise for all artists who passed that way. This was also the year that he painted *Weymouth Bay*.

Two major paintings were yet to result from the visits to Salisbury. The Bishop commissioned a painting of *Salisbury Cathedral from the Bishop's Grounds*. In this magnificent picture the cathedral is framed in an arch of trees; cattle drink at a pool; and the Bishop and his wife stroll near by. The Bishop said he 'liked all but the clouds', and in due course Constable painted another picture with less cloud. He also painted a smaller version for the Bishop's daughter, this time full of sunlight.

Constable had studied clouds from childhood: it was the sort of practical knowledge a millowner's son should have. He practised painting clouds for many years and, as he grew older, so the clouds grew increasingly heavy. The painting of *Salisbury Cathedral from the Meadows* is Constable in the grand manner, complete with sheepdog in foreground, a boatman, horses and cart, old fence stumps, the Cathedral, trees, watermeadows,

Stonehenge, 1837, by John Constable

clouds and a rainbow: a stage-managed painting, but magnificent.

While in Wiltshire in 1836, Constable completed a superb watercolour of Stonehenge; it was in fact unusual for him to draw or paint what he called 'landmarks'. When shown at the Royal Academy, it bore the legend: 'The mysterious monument of Stonehenge, standing on a remote and boundless heath, as much unconnected with the events of past ages as it is with the uses of the present, carries you back beyond all historical records into the obscurity of a totally unknown period.'

Throughout his life John Constable strove to portray nature in all her glory, he described the challenge in his own words: 'Light-dews-breezes-bloom and freshness; not one of which has yet been perfected on the canvas of any painter in the world.'

SEE ALSO PAGE 101.

T. S. ELIOT AT EAST COKER (AND LITTLE GIDDING)

Thomas Stearns Eliot (1888–1965) created a universal landmark in poetry rather than a personal landscape. The appearance of *The Waste Land* in 1922 wrought a revolution in English poetry. His conversational tones treating upon powerful themes outraged many and inspired others, although inspiration was a word that Eliot did not care to acknowledge.

T. S. Eliot was American by birth and came from St Louis, Missouri. His father was director of a brick company, his mother wrote poetry, and his grandfather had established Washington University. Very much an academic, he was educated at Harvard, the Sorbonne and Merton College, Oxford. His travels as a young man in England and on the Continent resulted in his adoption of British nationality in 1927, the first American to do so since Henry James (see page 151). He taught, worked for a bank, and eventually joined the publishing house of Faber and Faber.

Rules of poetic expression were shaken off and reappraised; T. S. Eliot was doing what

Wordsworth and Coleridge had done in an earlier age. *The Waste Land* was not the poetic message of comfort; it was the articulate thought of a new, postwar generation.

Between 1935 and 1942, T. S. Eliot wrote his *Four Quartets*, which made a slim but important volume. Each 'Quartet' has a title of its own: 'Burnt Norton', 'East Coker', 'The Dry Salvages' and 'Little Gidding'. Two of these, 'East Coker' and 'Little Gidding' have their own landscape.

It was at East Coker that an ancestor of Eliot, Sir Thomas Elyot, had lived, some four hundred years before. The village is about three miles south of Yeovil, Somerset, and the ashes of T. S. Eliot are buried in the church as the poet requested.

At Little Gidding, in Cambridgeshire, is the tiny stone church where Nicholas Ferrar, in 1625, founded a family community for prayer and charity. In the 'Four Quartets', the poet sets out to explore time and the human condition.

THE HARDY COUNTRY

Thomas Hardy (1840–1928) himself decided that his series of local novels required 'a territorial definition of some sort to lend unity to their scene'. The name 'Wessex' first appeared in *Far From The Madding Crowd*, and ever since then the many admirers of his Wessex novels have sought out the locations of events in his tales. It is not a difficult thing to do, for Thomas Hardy did not tamper with geographical detail, only renamed the places. Such is the power of his writing and so brilliantly drawn his characters, that it is a landscape as well known in Russia, the United States, or Japan as it is in the county of Dorset itself.

Anyone who goes to the Hardy country should first visit his birthplace at Upper Bockhampton, built in about 1800 by Hardy's great-grandfather. Changes have taken place, but this simple cottage in its quiet wooded landscape, overlooking Egdon Heath, still retains a sense of how things must have been

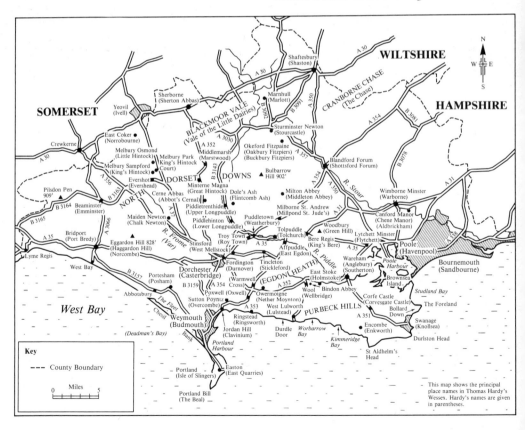

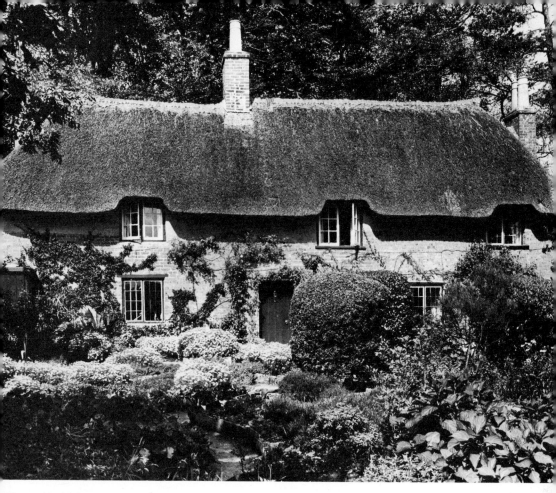

Thomas Hardy's birthplace, High Bockhampton, Dorset

in the days of Hardy's childhood. The cottage certainly meant much to Hardy. He wrote it into *Under The Greenwood Tree* (1872), and his earliest known poem, 'Domicilium', describes the property as he believed it to have been before his birth.

This use of a Latin title is interesting, for in 1849 Hardy went to school in Dorchester to learn Latin; his textbook was *Ainsworth's Latin Dictionary*. This survives and contains two very early signatures.

To read Hardy in his landscape brings a very special insight to his works. There are so many passages, rich in description, that only a poet's eye and ear can bring to the printed page; as when Gabriel Oak set out in search of Bathsheba:

The road stretched through water-meadows traversed by little brooks, whose quivering surfaces were braided along their centres,

and folded into creases at the sides; or, where the flow was more rapid, the stream was pied with spots of white froth, which rode on in undisturbed serenity. On the higher levels the dead and dry carcases of leaves tapped the ground as they bowled along helter-skelter upon the shoulders of the wind, and little birds in the hedges were rustling their feathers and tucking themselves in comfortably for the night, retaining their places if Oak kept moving, but flying away if he stopped to look at them. He passed by Yalbury Wood where the game-birds were rising in their roosts, and heard the crack-voiced cock-pheasant's 'cu-uck, cuck', and the wheezy whistle of the hens.

Next to Shakespeare this son of an obscure Victorian family is considered perhaps the greatest writer and poet in the language. So intense is the interest in the man and his work

that universities and biographers have created a 'Hardy industry', with a prodigious output of words. The reason for this is not hard to find. Hardy always remained a countryman and had in good measure the obstinacy and guile, developed over long centuries, with which the working man in Victorian England endeavoured to survive. Like the poacher in the wood, he covered his tracks. As he grew older so he tried to destroy the clues of his past, concealing his sexual affairs and relationships in a cloak of mystery. The effect of all this has been to encourage the literary sleuths to put Thomas Hardy under the magnifying glass. Yet while this fascinates and delights the literary scholar, his glorious novels and poems retain their everlasting pleasure. It is Hardy's understanding of country people, their expectations, speech and problems, in a Victorian world haunted by hardship, that brings his works to life with laughter and tears.

Hardy also had the eye of the antiquarian. In a cottage he would see the generations who had sat in a chair, and in the great earthworks of prehistory on the Dorset downlands he recognized the infinite mystery of the past. So it is that we find a wisdom in Hardy that is as deep as centuries, manifesting itself in such a poem as 'The Darkling Thrush', or using Maiden Castle, southwest of Dorchester, as an ancient landscape of passion.

Much of Hardy's countryside remains intact, and his intimacy with it is the primary key to his novels and poems. Hardy lived at a time of great agricultural change and increasing mobility of the workforce. Fortunately for us Dorset has not become a commuter county, and large areas of Hardy country are being carefully conserved.

GUSTAV HOLST
AND EGDON HEATH

Several works have been written by various composers that have stemmed from the novels of Thomas Hardy. Gustav Holst also became interested in the idea of linking music with Hardy country. By 1920 Hardy was somewhat frail, but he quickly summoned the energy and enthusiasm to take Holst for a walk on Egdon Heath and to describe his feeling for it. Holst set out to grasp the

atmosphere in the early pages of Hardy's *The Return of the Native*.

Intensity was more usually reached by way of the solemn than by way of the brilliant, and such a sort of intensity was often arrived at during winter darkness, tempests, and mists. Then Egdon was aroused to reciprocity; for the storm was its lover, and the wind its friend. Then it became the home of strange phantoms; and it was found to be the hitherto unrecognized original of those wild regions of obscurity which are vaguely felt to be compassing us about in midnight dreams of flight and disaster, and are never thought of after the dream till revived by scenes like this.

In 1927 Holst wrote a letter to Austin Lidbury discussing the composition of 'Egdon Heath':

. . . your gift of 'The Return of The Native' combined with a walk over Egdon Heath at Easter 1926 started my mind working and I felt that according to my usual slow method I might write something in 1930 or thereabouts. However, a cable came last Easter from the New York Symphony Orchestra asking me to write something for them! With the result that my 'Egdon Heath' was half done by the end of July, and last Friday I started walking here from Bristol via the Mendips, Wells and Sherbourne. I got here on Monday, and on Tuesday I had an unforgettable lunch and motor trip with Thomas Hardy himself, who showed me Melstock, Rainbarrow and Egdon in general. . . I've promised him to go up Rainbarrow by night. . . He is sorry I'm seeing it in summer weather, and wants me to come again in November.

'Egdon Heath' bears the subtitle 'Homage To Thomas Hardy', but the great novelist died a few weeks before its first performance.

At No. 4 Clarence Road, Cheltenham, there is now the Holst Birthplace Museum. Dedicated to Holst's life and music, it contains a collection of documents and autographed manuscripts of early compositions.

OPPOSITE *Makatu*, 1969, by Barbara Hepworth (*see* The St Ives School, p. 124)

W. H. HUDSON

Born of American parents in Argentina, W. H. Hudson (1841–1922) eventually came to England in 1874. He had been encouraged to come after being elected a corresponding member of the Zoological Society of London. Although he was to set up home in London, it was the South West of England that attracted him most of all. He saw himself always as a field naturalist first and as a writer second. His books, however, created interest in their day and several of them were reprinted many times. During his early years in Argentina he had come to know some of the shepherds of the Pampas, and it was because of this that he felt a particular affinity with the broad vistas of Salisbury Plain and the lonely lives of its shepherds. He published *A Shepherd's Life* in 1910; much of it was based on his conversations with a South Wiltshire shepherd who became the central character. It is a work that has long been a classic:

> One day, in September, when sauntering over Mere Down, one of the most extensive and loveliest-looking sheep-walks in South Wilts—a vast, elevated plain or table-land, a portion of which is known as White Sheet Hill—I passed three flocks of sheep, all with many bells, and noticed that each flock produced a distinctly different sound . . .

> At the last of the three flocks a curious thing occurred. There was no shepherd with it or anywhere in sight, but a dog was in charge; I found him lying apparently asleep in a hollow, by the side of a stick and an old sack. I called to him, but instead of jumping up and coming to see me, as he would have done if his master had been there, he only raised his head, looked up at me, then put his nose down on his paws again. I am on duty—in sole charge—and you must not speak to me, was what he said. After walking a little distance on, I spied the shepherd with a second dog at his heels, coming over the down straight to the flock, and I stayed to watch. When still over a hundred yards from the hollow the dog flew ahead, and the other jumping up ran to meet him, and they stood together, wagging their tails as if conversing. When

the shepherd had got up to them he stood and began uttering a curious call, a somewhat musical cry in two notes, and instantly the sheep, now at a considerable distance, stopped feeding and turned, then all together began running towards him, and when within thirty yards stood still, massed together, and all gazing at him. He then uttered a different call, and turning walked away, the dogs keeping with him and the sheep closely following.

Hudson never lost his feeling for Wiltshire, he wrote:

> . . . it is the likenesses that hold me, the spirit of the place, one which is not a desert with the desert's melancholy or sense of desolation, but inhabited, although thinly, and by humble-minded men whose work and dwellings are unobtrusive. The final effect of this wide green space with signs of human life and labour in it, and sight of animals—sheep and cattle—at various distances, is that we are not aliens here, or invaders on the earth, living in it but apart, perhaps hating and spoiling it, but with the other animals are children of Nature, like them living and seeking out subsistence under her sky, familiar with her sun and wind and rain.

KATHARINE HULL AND PAMELA WHITLOCK

The schoolgirl collaboration of Katharine Hull (born 1922) and Pamela Whitlock (1921–82), resulted in a delightfully written and important trilogy of children's books that was published between 1937 and 1939. Pupils at the same school, and only 14 and 15 years old, they decided to write a book about a riding holiday on Exmoor. They wrote the manuscript on sheets from an exercise book, and they called it *The Far-Distant Oxus*.

Using their knowledge of Exmoor they told a story, each writing alternate chapters, of carefree boys and girls enjoying a full and happy childhood while on the threshold of growing up. The two girls succeeded in capturing the fun of summer days spent in the open air with their ponies; and overlaid their adventures with a slight hint of mystery.

Still-life, by Ben Nicholson (*see* The St Ives School, p. 124)

Above all, they had the brilliant idea of creating a romantic Persian landscape out of Exmoor based on place names from Matthew Arnold's 'Sohrab and Rustum', such as Mount Elbruz, Bokhara, and the River Oxus.

They sent their manuscript to Arthur Ransome, who took it to his publisher and declared it to be 'this year's best children's

book'. The book has been reprinted many times and is still in print. The other books of the trilogy are *Escape to Persia* and *Oxus in Summer*.

THE ST IVES SCHOOL

St Ives has been an important art colony and an influence on British art for a hundred years. In 1883 James Whistler and William Sickert worked in the town, and after a number of sail lofts had undergone conversion, a group of painters began to use them as studios. Today St Ives and its bay continue to attract painters who find a profitable market among the summer tourists, and an excellent light in which to work.

However, St Ives is by no means just a haven for provincial painters: it has an international reputation in the arts that has been justly earned. Bernard Leach the potter made it his home, and the Japanese potter Haizi Hamada also spent several years in the town—two men who are probably the greatest potters of the 20th century.

In 1928 Ben Nicholson visited St Ives and for the first time met Alfred Wallis. Wallis, untrained and near illiterate, began painting when he was 70, and he used paints of any kind on almost any form of scrap material. He painted ships with a flat, childlike simplicity. For Nicholson it was an exciting experience, for he was employing techniques and ideas beyond the conventional. Wallis, who died in 1942, had lived in extreme poverty; Bernard Leach marked his grave with a plaque and the simple inscription 'Artist and Mariner'.

St Ives became the home of abstract art in Britain. Ben Nicholson's paintings have never been popular with the public at large, but they have received international acclaim in the art world.

Barbara Hepworth, Ben Nicholson's second wife, also worked here, her garden full of abstract sculpture. She liked to walk on the beach, searching for pebbles of interesting and meaningful shape; many of her sculptures suggest a curving shore line or a breaking wave. She died in a fire in 1975, and her home in the centre of St Ives is now a memorial museum.

A number of well-known painters continue to live and work in the area, although it may well be that the 'golden era' of St Ives as an artist community has now passed. Life has certainly changed, and the excellent folk museum shows how it used to be, when fishermen made model ships by using the breastbones of seabirds as hulls, and children's dolls were carved from broken oars.

RICHARD JEFFERIES

One of the foremost country writers of the 19th century, Richard Jefferies (1848–87) was probably the most sensitive and emotional. He was born in Wiltshire at Coate Farm near Swindon, and the surrounding landscape formed the basis for many of his country books as well as the evocative *Bevis* (1882) and *Wood Magic* (1881). These two books for boys are very far from being sentimental, and contain as well as the excitement, the poignancy and the discoveries of childhood. They demonstrate the realities of country life at that period. Fish, animals, and waterfowl were edible and there to be caught, and plants and fungi are investigated as food as well as for

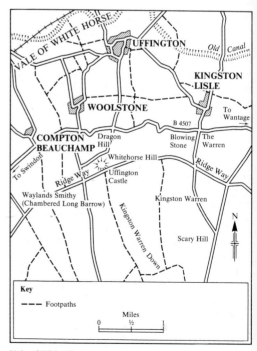

Vale of White Horse

Coate Farm, near Swindon, Wiltshire (*see* Jefferies)

their beauty. The centrepiece for so much of this activity is Coate Reservoir, the 'mere' that appears in several of Jefferies's books— including *The Gamekeeper at Home* (1878), *Round about a Great Estate* (1880), *The Amateur Poacher*, and, of course, *Bevis*—where Bevis and his friends played. Edward Thomas described this stretch of water as 'fish-shaped' with its tail turned towards Coate.

The landscape and the awareness it brings is never explored again with such intimacy as in childhood, and Richard Jefferies was never to forget the environment of his early years. As he describes in *Bevis* he

... felt with his soul out to the far-distant sun just as easily he could feel with his hand to the bunch of grass beside him; he felt with his soul down through into the earth just as easily as he could touch the sward with his fingers. Something seemed to come to him out of the sunshine and the grass.

The squirrel in *Wood Magic* confides to Bevis that elm trees are treacherous, and it had known one to '. . . fall down altogether when there was not a breath of wind, nor any lightning, just to kill a cow or a sheep, out of sheer bad temper . . .' Jefferies would have been interested to see how a century later the poet Ted Walker was to write:

> Elms are bad, sinister trees.
> Falling, one leaf too many,
> they kill small boys in summer,
> tipped over by a crow's foot,
> bored with the business of leaves.

Richard Jefferies felt a mystical union with nature, and its passion and power stream through his work. In *The Story of My Heart* (1883) he writes:

There were grass-grown tumuli on the hills to which of old I used to walk, sit down at the foot of them, and think. Some warrior had been interred there in the ante-historic times. The sun of the summer morning shone on the dome of the sward, and the air came softly up from the wheat below, and

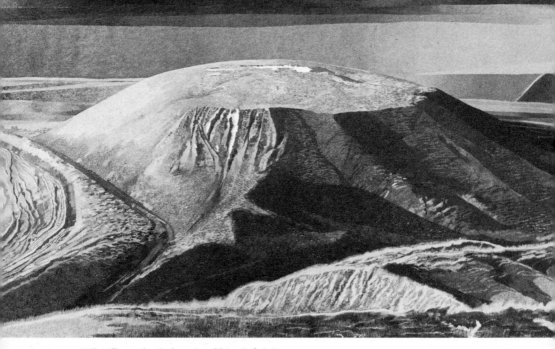

Dragon Hill, Uffington, by Graham Arnold (*see* Jefferies)

tips of grasses swayed as it passed sighing faintly, it ceased, and the bees hummed by to the thyme and heathbells. . . I felt at that moment that I was like the spirit of the man whose body was interred in the tumulus; I could understand and feel his existence the same as my own. He was as real to me two thousand years after interment as those I had seen in the body. The abstract personality of the dead seemed as existent as thought. As my thought could slip back the twenty centuries in a moment to the forest-days when he hurled the spear, or shot with the bow, hunting the deer, and could return again as swiftly to this moment, so his spirit could endure from then till now, and the time was nothing. . . Listening to the sighing of the grass I felt immortality as I felt the beauty of the summer morning, and I thought beyond immortality of other conditions, more beautiful than existence, higher than immortality. . . Two thousand times the woods grew green, and ring-doves built their nests. Day and night for two thousand years—light and shadow sweeping over the mould—two thousand years of labour by day and slumber by night. Mystery gleaming in the stars, pouring down in the sunshine, speaking in

the night, the wonders of the sun and of far space, for twenty centuries round about this low and green-grown dome. Yet all that mystery and wonder is nothing to the Thought that lies therein, to the spirit that I feel so close.

His landscape was full of mystery and the marks and mounds of early man. From the stone circles of Avebury, from Silbury Hill, the largest man-made mound in Europe, to his favourite walk to the ramparts of Liddington Hill, and on, eastwards, to Wayland's Smithy and Uffington Hill (see map p. 124).

Although he inherited from his parents the blood of Gloucestershire and Wiltshire farmers, Jefferies was never a farmer. He began work as a journalist on the staff of the *North Wilts Herald.* He spent twelve years doing newspaper work, and at the same time attempting to write novels. A turning point in his life came in 1872. He wrote a long letter to *The Times* about the farm labourers of Wiltshire. The letter was printed in full and to his astonishment Jefferies found himself acclaimed as an authority on agriculture. Five years later he moved to Sydenham, where he could keep in closer touch with the London editors. With the publication of *The Gamekeeper at*

Home, first seen in serial form in the *Pall Mall Gazette*, he was being spoken of in the same breath as Gilbert White of Selborne.

Jefferies's style of writing was a very personal one and easily recognized: 'Green rushes, long and thick, standing up above the end of the ditch, told the hour of the year as distinctly as the shadow on the dial the hour of the day.' So begins the opening sentence of *The Life in the Fields*.

Jefferies loved nature at first hand, but he also admired paintings of landscape, although many artists earned his disfavour. Richard Jefferies did not live in the past. He watched with keen interest the effect of steam ploughs and reaping machines on the land, and no doubt he saw a better life developing for the farm labourer. Yet so many Victorian painters continued to paint the landscape and gypsies of fifty years before: '. . . our sympathy is not with them,' said Jefferies, 'but with the things of our own time.'

Jefferies spent his last years in Sussex, and he felt at home in its downland. He enjoyed standing on Beachy Head and wrote: 'There is the sea below to bathe in, the air of the sky up hither to breathe, the sun to infuse the invisible magnetism of his beams. These are the three potent medicines of Nature, and they are medicines that by degrees strengthen not only the body but the unquiet mind.' This medicine, however, was not enough to defeat the wasting disease of his body. For six years he battled with tuberculosis. For a time he lived in Crowborough, then came the final move to a house called Sea View at Goring, near Worthing; he had only months to live. In the garden and in his bedroom, he dictated his last essays to his wife, which appeared after his death in the volume *Field and Hedgerow*. He was buried in Broadwater Cemetery where, thirty-five years later, the body of W. H. Hudson was also laid to rest.

A plaque on Jefferies's house in Jefferies Lane, Goring, proclaims him as 'Naturalist and Prose Poet of the Countryside'. There is a marble bust of Richard Jefferies in Salisbury Cathedral.

DAPHNE DU MAURIER

Through much of the work of Daphne du Maurier (born 1907) is threaded an abiding love of Cornwall, its coasts and its countryside. She is an author who has used her eye and imagination with great discernment. Her

Mawgan Creek on the Helford River, Cornwall (*see* Du Maurier)

Ivy Cottage, Coldharbour; Sun and Snow, by Lucien Pissarro

novels contain a compelling sense of place that in turn works upon the imagination of the reader. *Jamaica Inn* and *Rebecca* do precisely this, and so too does *Frenchman's Creek*.

'Frenchman's Creek' is a narrow inlet on the south bank of the Helford River, lying south of Falmouth, between Rosemullion Head and Nare Point. A road leads down to Helford Passage where the seeker of Frenchman's Creek will be ferried across the river.

'When the east wind blows up Helford river the shining waters become troubled and disturbed . . . and but for a few houses scattered here and there above Helford passage, and the group of bungalows about Port Navas, the river would be the same as it was in a century now forgotten. . .'

From Helford it is possible to walk westwards through National Trust land to Frenchman's Creek itself.

'The trees were thinning, she was coming to the bank—and there, suddenly before her for the first time, was the creek, still and soundless, shrouded by trees, hidden from the eyes of men.'

It is a creek where the heron and the curlew feed. At low tide it will turn to a trickle, but the walk through the woods is beautiful.

The Lizard is an area of Cornwall that makes excellent walking country, and it is easy to appreciate the passionate feelings of Daphne du Maurier for its landscape.

LUCIEN PISSARRO

The son of Camille Pissarro, Lucien (1863–1944) grew up among the celebrated Impressionists and Post-Impressionists; Monet, Cézanne, Signac, Seurat and Van Gogh were among his friends. His father encouraged him to draw and paint, while his mother did all she could to oppose any ideas of his becoming a professional artist.

In 1883 Lucien Pissarro came to London to learn English. He enjoyed visiting exhibitions

OPPOSITE ABOVE The Helford River, Cornwall
(*see* Du Maurier, p. 127)

OPPOSITE BELOW Durdle Door, Dorset
(*see* The Powys Brothers, p. 129)

and was enthralled by the collections of the British Museum. On his return to France the following year he became interested in wood engraving and the art of fine book production.

An introduction to John Gray, of the British Foreign Office, led to his meeting with Charles Ricketts and Charles Shannon, who first published his woodcuts. Lucien and his wife Esther founded the Eragny Press at Epping, near London, in 1894. They closed the press in 1914 having produced exquisite books which, astonishingly, did not attract the attention of collectors until the 1960s.

While Lucien Pissarro had no regard for the English Impressionists, he was becoming increasingly interested in the English landscape. His father warned him of submitting to Pre-Raphaelite tendencies. Then, in June 1916, Lucien became a British subject.

He painted the English landscape with care and accuracy. As with so many of the old masters he was particularly conscious of the changing seasons and the dramatic visual effects of English weather. The areas where he particularly enjoyed painting were Somerset, Devon, Dorset, Sussex, Surrey, and Westmorland (now part of Cumbria), Derbyshire and the Gower Peninsula in South Wales. His favourite location of all was at East Knoyle, Wiltshire, where he completed well over twenty canvases.

THE POWYS BROTHERS

The Reverend Charles Francis Powys was the father of eleven children. Of his six sons, three were to become recognized as representing one of the remarkable families in English literature. They were John Cowper Powys (1872–1963), Theodore Francis Powys (1875–1953), and Llewelyn Powys (1884–1939).

Other members of the family were also writers and together they published over a hundred volumes between 1896 and 1960. They grew up at Montacute Vicarage on the border of Somerset and Devon, and their landscape is very much that of the West

OPPOSITE ABOVE *Mallards coming in from the South*, 1979, by Peter Scott (*see* p. 130)

OPPOSITE BELOW Eggardon Hill, Dorset (*see* Young, p. 135)

Country and Wales. While John and Llewelyn travelled considerably, Theodore headed for the Dorset village of East Chaldon, once described as 'probably the most hidden village in the country'. Here he lived the life of a recluse while writing such allegorical novels as *Mr Weston's Good Wine* (1927). All three brothers were somewhat strange, egocentric and eccentric. John, the most prolific author among them, declared that he was 'the clever one of the family of trees', who had successfully studied to be a man. Among the best known of his books are the novels *Wolf Solent* (1929) and *A Glastonbury Romance* (1933). Llewelyn, who suffered from tuberculosis, also wrote beautifully; to appreciate his work *Skin for Skin* (1925) is an excellent book from which to begin.

John and Llewelyn were clearly far more gregarious than Theodore, who, when seeing someone approach his house, might well leave by a back window. His life and landscape were the cliffs and Dorset downs where he searched for God.

John was born in Derbyshire, where he described the Peak as 'like the boss of a shield'. Later in life he settled in North Wales, in Corwen, moving later to Blaenau Ffestiniog. While at school in Dorset he soon began to explore the countryside:

> . . . to this day I know the lanes and fields for miles round Sherborne better than I know the landscape of any other terrestial spot. Our favourite direction in the final issue was to what we used to call 'The Trent Lanes'. These were really a very singular phenomenon in that part of the country where Dorset and Somerset touched. They were quite a network of narrow grassy lanes between high hedges separating the Yeovil Road from the little village of Trent. It was from a woody eminence above this village that we used to be able to see the tree-topped summit of Montacute Hill. . .

I can well remember a particular treasure-trove of cider apples that we found on the grass by the edge of a lane not far from Marston Magna. Sherborne is really in a wonderful position as far as the romantic and fruit-bearing valleys of Wessex are concerned. On one hand it has the Black-

John Cowper Powys in about 1920

fifty feet, I looked round. There below me were the tracks I had made in the wet, red shingle. Above, the cliff flanked itself against the sky like a snow-covered alp. I began climbing again, and in a few minutes was once more clinging to the corroded iron stake. Only faintly now there came to my ears the monotonous ebb and flow of the sea, insistent and resonant as the respiration of some sleeping Cerne Giant.

A carved block of Portland stone near the cliff edge at White Nose marks the place where the ashes of Llewelyn Powys are buried.

PETER SCOTT

As a sailor, ornithologist, painter, glider pilot, writer and broadcaster, Peter Scott has a worldwide reputation. His love of wildfowl, and of geese in particular, has resulted in some of the best paintings of wildfowl in flight this century.

What is so interesting about this artist, is that he has done so much in his life and has done it all so well. He began exhibiting his work at the Royal Academy and at Ackermann's Galleries as long ago as 1933. The study of wildlife began as a child; indeed, it was his father, Scott of the Antarctic, who had written from his tent in Antarctica in March 1912: 'Make the boy interested in Natural History'. So much has come from that, including The Wildfowl Trust. During the Second World War years Peter Scott had contemplated the formation of a collection of wildfowl and the setting up of an educational and scientific research centre. Slimbridge, Gloucestershire, was the place eventually chosen; other possible locations had been considered in Scotland, High Halstow marshes in Kent, Amberley Wildbrooks in Sussex, and another in Westmorland.

more Vale, and on the other the beginning of the Great Somerset Plain that very soon becomes the fen-lands of Sedgemoor.

Another of our favourite walks was to the Corton Down, at the end of which is no less a place than the original site of the walls and towers of Camelot. This is unquestionably vouched for by the fact that the word Camel is used in those parts both for a stream and for the hamlets built along the stream; while at the foot of Cadbury Camp above Queen's Camel there is to this day a spring called Arthur's Well. We were always assured by local antiquaries that Arthur and his Knights were playing chess in the heart of Cadbury Hill until the Day of Judgment.

Llewelyn was ever attracted to the coastline, and one day he found, by noticing a rabbit disappear, an old smuggler's path that led him to a cove he had not visited before; after exploring the beach and a cave, he returned to the ascent:

I looked up. All was blue and white—white cliffs and blue sky, white surf and blue sea, white birds and blue, curling waves! I felt giddy. I could see the smuggler's stake sticking out of the precipice like a nail in a white-washed wall. When I had scaled some

ROBIN AND HEATHER TANNER

This gentle couple, pacifists and Quakers, and married for over 50 years, are observers in the tradition of Gilbert White, and admirers of the philosophy of William Morris. Between

WILTSHIRE VILLAGE

An oak gate and staple catch, with
great mullein growing near.

A gate "harr," with burdock growing near.

them they have written and illustrated two of the most beautiful and worthwhile books on the English countryside this century, *Wiltshire Village* published in 1939, and *Woodland Plants* published in 1981.

Wiltshire Village and *Woodland Plants* are illustrated with etchings and pen drawings from the hand of Robin Tanner, and Heather has written the texts. What makes their two volumes so remarkable is that they are entirely works of love made by two people who have cared about the English countryside and their fellow human beings all their lives.

They live in a house designed by an architect disciple of Voysey as a wedding gift. It has been described as a living museum of 1920s and 1930s craftsmanship. On moving into their new home they decided to have nothing in their house that was not hand-made—although for some items compromises had to be made!

Heather Tanner read English literature at King's College in the University of London; Robin was an art student contemporary of Graham Sutherland at Goldsmiths' College, and later an Inspector of Schools. The etchings

of Robin Tanner are highly detailed and pains-taking; his plant drawings sometimes take hundreds of hours to complete. He looks to Rembrandt and Samuel Palmer as his masters. 'It's always seemed to me that Rembrandt had more colour in his etchings than his paintings, in their black and white he says everything.'

In January 1940 he set out to draw the winter acomite and all the other plants as they appeared throughout the year. He then real-ized that a lifetime was not long enough; so he concentrated on the woodland plants.

Wiltshire Village is the story of Wiltshire and of so much of rural England. In their foreword to the book, Heather and Robin Tanner have written:

Kington Borel is not to be found on the map, for it is not any one village, but rather an epitome of some of the villages of North West Wiltshire. The book is to be regarded as fiction rather than as local history. . . Kington Borel has changed more in the last fifty years than in the five hundred before that; nor have all the changes been for the better. To call back yesterday would be

foolish even were it possible; but in order that what was noble in the yesterday that still lingers might not pass unhonoured and unlamented this book has been made.

The book is magical in its writing and illus-tration, capturing a landscape, its people, their crafts and their festivals like an enchanted lost world. Already these volumes are regarded as classics of the countryside. Future generations will look upon the life works of Robin and Heather Tanner with a sense of wonderment and gratitude.

HENRY WILLIAMSON

As the author of *Tarka the Otter*, Henry Williamson (1895–1977) is regarded by many as the greatest writer on wildlife that Britain has ever produced. His understanding of other people, however, was by no means so finely tuned. It was his experiences during World War I that marked him for the rest of his life, and he never lost his obsessive recall of the suffering and his sense of the futility of it all. It was a subject that could arise in the course of

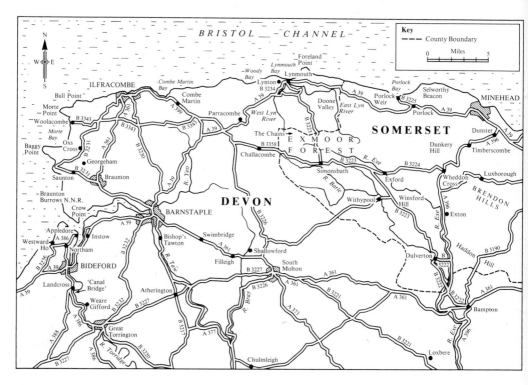

Woolacombe Bay towards Baggy Point (*see* Williamson)

almost any conversation with him. An underlying sense of sadness was in his character certainly, but Henry Williamson, always unpredictable, could be charming, lovable, a clown or a philosopher. Above all he loved the natural world of the English countryside and its creatures. The landscape that will for ever be associated with him is the seaboard from Porlock to Westward Ho, and what he described as 'the country of the two rivers' the Taw and the Torridge (*see* map opposite).

Following his demobilization in 1919, he read Richard Jefferies' *Story of My Heart*. It made a profound impression upon him and he remained a lifelong admirer of Jefferies and his work. Henry Williamson had first explored in Devon when he was 17, and he was eager to return there after his experience of war. He left London in 1921 to live in a cottage in the North Devon village of Georgeham; here he wrote *The Lone Swallows*, and *The Peregrine's Saga*. He named his dwelling Skirr

Cottage because of the sounds made in the roof by a pair of barn owls.

Williamson's earliest wanderings on Exmoor, Dartmoor and the coast between were continually retraced throughout the sixty years of his creative life. Perhaps the area of most influence, what he would have called his mainspring, is the high moorland at the source of the River Exe, known as The Chains. Here he first conceived his theory, personal to himself, that the earth of one's homeland provided the seeds of divine creativity. He always claimed ancestry from a family of Exmoor shepherds, and within the peat around The Chains was the 'ancient sunlight' of past existence and present inspiration through imagination. Here he would lie on summer days with his finger tips touching the grasses, just as Richard Jefferies had drawn strength from his native Wiltshire Downs.

Like an otter—and indeed Henry Williamson's portraits do remind us of an otter—he

133

Henry Williamson being sculpted by Anthony Gray

delighted in following streams. With Tarka in mind he travelled joyfully to the sea, especially to the estuary of the Rivers Taw and Torridge between Barnstaple and Bideford. Tarka was born in a hollow tree at the stone Canal Bridge near Weare Giffard between Torrington and Bideford. On the first page of Tarka, Williamson writes: 'Below Canal Bridge, on the right bank, grew twelve great trees, with roots awash.' And of Tarka's mother: '. . . seeking old dry grasses and moss. . . She returned to the river bank and swam with her webbed hindfeet to the oak tree, climbed to the barky lip of the holt, and crawled within.' Of Tarka himself: 'The eldest and biggest of the litter was a dog-cub, and when he drew his first breath he was less than five inches long. . . His fur was soft and grey as the buds on the willow before they open at Eastertide. He was called Tarka,

which was the name given to otters many years ago by men dwelling in hut-circles on the moor. It means Little Water Wanderer, or, Wandering as Water.'

Tarka died a mile downstream from the place of his birth, near the village of Landcross. Many of the place names mentioned in *Tarka the Otter* appear on the Ordnance Survey maps of the area.

Tarka the Otter was written at the Upper House, thirty yards away from Skirr Cottage in Georgcham. Almost daily Henry Williamson would take a walk, particularly to Baggy Point, a promontory to the west; also to Braunton Burrows (called The Great Plain in *The Pathway*) which is now a National Nature Reserve. The most significant area of the Burrows is undoubtedly Crow Point, the sandy peninsula opposite Instow and Appledore. It was here that much of *Tarka the Otter*

and *Salar the Salmon* were planned; and it is where Willie Maddison was drowned in *The Pathway*.

Tarka the Otter brought Henry Williamson the Hawthornden Prize in 1928 and he used it to buy a small field one mile north of Georgeham called Ox's Cross, marked by a spinney of beech trees. In the two writing huts he built in this field he wrote *Salar the Salmon* in 1936; his research for this book was done in and along the River Bray at his house at Shallowford near Filleigh.

After the Second World War he wrote all the novels of his 'Chronicle of Ancient Sunlight' at Ox's Cross or at his small house in Ilfracombe (4 Capstone Place).

A feature film of *Tarka the Otter* was made by Rank Studios on location in North Devon. On the day that Henry Williamson died, 13 August 1977, the death scene between Tarka and the otterhound Deadlock had just been completed. Henry Williamson is buried at Georgeham.

All of Williamson's country books are the product of what he termed his '. . . ambition to bring the sight of water, tree, fish, sky and other life onto paper.' It was an ambition amply fulfilled.

SEE ALSO PAGE 109

ANDREW YOUNG

There has been much written of Andrew Young (1885–1971) in recent years. It is not surprising, for he is among the finest Scottish poets of the century. He was a priest, poet, topographer, and naturalist, excelling in every discipline.

Andrew Young published his first poems in 1910, a very slim volume, *Songs of Night*. The book was paid for by his father, and a reviewer described the young poet as having 'admirable powers of imagery and an enviable delicacy of expression'. Between 1920 and 1931, the bookseller J. G. Wilson published six more titles in very small editions, but Andrew Young did not become widely known until the Nonesuch Press produced the beautiful *Winter Harvest* in 1933, and a 'new' poet was firmly established.

After taking his degree at Edinburgh University he went on to be ordained as a minister of the United Free Church of Scotland. Later, in 1939, he was ordained in the Church of England.

He was always a fit man, well able to walk all day or climb a mountain. Andrew Young loved wild flowers and looked for them all over Britain:

THE BEE-ORCHIS

I saw a bee, I saw a flower;
I looked again and said, For sure
Never was flower, never was bee
Locked in such immobility.

The loud bees lurched about the hill,
But this flower buried bee was still;
I said, O Love, has love the power
To change a bee into a flower.

Young's knowledge of places was astonishing, his memory of them refreshing. All his books are full of insights and illuminations, both his poetry and prose surprise and continue to do so after many readings. Thomas Hardy was his favourite poet, but he delighted in the poems of Edward Thomas (see p. 176) and John Clare (see p. 78).

Andrew Young liked landscapes that bore marks of early man, and he wrote several poems on the subject. One late spring he was walking in Dorset and came upon:

A PREHISTORIC CAMP

It was the time of year
Pale lambs leap with thick leggings on
Over small hills that are not there,
That I climbed Eggardon.

The hedgerows still were bare,
None ever knew so late a year;
Birds built their nests in the open air,
Love conquering their fear.

But there on the hill crest,
Where only larks or stars look down,
Earthworks exposed a vaster nest,
Its race of men long flown.

Eggardon Hill lies north of the A35, a few miles from Bridport, and part of Hardy country. Hardy calls Eggardon either Haggardon Hill or Norcombe.

South East

Stretching westwards from Kent to Hampshire's border with Dorset is a landscape as lush and richly wooded as any in the British Isles. Yet this is commuter country, heavily populated, and frequently treated with disdain by the connoisseurs of more rugged terrains. The South East, however, has much to offer. The Downlands of Hampshire, Sussex and Surrey have a quality that is unsurpassed: a springiness of turf and sufficient elevation from the hills to cause you to feel you are looking down upon the earth; and when the wind comes off the Channel you may smell the sea from many miles away.

Much of the coastal scenery of this area has now gone. Unrestricted building before the Planning Acts, destroyed much of it. The good things, like Beachy Head and the Seven Sisters, Romney Marsh and the harbours of the Solent, survive in precious pockets and are under pressure because of their small scale.

The Weald of Kent and Sussex is the broad shallow valley that runs between the North and South Downs. In Anglo-Saxon times it was the great forest of Anderida, and formed a giant barrier to any travel overland north or south, a forest where wolves and wild boar roamed, and it inhibited the development of Christianity in the south. Many patches of ancient oakwoods remain, but vast quantities of timber were cut from the 15th century onwards to make charcoal. Many old furnace ponds lie limpid in the Weald, and it is interesting to remember that heavy industry first began in the South East.

It is also important to remember the range of chalk plants that grow here and the butterflies that feed upon them. Once again, orchids and prehistoric long barrows have disappeared due to ploughing high on the Downs during the Second World War, and no regrets can reinstate them.

Wild fallow and roe deer abound in the South East. One of the reasons is that so many great estates have remained intact to give continuity and unity to the countryside, an important factor in landscape, good farming and conservation; but such familiar things are all too often taken very much for granted.

In Hampshire, the most-visited landscape is the New Forest, once hunted by William the Conqueror. It is also the landscape where Lewis Carroll (the Reverend Charles Dodgson) walked and talked with Alice Liddell, and composed *Alice's Adventures in Wonderland*. The grave of Alice, later Mrs Reginald Hargreaves, is to be found in the churchyard at Lyndhurst. The forest was also the setting for Frederick Marryat's well-known story *The Children of the New Forest*, published in 1842.

The ever-growing commuter population of the South East has had one particularly bad effect: the loss of the slow, rich dialects once spoken here. No doubt there are still many whose dialect betrays their origin, but the use of regional dialect words sadly grows less with the passage of years.

✹⊙⊂✺⊷✹⊙⊂✺

JANE AUSTEN AND THE COUNTRYSIDE

Jane Austen (1775–1817) was born in Steventon Rectory, near Basingstoke, Hampshire, where her father was rector of the parishes of Deane and Steventon. She lived at Steventon for twenty-five years. The rectory has long been demolished, but the novelist and her early life in the village is commemorated by a tablet in the church.

At the village of Chawton, just south of Alton, also in Hampshire, is the cottage where she completed the final versions of her six novels. The Jane Austen Memorial Trust now cares for the property and its contents.

Jane Austen grew up in a period when the appreciation of landscape as seen through the eyes of the Romantic poets was still comparatively new. Descriptions of scenery occur in all her novels but none to greater effect than in *Sense and Sensibility*, published in 1811. Here Elinor has spoken to Marianne of 'dead leaves'.

'Oh!' cried Marianne, 'with what transporting sensations have I formerly seen them fall!

Box Hill, Surrey (*see* Jane Austen)

How have I delighted as I walked to see them driven in showers about me by the wind! What feelings have they, the season, the air, altogether inspired!'

Elinor continued to see dead leaves rather than the wine colours of autumn. Edward Ferrars declared that he had no knowledge of the picturesque:

'I shall call hills steep which ought to be bold; surfaces strange and uncouth which ought to be irregular and rugged; and distant objects out of sight which ought to be indistinct through the soft medium of a hazy atmosphere. You must be satisfied with such admiration as I can honestly give...'

Elinor suspected that Edward Ferrars believed that, 'many people pretend to more admiration of the beauties of nature than they really feel.

Jane Austen, gentle and sensitive, found great joy in landscape. Box Hill, near Dorking, Surrey, particularly fired her imagination, with its mass of trees and magnificent views over the Weald. The hill is now cared for by the National Trust. When Robert Bloomfield came here in 1803 it was the highest ground he had ever seen.

Jane Austen visited the area to see her cousin, who lived at the nearby village of Great Bookham. Box Hill plays its part in her novel *Emma*: 'We are going to Box Hill tomorrow: you will join us. It is not Swisserland, but it will be something for a young man so much in want of a change.'

As readers of *Emma* will know, the picnic on Box Hill was a disaster, but the writing of it must have given Jane Austen much pleasure as she recalled the hill and its picturesque view.

HILAIRE BELLOC

Born of an English mother and a French father, Hilaire Belloc (1870–1953) is the greatest literary champion of Sussex. He loved what he called the South Country, and extolled its virtues in exuberant prose and verse.

Although a much-travelled man, it was in West Sussex that Belloc felt himself to be most at home. As he wrote in *The Four Men*: 'if I can get back to that country that lies between Lavant and Rother and Arun, I will live there as gratefully as though I were the fruit of it, and die there as easily as a fruit falls, and be buried in it and mix with it forever, and leave myself and all I had to it for an inheritance.' It is this land that is crossed by Stane Street, the Roman road running from London to Chichester, and it was part of that old road that Belloc once described as 'Britain's most lovely walk'. He wrote:

> It is very difficult to choose, but I think on the whole the most remarkable eight miles I know, which can only be seen by walking or riding, were those on the Stane Street, from near Eartham in Sussex to Hardham. Since the Nore Wood was cut down in the war [1914–18] only the last part of it from Gumber corner onwards preserves the old character. If this destruction has too much spoilt those eight miles, then my next choice would be the walk from Burpham, close by, over the Downs to Storrington by way of Parham House.

The author can testify that both walks are still magnificent, but the section of original Roman road, with its high trackways and side ditches, leading to the early mosaics at the Roman villa at Bignor, should not be missed. The road is easily followed through open and wooded country by using the Chichester sheet of the Ordnance Survey map. If possible read Belloc's 'Sussex' first. The enthusiast for archaeology would do well to read his monograph *Stane Street* written in 1912.

Belloc's homes in Sussex were the Dower House, Slindon, where he spent much of his childhood; Court Hill Farm, Slindon, where he lived after his marriage; and at the rambling old house known as Kings Land, at Shipley near Horsham, where he and his wife lived for the rest of their lives. Close by is a superb example of a Sussex windmill. It was restored as a memorial to him. Above its entrance a stone plaque reads 'Let this be a memorial to Hilaire Belloc who garnered a harvest of wisdom and sympathy for young and old.'

WILLIAM BLAKE

Painter, poet and mystic are descriptions that could all be applied to William Blake (1757–1827). He came to live in the seaside village of Felpham, near Bognor Regis in Sussex, in 1800. The sculptor John Flaxman had introduced Blake to William Hayley, who was squire of the village, a poet in his own right, and an important patron of Blake.

The Blakes established themselves in a thatched cottage which they rented from the landlord of the Fox Inn for £20 a year. This was the first real excursion that Blake, a Londoner, had ever made into the countryside. They were charmed by both cottage and village, Blake wrote: 'Felpham is a sweet place for Study, because it is more spiritual than London. Heaven opens here on all sides her Golden Gates; her windows are not obstructed by vapours; voices of Celestial inhabitants are more distinctly heard, & their forms more distinctly seen; & my cottage is also a shadow of their houses.'

It was in the garden of this cottage that Blake watched a fairy funeral! He also saw the open sea here for the first time, which inspired the famous watercolour drawing 'The Spirit of God moves upon the Face of the Waters'. He walked the seashore at Felpham in communion with the poets of the past, describing them as 'majestic shadows, gray but luminous, and superior to the common height of men'.

All Blake's work at this time shows an awareness of nature not seen before in his earlier writing. A charge of sedition in 1804, following a dispute with a soldier at the Fox Inn, soured his view of Felpham and he returned to London.

Today, the village of Felpham is obviously much changed and has lost its rural atmosphere. Even so, Blake's cottage and garden remain, so too does the Fox Inn, the village church and, of course, the seashore itself, where Blake once communed with ghosts.

Blake's Cottage at Felpham.

William Blake's cottage at Felpham, Sussex, by James Guthrie

BLOOMSBURY IN SUSSEX

Charleston is a remote 18th-century farm-house in the Sussex Downs, it was first 'dis-covered' by Virginia Woolf who decided to rent the property from the estate of Lord Gage. For many years it was the home of the painters Duncan Grant (1885–1978) and Vanessa Bell (1879–1961). There were other residents and many visitors, Roger Fry, Leonard and Virginia Woolf, Lytton Strachey and David Garnett among them. In an upstairs room John Maynard Keynes wrote *The Economic Consequences of the Peace*, and Clive Bell wrote *Civilization* (1928). The house is certainly what the writer and artist Quentin Bell describes as '. . . a local habitation of genius and of talent, a theatre of intellectual activity in the first part of our century. . .' Yet that is only part of the story. Charleston has been enriched by

Duncan Grant and Vanessa Bell with all manner of decorative effects that have turned the house into a unique setting that is itself now part of our history.

Charleston was a focal point for the 'Blooms-bury Group'. The interior is embellished with colour and the furniture of Bloomsbury, doors and fireplaces painted with murals, colourful mosaics, pottery and textiles, and richly stencilled wallpapers. The future of this farmhouse and its treasures has now been secured by public contributions.

The surrounding Downland landscape had a vital role to play in the development of Charleston. Duncan Grant became better acquainted with Sussex when during the First World War he worked on farms in the area. Vanessa Bell and Duncan Grant were devoted to Charleston and its environs, and many

Sussex Landscape, 1920, by Duncan Grant (*see* Bloomsbury in Sussex)

people feel Grant's Sussex paintings to be among his finest work.

Both painters were intent on capturing lasting images of the rural world about them which was not only slowly changing, but in some respects disappearing.

WINSTON CHURCHILL

It is astounding to realize that Winston Churchill (1874–1965), a man who achieved such high distinction as a soldier, statesman, and war leader, also won the Nobel Prize for Literature in 1953 and was a highly talented amateur painter. Churchill's feeling for language was founded in his love of the works of Gibbon, Macaulay, Shakespeare and, not least, of the King James Bible. From this background he developed an individual style and vocabulary that was to make his oratory and writing unique. His magnificent phrases rang out like bells; before and during the Second World War his words resounded in their response to the menace of Hitler, and echoed in defiance of tyranny throughout the world.

Such powerful gifts alone might well have been sufficient for the Nobel Prize, but his published works also make a formidable list. Churchill was not one of the great historians, but his sense of history was majestic. His biography of his father, *Lord Randolph Churchill*, and his six-volume *Marlborough, his Life and Times* are very fine works indeed. Such early books as *The Malakand Field Force*, *My Early Life* and *My African Journey* are excellent narratives of travel and adventure. His one novel, *Savrola*, was not successful, nor was his single short story 'Man Overboard', published at the beginning of the century. Apart from these books he wrote hundreds of articles for newspapers and magazines.

Much of his literary output was written at Chartwell, in the heart of the Kent countryside. Churchill bought Chartwell and its 79 acres in 1922. This great house, of which he once remarked, 'Time away from Chartwell is time wasted', is owned by the National Trust and is a Churchill memorial. *The World Crisis*, *The Second World War* and *A History of the English-speaking Peoples* were all written in his study, one of the most fascinating rooms of an extraordinary house.

Churchill did not take up painting until middle age, following his resignation from the

The Terrace, 1912, by Roger Fry (*see* Bloomsbury in Sussex)

Admiralty in 1915. As he so graphically described the change from hyperactivity to unwonted leisure, he was 'Like a sea beast . . . or a diver too suddenly hoisted, my veins threatened to burst from the fall in pressure.' It was painting that came to his rescue, and he relaxed as the new experience of applying paint to canvas began to reveal itself.

The treatment of his subject matter is always bold, the technique good and, because of his excellent eye for a picture, his sense of composition is fine. As a result there is frequently a professional level of accomplishment to the work of this amateur.

Churchill produced nearly 400 finished paintings, and they now attract worldwide interest. His love of the countryside had developed from boyhood, and he enjoyed riding until well into his seventies. Chartwell is perfectly situated for a landscape painter. From the house the view sweeps down the valley and out into the wooded Weald of Kent beyond. In 1947 two of his paintings were chosen by the selection committee for the Royal Academy Summer Exhibition. They had been entered under the name 'David Winter', and it was not until the pictures were hung that Churchill revealed his identity. His work tends to be mostly landscapes full of sunlight; he also revelled in painting water.

Augustus John wrote of Churchill, 'I am staggered by his adventure into painting which he tackles with the same gusto and fearlessness we have learned to expect in his other activities. This never fails him.'

CHARLES DARWIN

Down House, in the village of Downe, Kent, was the home of Charles Darwin (1809–82) from 1842 until his death. Today, the house and garden must rank high among the more

The Lake at Chartwell, c. 1950, by Winston Churchill

interesting and exciting places to visit in the world. Here is Darwin set in his English landscape, where he read and re-read his notes on the fossils, geology, plants, and all manner of living creatures, made during his celebrated five-year voyage aboard HMS *Beagle*. Here he distilled his thoughts and clarified the scientific information he had so meticulously gathered, into the development of his evolutionary theories. The result of publishing *On the Origin of Species by Means of Natural Selection* in 1859 was an earthquake that shook the world of science and rattled Church and State to their foundations. The first edition of 1250 copies was sold out on the day of publication.

Darwin's writings are extraordinary in both range and observation. He not only wrote of his voyage, but also of *Barnacles, Coral Reefs,*

The Geology of South America, The Volcanic Islands, Fertilization of Orchids, The Descent of Man, Movements and Habits of Climbing Plants, The Formation of Vegetable Mould through the Action of Worms—and these works form only part of his output.

Charles Darwin was the son of Robert Waring Darwin, a medical practitioner in Shrewsbury. His mother was Susannah, eldest daughter of Josiah Wedgwood who founded the great Staffordshire pottery firm that flourishes still at Barlaston near Stoke-on-Trent. Dr Darwin was opposed to his son accepting an appointment on HMS *Beagle*, but he did promise: 'If you can find any man of common sense who advises you to go I will give my consent.' The words proved to be the key to Charles Darwin's future, for his uncle,

the younger Josiah Wedgwood, supported Darwin in the enterprise and his father's permission was duly given.

Soon after Darwin's return he married his cousin Emma Wedgwood. For a time they lived in London, but Darwin was no longer the outgoing, robust young man who had left Plymouth in 1831. Now they searched for a house in the country, a place of quiet in which to think and write. His health had become, and was to remain, delicate. He began to go bald, suffered palpitations, vomiting, insomnia and exhaustion. The once carefree young man had begun to age, and it was clear that the mass of work that lay ahead of him became a heavy weight to bear.

Finding Down House was just what he needed. Darwin had always loved the countryside, and in a letter to his sister he wrote:

On the road to the village, on a fine day the scenery is absolutely beautiful: from close to our house the view is very distant and rather beautiful, but the house being situated on a rather high table-land has somewhat of a desolate air. . . The charm of the place to me is that almost every field is intersected (as also is ours) by one or more footpaths. I never saw so many walks in any other county. The country is extraordinarily rural and quiet with narrow lanes and high hedges and hardly any ruts. It is really surprising to think that London is only 16 miles off.

Of the village itself, he commented: 'Village about forty houses with old walnut trees in the middle where stands an old flint church and the lanes meet. Inhabitants very respectable. . . There are butcher and baker and post-office. A carrier goes weekly to London and takes anything anywhere.' He was also pleased with the trees in his garden: '. . . there are some old (very productive) cherry trees, walnut trees, yew, Spanish chestnut, pear, old larch, Scotch fir and silver fir and old mulberry trees, which make rather a pretty group. They give the ground an old look. . .'

Emma at first found the countryside 'desolate'. Charles, however, declared: 'I think all chalk countries do, but I am used to Cambridgeshire, which is ten times worse.'

Down House itself was bought by Charles Darwin for £2020, money that was advanced

Down House, Downe, Kent (*see* Darwin)

The Sandwalk (*see* Darwin)

to him by his father. When the family moved in they began at once to make it more secluded by having the lane that passed the property lowered! A bow window was added to the dining room, and later came the addition of the veranda. One room that particularly attracted Darwin was the '. . . capital study 18 × 18'. The improvements they made were vital, for the first impressions had not been good 'House ugly, looks neither old nor new; walls two feet thick; windows rather small. . .'

In the garden he planted trees and flowering shrubs, made a new vegetable garden, and created a feature vital to him, which he called his 'thinking path'. This now famous Sandwalk, so called because he covered it with sand from a nearby sandpit, was where he took his daily exercise; he kept a pile of stones at the path's edge and kicked one to the side each time he passed.

The local birds and insects never failed to interest him, and he followed closely the fortunes of his hay crop. In 1847 *Bagshaw's Directory* listed him under 'Householders in Downe' and described him as 'Darwin, Charles, Farmer'. No doubt he was delighted at being so described.

When the storm broke with the publication of *The Origin of Species*, Charles Darwin was indeed fortunate in his friends and champions T. H. Huxley, Charles Lyell and Sir Joseph Hooker.

In 1970 Sir Julian Huxley, T. H. Huxley's grandson, published his first volume of *Memories* in which he describes the international gathering of 1909 to celebrate at Cambridge the centenary of Charles Darwin's birth:

I thought of my grandfather defending Darwin against Bishop Wilberforce, of the slow acceptance of Darwin's views in face of religious prejudice, and realized more fully than ever that Darwin's theory of evolution by natural selection had emerged as one of the great liberating concepts of science, freeing man from cramping myths and dogma, achieving for life the same sort of illuminating synthesis that Newton had provided for inanimate nature.

OPPOSITE ABOVE View of the grounds at Chartwell (*see* Churchill, p. 140)

OPPOSITE BELOW Wild daffodils in the wood behind Brinkwells, Sussex (*see* Elgar, p. 146)

It proved to be an inspiration that remained with Huxley all his life.

Sir Julian's proposal of the establishment of the International Union for the Conservation of Nature inspired Ecuador, which owns the Galapagos Islands, to make them a national park. Huxley's grandfather and Charles Darwin could not have been better served. Britain showered no great honours upon Darwin—he had scarred the Establishment far too deeply. As T. H. Huxley remarked in his obituary in the journal *Nature*, Darwin was '. . . ignored in life by the official representatives of the Kingdom, but laid in death among his peers in Westminster Abbey by the will of the intelligence of the Nation.'

Down House, administered today by the Royal College of Surgeons, was bought in 1929 with money provided by Sir George Buckstone Browne. The house has been carefully restored and contains many interesting pictures, relics from Darwin's voyage, furniture and manuscripts. It is the house and landscape of a great man who cared for life in all its forms, and particularly homo sapiens blessed with open minds.

CHARLES DICKENS AND GAD'S HILL COUNTRY

Kent was the county that Charles Dickens (1812–70) loved, and in particular the city of Rochester, the old Dover Road and the flat marshes that bound the Medway. His father had taken him to Chatham as a child and it was then that he first saw a house named Gad's Hill, and he was never to forget it. He once said, 'I have many happy recollections connected with Kent, and am scarcely less interested in it than if I had been a Kentish man bred and born.'

The childhood glimpse of Gad's Hill reappeared later in one of Dickens's pieces in his *The Uncommercial Traveller* series. In it the following dialogue takes place:

'You admire that house?' said I.
'Bless you, sir!' said the very queer small boy, 'when I was not more than half as old

OPPOSITE ABOVE Cooling churchyard (*see* Dickens)

OPPOSITE BELOW The marshes near Cooling (*see* Dickens)

as nine it used to be a treat for me to be brought to look at it. And ever since I can recollect my father, seeing me so fond of it, has often said to me: "If you were to be very persevering, and were to work hard, you might some day come to live in it," though that's impossible said the very queer small boy, drawing a low breath.'

Dickens selected the village of Chalk, near Gravesend, for his honeymoon, and he wrote some of the early pages of *The Pickwick Papers* there. He liked to stroll to Chalk Church, and also to visit the village of Shorne, which was in his mind when he referred in *Pickwick* to '. . . one of the most peaceful and secluded churchyards in Kent, where wild flowers mingle with the grass, and the soft landscape around forms the fairest spot in the garden of England.'

The seven-mile walk from Maidstone to Rochester Dickens considered 'one of the most beautiful walks in England'. Another joy was to visit Blue Bell Hill. From here it was possible to see wide views and hamlets and hop gardens, orchards and cornfields, with the River Medway wandering off to Rochester.

The ancient city of Rochester, with the exception of London, is a location that occurs more frequently and in more depth than any other place in Dickens's work.

The village of Cooling, once a very bleak area indeed, held a compelling fascination for Dickens. It was here that he obtained the atmosphere for *Great Expectations*. It was here in that desolate setting that young Pip had his first terrifying confrontation with the escaped convict who pounced upon him in Cooling churchyard.

Pip described the neighbourhood in which he lived with Mr and Mrs Joe Gargery:

Ours was the marsh country, down by the river, within, as the river wound, twenty miles from the sea. My first most vivid and broad impression of the identity of things seems to me to have been gained on a memorable raw afternoon towards evening. At such a time I found out for certain that this bleak place overgrown with nettles was the churchyard, and that Philip Pirrip, late of this parish, and also Georgina, wife of the above, were dead and buried; and

that Alexander, Bartholomew, Abraham, Tobias, and Roger, infant children of the aforesaid, were also dead and buried; and that the dark, flat wilderness beyond the churchyard, intersected with dykes, and mounds, and gates, with scattered cattle feeding on it, was the marshes; and that the low leaden line beyond was the river; and that the distant savage lair, from which the wind was rushing, was the sea; and that the small bundle of shivers growing afraid of it all, and beginning to cry, was Pip.

The marshes, were just a long black horizontal line then . . . and the river was just another horizontal line, not nearly so broad nor yet so black; and the sky was just a row of long angry red lines and dense black lines intermixed. On the edge of the river I could faintly make out the only two black things in all the prospect that seemed to be standing upright. One of these was the beacon by which the sailors steered—like an unhooped cask upon a pole—an ugly thing when you were near it; the other a gibbet, with some chains hanging to it which once held a pirate.

A row of strangely shaped gravestones in Cooling churchyard suggested to Dickens the 'five little stone lozenges' where the five little brothers of Pip lay buried.

In 1856 Gad's Hill Place came on to the market and Charles Dickens bought it for £1790. He lived at Gad's Hill for the rest of his life. The small boy had clearly persevered!

EDWARD ELGAR

Elgar will always be associated with the landscapes of Worcestershire and Herefordshire, where he lived for most of his life (see main entry, page 79); but an interlude of four years in Sussex resulted in his last and perhaps internationally best-known major work, the Cello Concerto.

As the First World War progressed, so Elgar had increasingly felt despair and disillusionment. Here was the horror of war and his growing realization that life in Britain as he had known it before 1914 was gone and would never be the same again. His state of mind at this time is illustrated by a line from a letter he wrote in 1917: 'Everything good and nice and clean and fresh and sweet is far away— never to return.'

It was at this most critical period of Elgar's life, in terms of both health and creativity, that the great composer discovered Sussex. Sir Sydney Colvin had suggested that he should visit the county, and it was there that Elgar met the landscape painter Vicat Cole. Cole was then living at Brinkwells, a humble thatched cottage tucked away in the hamlet of Bedham, near Fittleworth in the Sussex Weald. Elgar recognized and loved the simplicity of Brinkwells from the moment he saw it, and to his delight Vicat Cole leased the cottage to him.

Here in 1917, among the deep woodlands and with the South Downs stretching around him, Elgar rapidly found new mental stimulation and regained physical vigour. He revelled in the isolation of his new-found home. The tree shapes and the natural sounds of the surrounding countryside excited Elgar beyond bounds; inspiration for composition came flooding again through his imagination. The final years of war were among the most creative of his life. Lady Elgar noted in her diary: 'wonderful new music, real wood sounds and other laments which should be in a war symphony.'

Brinkwells is a private home and is not open to the public, but Elgar's music is not confined by four walls. Visitors to this part of Sussex will find the spirit of it in the woodlands that stretch from Brinkwells to Flexham Park.

Lady Elgar had reservations about life at Brinkwells. There was no sanitation, water had to be pumped by hand and cooking was done on a paraffin stove. In the evenings they listened to records together, played on a tall wind-up cabinet gramophone.

As well as the Cello Concerto, Elgar also completed three chamber works here, a violin sonata, a string quartet and a piano quintet, music that was far removed from his 'Pomp and Circumstance'.

Brinkwells, Sussex (*see* Elgar)

E. M. FORSTER

Edward Morgan Forster (1879–1970) is one of the most important novelists of the 20th century. He was a man of great intellect, who might better be described as a sage. His imaginative gifts brought elements of surprise and insight to the five novels he published: *Where Angels Fear to Tread*, *The Longest Journey*, *A Room with a View*, *Howards End*, and *A Passage to India*. The first four titles were written between 1905 and 1910; *A Passage to India* made its appearance fourteen years later.

The novels have a great sense of place, outstanding among them being *Howards End*, which was based on Forster's first home, Rooks Nest House, near Stevenage in Hertfordshire. It is a listed building in an agricultural landscape where building development might well bring a change in its character.

From 1902 to 1945 Forster lived in a house called West Hackhurst, at Abinger Hammer, a village near Dorking, Surrey. In 1936 he made a collection of essays, broadcast talks, and reviews, and published them under the title of *Abinger Harvest*. Near the house is Piney Copse, which Forster called 'My Wood'. The American royalties from *A Passage to India* enabled him to buy the wood, which gave him great pleasure. In his will Forster bequeathed these woodlands to the National Trust.

Forster was also involved in the writing of an Abinger Pageant, for which Ralph Vaughan Williams wrote the music. Later, in 1937, the two men again collaborated in the preparation of a pageant for the Dorking and Leith Hill Preservation Society; they were passionately opposed to the ribbon development that was damaging so much of the Surrey countryside.

Benjamin Britten described Forster as 'our most musical novelist', and, of course, Forster worked on the libretto of *Billy Budd* with Britten and Eric Crozier.

JOHN GALSWORTHY

It was during a November game of croquet on the lawn of Bury House that John Galsworthy (1867–1933) received the news that he had been awarded the Nobel Prize for Literature for 1932. Such a setting could hardly have been more fitting. Galsworthy was undoubtedly a gentleman writer, pleased to find himself so honoured, but to whom the cash prize meant little. He was the first president of the international society of writers known as the PEN Club, and he used the award to establish a trust fund in its favour.

Galsworthy will be remembered most of all as the creator of the great sequence of novels, beginning with *The Man of Property*, that was to become known as *The Forsyte Saga*. No one could have been better equipped than Galsworthy to write of the Forsytes; he would have known such people and, like them, was one of the upper middle class. With his books and plays, and years later through the medium of television, Galsworthy reflected British society of his period to the world.

In 1926 Galsworthy began looking for a home in Sussex. He had suggested buying a house in which he and his wife, Ada, might live, with his nephew and his wife occupying the rest of the property. Eventually he found a large stone manor house, built in 1910, in the village of Bury. The asking price was £9000 and Galsworthy completed the purchase without delay.

Bury House is magnificently situated at the foot of Bury Hill. To the east the River Arun follows the valley through the chalk hills of the South Downs. The hills overlooking Bury Galsworthy described as 'clean swept, even spiritual'; each night at about 11 o'clock he would stand and stare at their high silhouette before retiring to bed. He was an active man with a keen eye for landscape: after all, Soames Forsyte enjoyed the scenery around Arundel, a few miles from Bury. Each day Galsworthy allowed at least two hours for riding and walking, usually with a dog. His nephew, R. H. Sauter, has described the daily ride as:

> . . . his mad wild run across country, and canter on the Downs, jogging his liver and clearing his mind for the mornings work. . . Walking his horse beneath the dappled, flickering light of the beechwood, he would become so much as one with beast and tree, and air and sun and shadow, moving, as it were, in a world remote, that a mood of ecstasy, very nearly approaching religious exaltation, would come over his face. And so, reluctantly, with few words, over the clean, smooth, lark infested edge of the Down, which hung above the marvellous view of Amberley Wildbrooks which he so loved, we would descend once more by sunken ways to the more prosaic business of the day.

He became the unofficial 'squire' of the village, buying all the cottages he could obtain, installing bathrooms and other amenities and then, instead of raising the rents, he reduced them. When he doubled the wages of his five gardeners he annoyed all other landowners throughout the county!

Today Bury House is owned by the West Sussex County Council and is used as a home for elderly people, but Bury itself has changed very little since Galsworthy's day. Towards the end of his life he wrote a poem entitled 'Scatter My Ashes' it finishes:

> *Scatter my ashes!*
> *Hereby I make it a trust;*
> *I in no grave be confined,*
> *Mingle my dust with the dust,*
> *Give me in fee to the wind!*
> *Scatter my ashes!*

On 28 March 1933, his wishes were carried out on Bury Hill, well away from the road. This is undoubtedly the place John Galsworthy came to love most.

KENNETH GRAHAME

In many ways Kenneth Grahame (1859–1932) is at first sight an unlikely personality to have conceived and written one of the very best books for children and one that adults also love. *The Wind in the Willows* is a magical volume—and it came from the pen of the Secretary of the Bank of England!

He very nearly did not write the book: he came near to death from pneumonia in 1899,

Bury House (*see* Galsworthy)

and in 1903 he was wounded by a lunatic's revolver shot.

Kenneth Grahame was a Scot, descended from Robert the Bruce, and from the age of 20 began to show an interest in writing. He was encouraged by W. E. Henley, Robert Louis Stevenson's friend and collaborator. *Pagan Papers*, Grahame's first book, was published in 1893, and he contributed later to *The Yellow Book*, the illustrated quarterly issued from 1894 to 1897.

The Wind in the Willows, which began as bedtime stories for his only son Alistair, was published in 1908 and its success was immediate. The adventures of Rat, Toad, Mole, Badger, and friends, together with the illustrations of E. H. Shepard, have set Kenneth Grahame among the leading writers of children's books. In 1929, A. A. Milne dramatized the book as *Toad of Toad Hall*.

As with the Milne stories of Christopher Robin and Winnie the Pooh, what clearly underlies the book is a poignant search for the lost innocence of childhood. Kenneth Grahame dreamed of an ever-pastoral England and feared the spread of industrialization. His interest in the River Thames began in boyhood with visits to his grandmother at Cookham Dean, in the Thames Valley, and his uncle also took him out on the river.

Kenneth Grahame retired to his final home at Church Cottage, Pangbourne, in 1924. It was here that E. H. Shepard came to discuss the illustrations for the book.

At his death in the summer of 1932, thousands of flowers lined the grave of Kenneth Grahame, sent by children from all over Britain.

IVON HITCHENS

Always interested in portraying the English landscape, Ivon Hitchens (1893–1979) was to develop a style of painting that has become easily recognized, although to the casual eye his paintings may appear to have a baffling sameness. Indeed, some critics have suggested that Hitchens has been painting the same picture throughout his life; and his use of canvases twice as long as they are high has also prompted the epithet of 'cinemascope'. However, any close examination of his work over

Damp Autumn, by Ivon Hitchens

a period of 50 years or so soon reveals a steady progression and development in his painting that is richly rewarding.

Hitchens had painted several landscapes and nudes in his early period, but it was during the Second World War that his painting took a new and exciting turning, which he continued to explore for the rest of his life.

After his London home had been bombed, he moved to West Sussex and purchased six acres of woodland at Lavington Common near Petworth. Home was at first a Romany caravan, which still remains on the property. He and his wife built a house, cleared a pond and bought an orchard. Appropriately they called the house Greensleaves. Here, amid a lushness of light and foliage, Ivon Hitchens nurtured his art. Most of his landscapes are local, some painted at Terwick Mill, now a private house, many on his own property. Here at Lavington he found an inspirational solitude, and was fascinated by its colour harmonies.

Like Thoreau, Ivon Hitchens drew strength and confidence from wild nature, discarding topographical detail and reducing his landscapes to the barest essentials. His paintings became increasingly abstract, but full of woodland colour and stretches of shining water. He also painted at Church Norton, near Selsey Bill, where he had a small dwelling on the beach. He declared the philosophy of his painting to be '. . . that colour is space and space colour'.

JOHN IRELAND

The music of John Ireland (1879–1962) is rooted in his deep and fertile sense of place. John Ireland first became acquainted with the area of Sussex around Steyning, Storrington and Washington in the early 1920s, and as a composer it was the most prolific period of his life. Although he was born in Cheshire and later lived in London for some 55 years, there can be no doubt that his adopted county of Sussex, and the South Downs in particular, became his spiritual home. The great earth-works of prehistory, the camps and barrows, that sprawl across the southern chalk hills fascinated him. The music of his haunting and much-loved 'Downland Suite', composed in 1932, could hardly be more evocative of the vistas of swelling hills that unfold before the Downland walker like a windblown scarf.

The South Downs between Amberley and Washington he made his own, and the land-mark that fascinated him most of all was

Chanctonbury Ring, Sussex (*see* Ireland)

Chanctonbury Ring, the great Iron Age hill fort with its crown of beech trees that dominates so much of the Sussex skyline. In 1953 he bought Rock Mill, his last home, which gave him a permanent view of Chanctonbury Ring for his remaining years.

It was on Chanctonbury Ring that Ireland was inspired to write 'Equinox', a splendid concert piece that developed in his mind while walking on the hill in a high wind. The towering tree clump of Chanctonbury undoubtedly has atmosphere; it is a place that reflects age and suggests great power as it looks out above the earth. Although now in the heart of commuter country these hills retain their sense of wildness. The beech trees of Chanctonbury are like a timber-built abbey, with a texture that needs to be touched. .To stand here is to be in the midst of John Ireland's most glorious English music.

His compositions were seldom made at the piano. As he walked these hills, visualizing the life and rites of early man, he carried the sound of it all home in his amazing musical memory. John Ireland was a musician with an ear for

poetry; his piece for piano 'Amberley Wild-brooks', those great wetlands so filled with birds and rare plants that lay beneath the north escarpment of the Downs, is a nature poem in itself. This area is now conserved by the Sussex Trust for Nature Conservation.

Those who only know of Ireland as teaching composition to Benjamin Britten, or for his musical setting of John Masefield's 'Sea Fever', do not really know John Ireland at all.

HENRY JAMES

This famous American novelist and short story writer (1843–1916) made his home in England in 1876, took British citizenship in 1915, and was awarded the Order of Merit in 1916. Although he enjoyed London, the place that delighted him most was the little East Sussex town of Rye, on the Channel coast. It was here that the French Huguenot refugees had once settled in their hundreds. Perched on a hill, it is capped by a 12th-century church with a clock that has worked continuously since 1560. Cobbled streets and ancient buildings

abound; it is a small town with the attraction of a fishing village.

Henry James fitted perfectly into the Rye community. His home was Lamb House, a three-storeyed redbrick house finished in 1723, but with cellars reaching back to Elizabethan times; George I once slept there. It was the perfect place for the anglophile New Yorker. He liked to walk to Winchelsea a few miles distant, an ancient walled town, laid out in blocks, like New York.

Walking the road to Romney Marsh was another pleasure, with its small and ancient churches; so too was cycling out to Brede. Henry James liked it all, except the winters. One of his American neighbours at Brede, was Stephen Crane, author of *The Red Badge of Courage*. He and Henry were close friends,

Crane rented Brede Place, a lovely building, owned by Moreton Frewen whose wife was one of the Jerome sisters and therefore an aunt of Winston Churchill. All manner of authors sought out Henry James at Rye. Crane on horseback, wearing a cowboy shirt; Rudyard Kipling in his motor car; and Joseph Conrad back from the sea. It was a golden period for Rye, generated by the presence of Henry James. Some of his best writing was done at Rye, novels, short stories, and a biography of Nathaniel Hawthorne.

Henry James, Jun., nephew of the writer, presented Lamb House to the National Trust 'to be preserved as an enduring symbol of the ties that unite the British and American People'. A Henry James room at Lamb House is open to the public at stated times.

Lamb House, Rye, Sussex (*see* James)

OPPOSITE Mermaid Street, Rye, Sussex (*see* James)

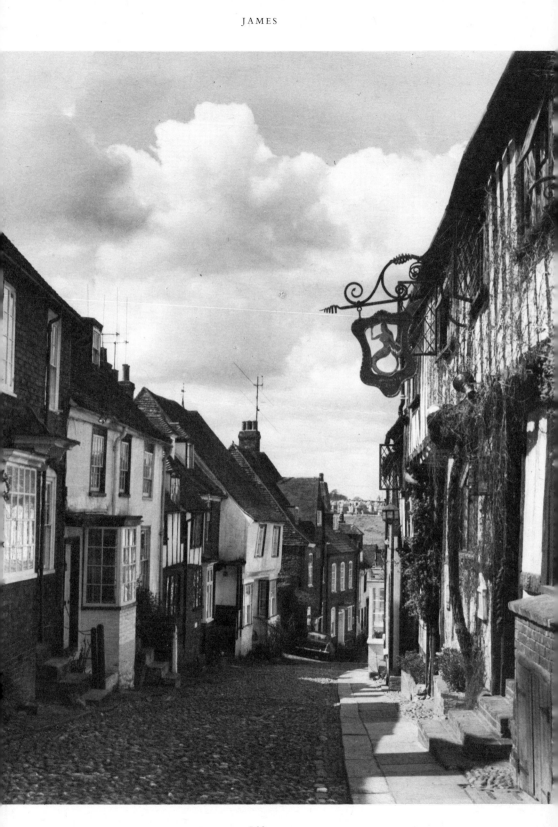

JOHN KEATS AT WINCHESTER

During the autumn of 1819 the poet was at Winchester, in Hampshire, revising 'The Eve of St Agnes' and composing what perhaps ranks among the most beautiful poems in the language—'Ode to Autumn'. Each day the poet walked for an hour before dinner, going into the cathedral yard, past the front of the cathedral, through two college-like squares 'seemingly built for the dwelling place of Deans and Prebendaries—garnished with grass and shaded with trees. Then I pass through one of the old city gates and then you are in College Street.'

Very little has changed of this scene since Keats's day. In autumn the richly fertile and well-stocked gardens were, and are, heavy with fruit, 'a country alley of gardens' Keats called it.

Through a wicket gate behind the college a path leads across serene water meadows to the old monastery of St Cross. In those September days the young poet's eyes and sensitive imagination fixed such scenes fast in his brain. 'Ode to Autumn' was written on Sunday 19 September. Here was the work of the mature poet, his muse certain, his song perfect. How well the opening lines fall like wine-tinted leaves, autumn after autumn.

Season of mists and mellow fruitfulness,
Close bosom-friend of the maturing sun.

The beautiful landscape described above was astonishingly threatened by plans for a motorway to bypass Winchester. It was only in February 1983 that it was decided to abandon this plan!

SEE ALSO PAGES 11, 34.

JOHN KEATS IN HAMPSTEAD

When John Keats (1795–1821) lived in Hampstead it was a country village just northwest of London. Since then the district has witnessed much change, not least at the hands of Victorian builders. Wentworth Place, now called Keats House, was itself threatened with speculative development soon after the First World War. Fortunately the Mayor of Hampstead and others secured an option on the property and in due course the house was saved. It is certainly the most significant

The Hospital of St Cross (*see* Keats at Winchester)

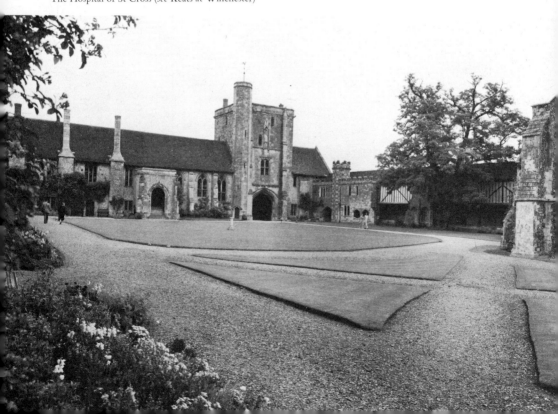

Keats' House, Hampstead, London

building in Hampstead. Keats lived there between 1818 and 1820. The house had been built three years earlier as two semi-detached dwellings. From about 1816 Charles Wentworth Dilke and his family lived in one of them, and Charles Brown, who was a bachelor, had the other, slightly smaller one.

It was while Keats was lodging in Hampstead that he first met Brown. They enjoyed each other's talk and company. The friendship quickly developed and it was not long before they were off on a walking tour that took them through the Lake District and Scotland (see p. 34).

Soon after their return Keats moved into Wentworth Place. In the spring of 1819 Charles Brown noted that a nightingale had built a nest near the house. Keats was enchanted by the nightingale's song from which, Brown tells us, the poet 'felt a tranquil and continual joy'. Twenty years later Charles Brown described the circumstances that produced the inspiration for Keats's 'Ode to a Nightingale'.

. . . one morning he took his chair from the breakfast table to the grass-plot under a plum-tree, where he sat for two or three hours. When he came into the house, I perceived he had some scraps of paper in his hand, and these he was quietly thrusting behind the books. On inquiry, I found those scraps, four or five in number, contained his poetic feeling on the song of our nightingale. The writing was not well legible; and it was difficult to arrange the stanzas on so many scraps. With his assistance I succeeded, and this was his Ode to a Nightingale, a poem which has been the delight of everyone.

The passage of years deceived Brown's memory for the 'scraps of paper' were only two and the handwriting quite legible. More important is that on a quiet morning in a garden in Hampstead a work of genius flowed from the mind of John Keats. If ever a poet could be said to have a spiritual home it was Keats at Hampstead.

SEE ALSO PAGES 11, 34

Bateman's, near Burwash, Sussex (*see* Kipling)

RUDYARD KIPLING

Before Rudyard Kipling (1856–1936) left England for India, he called on his aunt, Lady Burne-Jones who was living at Rottingdean, near Brighton. The area clearly made an impression upon him for he eventually returned to live in the village.

Kipling achieved a certain fame and literary success with the verse of *Departmental Ditties* (1886), the stories of *Plain Tales from the Hills* (1888), *Barrack-Room Ballads* (1892) and *Kim* (1901). He was the poet laureate of the British soldier; but above all he wrote such splendid books for children, the *Jungle Book* (1894) and *Second Jungle Book* (1895), the *Just-So Stories* (1902), *Puck of Pook's Hill* (1906) and *Rewards and Fairies* (1910).

On 3 September 1902, some years after Kipling's return from India, he and his wife moved into a new home, a house called Bateman's, near Burwash. This delightful house

was built in stone by a Sussex ironmaster in 1634. It stood in a quiet valley at the foot of a steep lane. Kipling wrote:

We had seen an advertisement of her, and we reached her down an enlarged rabbit-hole of a lane. At very first sight the Committee of Ways and Means [Mrs Kipling and himself] said; 'Thats her! the only She! Make an honest woman of her—quick!' We entered and felt her spirit—her Feng Shui—to be good. We went through every room and found no shadow of ancient regrets, stifled miseries, nor any menace, though the new end of her was three hundred years old.

In 1907 Kipling received the Nobel Prize for Literature. Eight years later came tragedy and sadness when their only son John was killed in the battle of Loos.

The Dudwell flows through the grounds of Bateman's, and it was near this little river that his children John and Elsie found a fairy ring at the foot of a slope known as Pook's Hill. It became a theatre in which to act the story of Puck and Titania. At the same time Kipling was delving deep into local Sussex history. In *Something of Myself*, posthumously published in 1937, he writes:

> Just beyond the west fringe of our land stood the long, over-grown slag heap of a most ancient forge, supposed to have been worked by the Phoenicians and Romans and, since then uninterruptedly till the middle of the eighteenth century . . . and if one scratched a few inches through the rabbit-shaven turf, one came on to the narrow mule-tracks of peacock hued furnace-slag laid down in Elizabeth's day. The ghost of a road climbed up out of this dead arena, and crossed our fields, where it was known as 'The Gunway', and popularly connected with Armada times. Every foot of that little corner was alive with ghosts and shadows.

Out of this feeling for the past, Kipling used history, pegged to local places, to create the stories of Pook's Hill. The old inhabitants of the past tell the tales of history when brought forth by Shakespeare's Puck.

> *. . . cantering through*
> *The misty solitudes*
> *As though they perfectly knew*
> *The old lost road through the woods . . .*
> *But there is no road through the woods.*

Kipling had set out to show how the land and its people had continued in a relay of generations from prehistory to the present. His children John and Elsie are the 'Dan' and 'Una' of the books, and his mode of bringing together the past and present stemmed from his family's enthusiasm for the works of E. Nesbit.

One of Kipling's finest poems is 'The Land', for it tells the story of Bateman's valley from Roman times. The hero of the poem and the stories, however, is neither the Roman Sub-Prefect nor the Dane, nor Puck, nor Dan or Una, but a man of the soil, a hedger named Hobden.

I have rights of chase and warren, as my dignity
requires.
I can fish—but Hobden tickles. I can shoot—but
Hobden wires.
I repair, but he reopens, certain gaps which, men
allege,
Have been used by every Hobden since a Hobden
swapped a hedge.

His dead are in the churchyard—thirty
generations laid.
Their names were old in history when Domesday
Book was made.
And the passion and the piety and prowess of his
line
Have seeded, rooted, fruited in some land the Law
calls mine.

Bateman's is now a property of the National Trust and with its grounds is open to the public. A fine collection of Kipling family mementoes are on display.

GEORGE MORLAND

There are many exciting facets to the life and work of George Morland (1763–1804), the foremost being his delight in painting English rural life. Not the gentlemen foxhunters, the racehorses and the shooting parties, but the cottagers with their pigs and chickens, the alehouses, the coaching and heavy horse stables, the men who laboured on the land, and fishermen hauling their catch. It was as though he had translated the Dutch genre paintings of a century before into English, but the English country settings are more exciting.

George Morland took his painting seriously, but not his life. He was a devil-may-care character full of fun, and with never a thought for tomorrow. This may be the reason for the many happy and well-fed rustic figures who people his canvases—yet life on the land in many parts of Britain was of a harsher reality. Even so, it was a period when the rural landscape could not have looked more picturesque, with its oak forests, thatched cottages, mailcoaches, and horse-drawn wagons of many kinds and colours. In coastal areas, smuggling was almost an industry, and the Navy press gangs were increasingly active. All these things are recorded in the works of

Morning: Higglers Preparing for Market, by George Morland

George Morland. He was not among the foremost painters in the land, but he was certainly among the best loved and has remained so ever since.

Morland was educated in London. Both his parents were painters and it is not too surprising to learn that from the age of 7 he was beginning to show a remarkable talent for sketching. As a child he amused himself by drawing objects on the floor in order to see his parents stoop to pick them up! At 14 he was articled to his father for seven years, and the following year he exhibited at the Royal Academy as 'Master G. Morland, two landscapes, stained drawings'. He painted with unusual swiftness and skill, a facility that ran counter to the technique of his father who concentrated on detailed works with a high finish. Although the young Morland enjoyed walking in the countryside he was allowed to paint very little from nature, and was made to

concentrate on copying the work of European masters, and Thomas Gainsborough.

Morland developed an extraordinary memory for landscape. During a walk with the painter George Daw, later Morland's biographer, they set out over Shooters Hill and Woolwich Warren, through Charlton and the Sandpits to Hanging Wood, which Morland considered to be the most romantic landscape near London. Three months later he showed Daw two drawings that he had made depicting the activity of men, wagons and animals at the Sandpits, Daw could not believe that they had not been sketched from life.

His apprenticeship came to an end in 1784. He was now 21 years old, a strong young man with the spirit of a wild bird. He left home with all speed, determined to have the freedom he had been longing for. The Cheshire Cheese off Fleet Street became his haunt. He drank heavily, became involved in many drunken

escapades and for a time was in the clutches of an Irish art dealer who made him paint: '. . . a sufficient number of pictures to fill a room'.

Free of the dealer, he painted some portraits, made a trip to France and was to fall in love on several occasions. Eventually he married Anne Ward, the sister of William Ward the engraver. In turn, William Ward married Morland's sister Maria, and for a time the couples lived in the same house.

From 1791 there began in Morland's pictures what has so often been called the 'Morland style'. It was the year he painted *The Farmer's Stable*, one of his largest canvases, which now hangs in the National Gallery, London. For ten years a steady flow of excellent country scenes and episodes flowed from his brush, including gypsy encampments. Such was the fame he had now acquired that a 'Morland Gallery' was opened at 14, Old Bond Street. His pictures were equally popular in many parts of Europe. In the meantime, William Ward, James Ward, R. A. and J. R. Smith were busy producing engravings of his work. The reputation that Morland had achieved enabled him to sell pictures direct to clients at his own price, which had the effect of changing the basis of 18th-century patronage. Best of all, Morland felt that without patronage painters could be free to paint as they pleased, without interference.

Morland should have made a fortune, but he placed little value on money and disposed of it carelessly among the bad company he kept. Afraid to leave his home in case he was arrested by his creditors, he gave up drinking tea on the grounds that it was pernicious, and began imbibing increasing quantities of gin.

In 1799, a surgeon in Westminster offered Morland the use of a cottage he owned near Cowes, on the Isle of Wight. Here he painted several fine coastal and fishing scenes, but again creditors were hard on his heels, and Morland was forced to move from Cowes to the southwest corner of the island at Yarmouth.

Lodgings were found with an old smuggler named George Cole, but disaster followed disaster. This was the time of the Napoleonic wars and the threat of French landings was taken seriously. Soldiers of the Dorset Militia noticed the artist sketching and arrested him

as a spy. He was marched to the island capital of Newport to face the justices. Fortunately, he still retained a letter of introduction given to him by the Westminster surgeon who owned the cottage at Cowes. Morland was promptly released but ordered to make no further sketches on the Isle of Wight. However, on returning to Yarmouth he painted two of his finest coast scenes, one of a view to the Needles and another of Freshwater Gate. Freshwater Gate was a hamlet on the shore close to the inland village of Freshwater. It is an area of great beauty, of chalk cliffs, and old stone-built thatched cottages. Most people who visit the area recall it as the home of Tennyson; few remember George Morland.

The Isle of Wight was Morland's last real breath of fresh country air. Returning to London he was arrested for debt and died on 24 October 1804, making a sketch of a bank and a tree. His wife Anne died four days later. Morland led a desperate life, bankrupt and finally broken, but his wealth of paintings and sketches form a legacy of 18th-century rural life that provide us with a glimpse of old England, and enrich the spirit.

WILLIAM MORRIS AND EPPING FOREST

The early life of William Morris (1834–96) was spent in and around Epping Forest, to the northeast of London, where he became interested in the identification of birds and developed his love of trees and wild flowers. He lived at Woodford Hall, the Morris family home, with a view to the River Thames, giving glimpses of the sails of barges that appeared to glide through the cornfields. This love of nature never left him. His solitary walks among the hornbeams of the Forest, with shafts of filtered light splashing the woodland floor like an illuminated manuscript, left indelible marks on his imagination.

Ancient festivals were still observed and maintained at Woodford Hall. Twelfth Night was always made a great occasion, and so too was the masque of St George. St Martin's Day would find the commoners of Epping Forest cutting timber at midnight, with white horses to draw away the first load. Such sights and stories helped to mould the man; above all

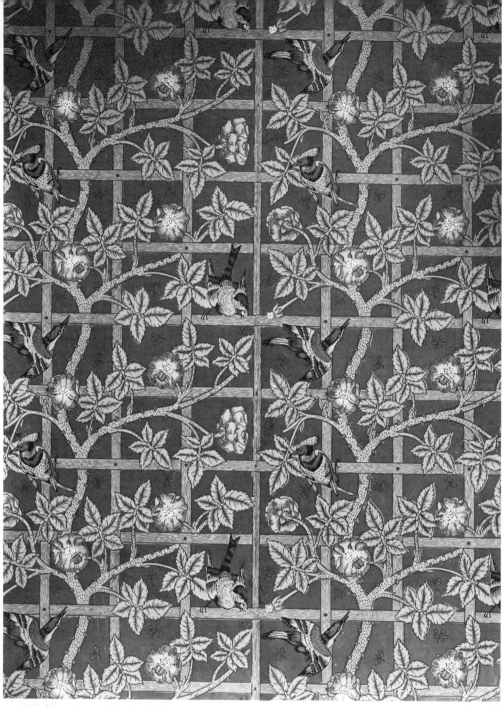

ABOVE Trellis wallpaper design, by William Morris

OPPOSITE ABOVE Amberley Wildbrooks
(*see* Ireland, p. 150)

OPPOSITE BELOW The gnarled trees and ancient
earthworks at Chanctonbury Ring, Sussex
(*see* Ireland, p. 150)

OVERLEAF LEFT 'Pook's Hill' (*see* Kipling, p. 156)

OVERLEAF RIGHT *Inside a Stable*, by George Morland

they provided him with ancient values that were beginning to be lost during the 19th century.

The Industrial Revolution had wrought great changes in Britain. Industrialization and the spread of the factory system and machine production were an oppressive burden to a man who felt the Middle Ages to be his world. He turned his hand to no fewer than ten different types of decorative art including wallpaper, textiles, carpets, stained glass and tapestry. All this work was done by hand at the decorating firm he helped to found. Morris later set up the Kelmscott Press, a private printing works at Hammersmith, where books were handmade from beginning to end in accordance with his principles. This extraordinary man, who had once planned to take Holy Orders, became instead a designer, a painter, poet, weaver, writer, political thinker (he was a member of the Democratic Federation, and later of the Socialist League), manufacturer, traveller and a man of ideas. He was very interested in the concepts of the Pre-Raphaelite Brotherhood, some of whose members were associated with him in his arts and crafts enterprises.

Most important of all he became deeply concerned about the future of Britain's natural environment. In 1880 he gave a lecture with the title 'The Beauty of Life'. This extract is even more valid now than it was in 1880:

> . . . I must ask what do you do with the trees on a site that is going to be built over? Do you try to save them, to adapt your houses at all to them? Do you understand what treasures they are in a town or a suburb? Or what a relief they will be to the hideous dog-holes which you are probably going to build in their places? I ask this anxiously, and with grief in my soul, for in London and its suburbs we always begin by clearing a site till it is as bare as the pavement: I really think that almost anybody would have been shocked, if I could have shown him some of the trees that have been wantonly murdered in the suburb in which I live, amongst them some of those magnificent cedars, for which we along the river

William Morris

used to be famous once. . . Pray do not forget that anyone who cuts down a tree wantonly or carelessly, especially in a great town or its suburbs, need make no pretence of caring about art. . .

Fifteen years later he was writing to the editor of *The Daily Chronicle* on the landscape closest to his heart, Epping Forest.

> The special character of it was derived from the fact that by far the greater part was a wood of hornbeams, a tree not common save in Essex and Hertfordshire. It was certainly the biggest hornbeam wood in these islands, and I suppose in the world. The said hornbeams were all pollards, being shrouded every 4 or 6 years, and were interspersed in many places by holly thickets; and the result was a very curious and characteristic wood, such as can be seen nowhere else. And I submit that no treatment of it can be tolerable which does not maintain this hornbeam wood intact.

OVERLEAF *The Failure of Sir Gawain,* from the Quest for the Holy Grail series of tapestries, designed by Edward Burne-Jones and woven by William Morris & Co. at Merton Abbey after 1881

OPPOSITE Epping Forest, Essex (*see* Morris)

But the hornbeam, though an interesting tree to an artist and reasonable person, is no favourite with the landscape gardener, and I very much fear that the intention of the authorities is to clear the forest of its native trees, and to plant vile weeds and outlandish conifers instead. . .

PAUL NASH

An artist of great poetic imagination, Paul Nash (1889–1946) has painted the English landscape with the eye of the surrealist, but it was work of a very different kind that first brought him to the public eye. These were his First World War drawings of violated landscapes on the Western Front, making fitting counterparts to the work of the war poets. He served at the front before being made a war artist.

During the Second World War he was again appointed Official War Artist. While living with friends in a house at Boars Hill, Oxfordshire, two domed hills topped by clumps of trees, and called the Wittenham Clumps, could be seen in the distance. He had seen them before as a young man, and in 1911 described them as 'grey hallowed hills crowned by old trees, Pan-ish places down by the river – full of strange enchantment – a beautiful legendary country haunted by old Gods long forgotten.' They formed a frequent symbol, or motif, in his paintings throughout his life.

Paul Nash visited the Romney Marsh village of Dymchurch, Kent, in 1919 and stayed for several years. He was fascinated by the great sea wall built to stop erosion and flooding. The sea wall was an ideal subject for Nash, who at that time was experimenting with abstract shapes and ideas.

The landscape around the Cinque Ports delighted Nash. A close friend was Edward Burra, who lived near Rye where his father owned a large house called Springfield Court. Paul Nash took a number of photographs at this house, which he used in his paintings. After living for a time in the village of Iden and painting some exceptional landscapes he moved on to Rye.

In 1933 he also painted at Avebury in Wiltshire, reducing the great standing stones to geometrical forms. For the next two years he was painting in Dorset, at Swanage, and revelling in the scenery that surrounded it. Nash also did much work as a designer and book illustrator.

SAMUEL PALMER

The watercolours of Samuel Palmer (1805–81) have in recent times risen steadily in public appreciation but such recognition was slow in coming. Palmer was deeply imbued with the imagery of the English poets, and of John Milton in particular; he was also the friend of William Blake, whom he revered. It was a friendship that yielded for a time a series of remarkable paintings and drawings which now enjoy wide acclaim.

The pictures he produced at Shoreham, in Kent, during a period of ten years from 1826 transcend the rest of his entire output. Lord Clark has described these pictures, usually small and executed in ink and body colour as, '. . . . so pure and self-sufficient that one cannot think of them as provincial, and some years ago I invented, to describe them, the word "micropolitan", which still seems to me worth retaining.'

Palmer was the son of a poor bookseller in Newington and as a child he is said to have had what he regarded as a visionary experience that was to effect his entire life and work. He found himself in a garden with a young nurse on a moonlit night, and was awestruck by the shadows of an elm tree thrown upon a wall by the moon. The moon and shadowy outlines of overhanging trees came to play a major role in his paintings and drawings. These are idealized landscapes from which poverty and suffering have been banished, with visionary shapes and images that turn human figures, sheep anf foliage into an atmospheric glimpse of the Holy Land in Kent.

The young Palmer, who was fascinated by work of J. M. W. Turner, had three landscape paintings in the Royal Academy when he was 14. George Richmond became his lifelong friend, and a meeting with John Linnell eventually led to his introduction to William Blake. Like Palmer, Blake admired Milton, and he also experienced visions (see p. 85). There was an intuitive understanding between the two men, enabling them to discuss freely

Shoreham Garden, Kent, by Samuel Palmer

subjects that, at the very least, would have been difficult to talk of with others.

Of the young disciples who surrounded William Blake, Samuel Palmer was by far the most important. When Blake died in 1827 Palmer felt that a prophet had left the earth.

How Palmer came to think of settling at Shoreham, Kent, is not known, but he felt the need of the kind of country life that might help his recurring illness, which was probably bronchitis. A legacy from his grandfather enabled him to move to Shoreham. After first taking lodgings, he acquired a cottage so dirty and dilapidated that it was nicknamed 'Rat Abbey'.

The natural beauty of the area was precisely what he required; he began to feel at one with nature and, what was more, was able to condense such feeling into his work. His sketch-book notes of 1824 reveal the intensity of his observation and the strength of his creative imagination:

Seen in Midsummer 15th July 9 o'clock p.m. At that time of twilight where the azure behind a high spired turret was very cool but almost blueless, the chastened glow

of the light tower against it was very beautiful . . . but what I write this for is to remark that though all was low in tone as preparing to receive the still and solemn light, yet the tower on which the last light glimmered seemed luminous in itself and rather sending out light from itself than reflecting it, and I noticed it on other stone buildings going along as if they had inherent light somewhat reminding one of mother-of-pearl. It was luminous though pale faint and glimmering.

These leaves were a Gothic window, but sometimes trees are seen as men. I saw one a princess walking stately and with a majestic train.

Sometimes the rising moon seems to stand tiptoe on a green hill top to see if the day be going and if the time of her vice-regency be come.

In 1837 Samuel Palmer married Hannah, the eldest daughter of John Linnell, and in company with the Richmonds visited Italy to study and to paint. In due course they returned to London rather than Shoreham. The imagi-

Stone Cottage, Coleman's Hatch, Ashdown Forest, Sussex (*see* Pound)

native fires that had once burned so brightly in his mind were no longer there to create pictures in the flames. The skill of the painter remained but, like Blake, the vision had departed.

EZRA POUND

The name of Ezra Pound (1885–1972), one of the most controversial figures among the writers and poets of this century, constantly recurs in any history of modern literature. This extraordinary American had a great impact on contemporary poetry and the *Cantos*, his cycle of poems, produced over many decades, have either delighted or enraged readers throughout the Western world. Pound began writing the 'Pisan Cantos' while held in custody by the Americans towards the end of the Second World War. He was detained because of the broadcasts he had made allegedly in support of the Axis Powers.

Part of the *Cantos* cycle looks back to the years when he acted as secretary to W. B. Yeats in Sussex. (Pound was in England from 1909 to 1919.) They rented rooms at Stone

Ashdown Forest (*see* Pound)

Cottage, Colemans Hatch, in Ashdown Forest. At first the prospect did not look too promising. In a letter to his mother Pound wrote: 'My stay in Stone Cottage will not be in the least profitable. I detest the country. Yeats will amuse me part of the time and bore me to death with psychical research the next. I regard the visit as a duty to posterity.'

Things did not prove to be as bad as Pound was painting them, and the heather-covered miles of Ashdown Forest did them both good; they walked all day and talked and wrote each evening. Pound now wrote: 'Yeats is much finer in time than seen spasmodically in the midst of the whirl. We are both, I think, very contented in Sussex.'

Pound and Yeats attended the seventieth birthday party of Wilfrid Blunt, who lived near by. Blunt was the first Englishman to suffer imprisonment for his support of Irish Home Rule in 1887. The birthday lunch consisted of a peacock. Yeats immediately composed his poem 'The Peacock' in celebration of the event, but Pound waited until old age to write:

. . . so that I recalled the noise in the chimney
as it were the wind in the chimney
* but was in reality Uncle William*
downstairs composing
that had a great Peeeeacock
* in the proide ov his oiye. . .*

Stone Cottage is now a well-appointed modern home, vastly altered from the simple dwelling of the First World War period. However, the cottage and forest remain, reminding us of the two diverse literary personalities who worked together here.

ARTHUR RACKHAM

One of the most widely admired book illustrators of the last hundred years, Arthur Rackham (1867–1939) was to find his spiritual home in the village of Houghton, West Sussex. He was very much an artist of Northern Europe, influenced by Bosch, Daumier and Dürer, and to some extent perhaps by Richard Dadd. The fount of his inspiration sprang from landscape, and from Gothic art and archi-

tecture. Many of his friends and relations have described his appearance as being that of a gnome or goblin. Indeed, he would even use himself as a model, pulling faces while drawing in front of the mirror.

Rackham's imagination was inhabited by subterranean creatures, fairies, goblins; a richly compulsive fantasy world where weird, gnarled tree shapes became humanoid. He worked swiftly and with great certainty. His line work is superb and his watercolours are ravishing, with the result that his books and original works are avidly sought throughout the world. The fresh impact of his illustrations upon successive generations continues unabated. Chou-Chou, the daughter of Claude Debussy, so loved Rackham's picture of 'The Fairies are exquisite Dancers' from his illustrations for J. M. Barrie's *Peter Pan*, that her father composed a prelude on it.

E. V. Lucas, such a powerful figure in the art world during the early part of this century, declared that Rackham had the ability to combine grace and the grotesque. Among the many titles he illustrated are *The Ingoldsby Legends*, *A Midsummer Night's Dream*, *Gulliver's Travels*, *Grimm's Fairy Tales*, *Rip Van Winkle*, *The Rhinegold and the Valkyrie*, *Aesop's Fables*, *Hans Andersen's Stories*, and *The Wind in the Willows*, his last work of illustration.

Arthur Rackham painted many landscape watercolours, particularly in Sussex, but also in other places, including the Lake District, Yorkshire, and Devon. He also equipped himself with watercolours while on walking holidays in Switzerland, Germany and Italy.

In 1903 he married the portrait painter Edyth Starkie, who did so much at the beginning of his career to encourage his fantasy drawings. The Rackhams discovered Sussex during the First World War. They eventually moved into Houghton House overlooking the Arun valley. On the other side of the river, beyond Amberley, is Rackham with its ancient earthworks: such a coincidence of names may well have provided him with a sense of belonging.

Their home was a flint-built Georgian farmhouse facing the narrow road that winds its way down to Amberley. Immediately opposite The George and Dragon still flourishes, an inn where Charles II refreshed himself before making his escape to France. Here Rackham was in his element, an artist who loved working and living amid mag-

Cobwebs, early morning (*see* Rackham)

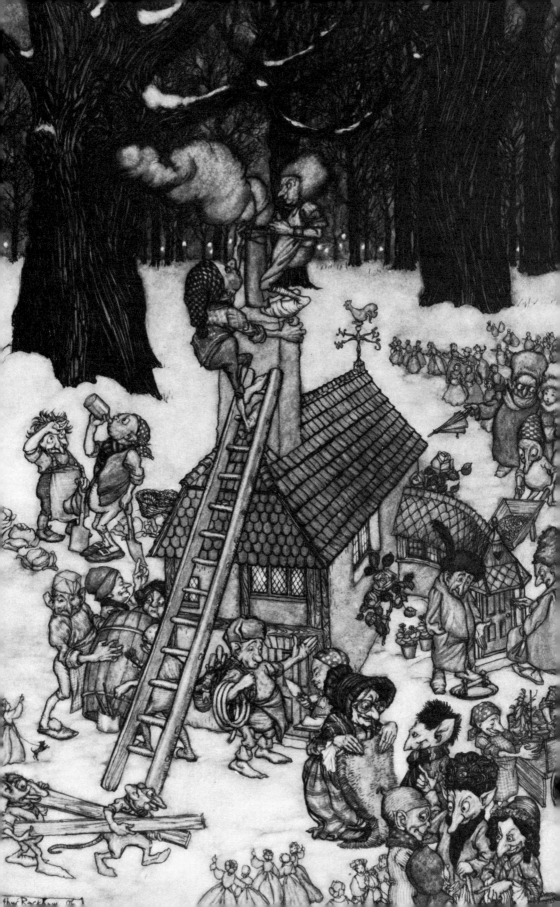

nificent walking country. The gnarled old
beech tree in his garden appears in several
illustrations and so too does a fine elm; and
the half-timbered medieval cottages of the
neighbourhood fired his highly fertile mind.

Although loving the countryside so much
he did not have the appearance of a country-
man; a navy-blue suit and bow tie was very
much his 'rig of the day'. The family lived a
simple life at Houghton, although it proved
too simple for Mrs Rackham, who was not
in good health. Water from the well and rats
in the rafters were the final straw. They
retreated to Limpsfield, Surrey, closer to
London but further removed from that land-
scape that had provided Arthur Rackham
with so much inspiration.

OPPOSITE *The House that Maimie Built*, by Arthur Rackham

ERNEST SHEPARD AND A. A. MILNE

The village of Lodsworth, a few miles north of
Midhurst in Sussex, was the home for many
years of Ernest Shepard (1879–1976). He was
the possessor of a rare talent for illustration,
bordering on genius. His line illustrations for
A. A. Milne's *Winnie the Pooh* series have been
acclaimed, like the stories themselves, through-
out the world. At the age of 90 he was com-
pleting work for the first colour editions of
Winnie the Pooh.

This tall, elegant and retiring man began to
shape his career when working for *Punch* in
1907. He was a cartoonist as well as a book
illustrator. This aspect of his work is often
overlooked, yet his cartoons have great power,
particularly those he drew in the Second World

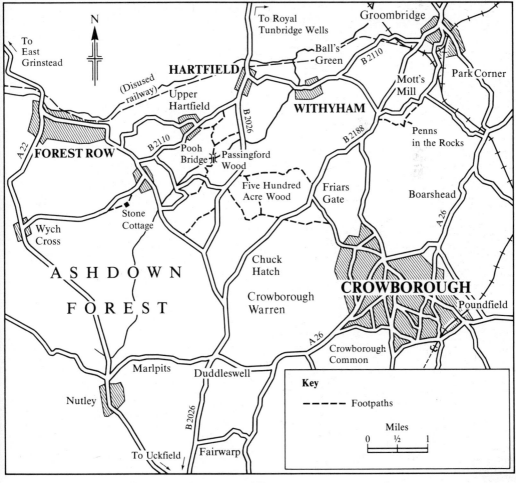

Poohsticks bridge, Ashdown Forest, Sussex (*see* Shepard)

Ernest Shepard illustration from *The House at Pooh Corner*

War period. It was in 1945 that he became chief cartoonist for *Punch*.

It is, however, for 'Pooh' that he will be most remembered, but when drawing the characters in the stories he was always aware that his task was to bring life to toys. Illustrating Kenneth Grahame's *Wind in the Willows* was of much greater satisfaction to Shepard, because the animals were real. Even when he was drawing animals wearing human clothes, the real animal was always there.

The book he enjoyed working on most was Richard Jefferies' classic story of boyhood, *Bevis*. For this, Ernest Shepard travelled to the lake and farmhouse, near Swindon in Wiltshire, where Jefferies was born. Now a pleasure park, it was then unspoiled, with all the places where Bevis and his friends had once played still intact.

Perhaps the most widely loved and remembered Shepard drawing of all is the frontispiece to *The House at Pooh Corner*, where Christopher Robin and his little friends are playing Poohsticks together. For many years this bridge, in Ashdown Forest where A. A.

Milne lived, and where his stories were set, became a place of pilgrimage for fans of Winnie the Pooh. The bridge began to fall into disrepair, but restoration has now been carried out and its safety is assured for years to come. To find Poohsticks bridge the map must be carefully followed (*see* p. 171).

At Cambridge A. A. Milne had edited the magazine *The Granta* and later worked as a journalist. Like Shepard Milne made his early reputation as a contributor to *Punch*. He also became a leading playwright during World War I and the inter-war years.

His renowned childrens books *When We Were Very Young, Winnie the Pooh*, and *House at Pooh Corner*, owe their background to A. A. Milne's beloved Ashdown Forest.

STANLEY SPENCER

A man of extraordinary talent, Stanley Spencer (1891–1959) brought a unique fame to the Berkshire village of Cookham. His paintings frequently caused controversy during his lifetime and continue to do so today. Spencer was a visionary who regarded his village and his stretch of the Thames as a 'holy suburb of heaven', and in so doing created an immor-

tality for Cookham, as Constable did for Dedham Vale.

Spencer's work has an originality and a religious feeling that comes near to William Blake, but in the Cookham pictures we also see his friends. In *Resurrection, Cookham*, the tombs open in the churchyard and old friends from many ages meet again.

His landscapes have a Pre-Raphaelite quality and are full of detail, whether they are of Cookham Moor or the village street. His Thames paintings have a very fine quality, 'Swan Upping at Cookham', which he began before the First World War and finished afterwards, has been much reproduced. The style of his crowded and apocalyptic paintings owes something to the Flemish and Dutch masters, while 'Christ Preaching at Cookham Regatta: Listening from Punts' has more than a hint of Botticelli. Stanley Spencer trained at the Slade School in London, but his entire outlook on life sprang always from his Bible-reading youth and from the village of Cookham. Even the paintings with no human figures in them project an intuitive sense that something remarkable is imminent. But then, Stanley Spencer always believed that Paradise might be just around the next corner.

The Resurrection, Cookham, 1923/7, by Stanley Spencer

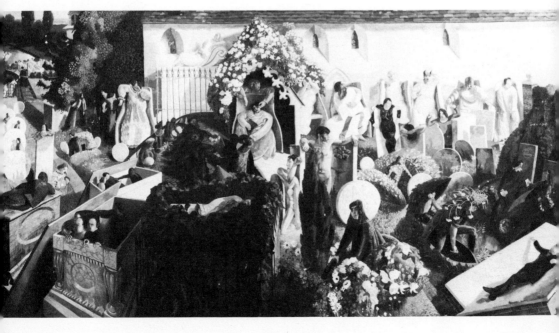

A. C. SWINBURNE

The sea was always the main source of inspiration for Algernon Charles Swinburne (1837–1909). He called it his 'mother', and his earliest memory was of being plunged into it. Swinburne came to know the English coastline from Northumberland to St Catherine's lighthouse at the southern extremity of the Isle of Wight. In his early years he spent considerable time at his grandfather's house at Capheaton, Northumberland, and the imagery of the northern moors, cliffs, and seascapes appears many times in his poetical works. In the west he ranged from the Atlantic coast at Tintagel and on through the West of England to the Channel Islands.

Swinburne had a great love of the east coast, and especially of Suffolk and Norfolk. At Dunwich he wrote 'By the North Sea'. Much of his poetry contains a balance of description and meditation:

> *A land that is thirstier than ruin;*
> *A sea that is hungrier than death;*
> *Heaped hills that a tree never grew in;*
> *Wide sands where the wave draws breath.*

Much of Swinburne's life, however, was spent in the south. He loved the Isle of Wight, where he had spent many youthful years. It was on the island that he was introduced to the poets Samuel Rogers and William Wordsworth. Charles Dickens wrote part of *David Copperfield* here, and Swinburne played with his sons. Later, the young poet was to do important work here. It was at East Dene, the family home at Bonchurch, that he began the dramatic poem *Atalanta in Calydon*. His cousin, Mary Gordon, recalled later that it was on the road between Newport and Shorwell that Swinburne had first repeated to her the famous chorus 'When the hounds of Spring are on Winter's traces'.

The Isle of Wight has some lovely landscape, and also danger, represented by the massive Culver Cliff. During the Christmas holiday of 1854, Swinburne, who looked far more a poet than a mountaineer, decided that he would attempt to climb Culver Cliff; so far as he knew no one had ever completed the ascent before. His description of the climb is a dramatic one; the first route he chose proved impossible because of an overhanging ledge, so he tried another:

> As I began again I must own I felt like setting my teeth and swearing I would not come

Bonchurch churchyard, Isle of Wight (*see* Swinburne)

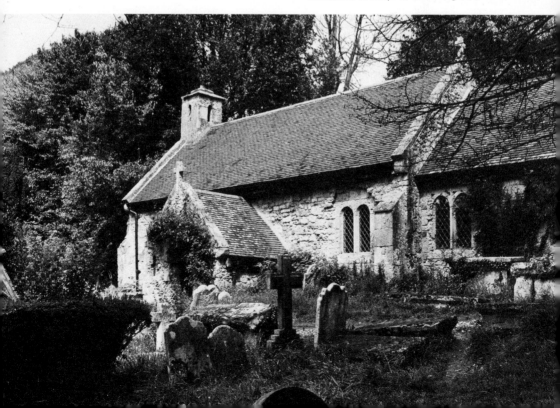

down again alive . . . if I did return to the foot of the cliff again it should be in the fragmentary condition, and there would be much of me to pick up. . . I was a little higher, quite near the top or well within hail of it, when I thought how queer it would be if my very scanty foothold gave way; and at that very moment it did . . . and I swung in the air by my hands from a ledge on the cliff which gave room for the fingers to cling and hold on.

There was a projection of rock to the left at which I flung out my feet sideways and just reached it; this enabled me to get breath and crawl at speed (so to say) up the remaining bit of cliff. At the top I had not strength enough left to turn or stir; I lay on my right side helpless, and just had time to think what a sell (and what an inevitable one) it would be if I were to roll back over the ledge after all. . .

He promised his mother he would not do it again. However, if Swinburne had worried his mother, he was to shock Victorian society later, with his poems of passion in 1866, which were regarded as a challenge to morality.

Swinburne died on 10 April 1909, and was buried in the churchyard of St Boniface, Bonchurch, near other members of his family. In 1910 Thomas Hardy visited Swinburne's grave, and wrote 'A Singer Asleep'. This fine poem ends:

Shake him when storms make mountains of their plains.

And deft as wind to cleave their frothing manes—
I leave him, while the daylight gleam declines
Upon the capes and chines.

TENNYSON AT FARRINGFORD AND ALDWORTH

In 1853, Tennyson and his wife visited Bonchurch on the Isle of Wight—they had crossed the Solent in a rowing boat!—and learned that a house called Farringford might make a suitable home. On 25 November they took possession of Farringford, which was to be their home for 40 years, and where many fine poems were written. Today Farringford is an hotel.

Tennyson bought a pair of binoculars for bird watching and also began to study geology. The poet became a familiar and unmistakable bearded figure on his favourite walks over High Down, his great military cloak flapping in the wind.

Three years after moving in, the title of Farringford was proved good, and the Tennysons now finally completed the purchase of the property. Mrs Tennyson noted in her journal: 'At sunset, the golden green of the trees, the burning splendour of Blackgang Chine and St Catherine's, and the red bank of the primeval river, contrasted with the turkis-blue of the sea that is our view from the drawing room, make altogether a miracle of beauty. We are glad that Farringford is ours.'

Tennyson also visited the New Forest. While staying at the Crown Hotel at Lyndhurst, Hampshire, he noted in his letter-diary:

I lost my way in the Forest today, and have walked I don't know how many miles. I found a way back to Lyndhurst by resolutely following a track which brought me at last to a turnpike. On this I went a mile in the wrong direction, that is towards Christchurch, then met a surly fellow who grudgingly told me I was four miles from Lyndhurst. My admiration of the Forest is great: it is true old wild English Nature, and then the fresh heath-sweetened air is so delicious. The Forest is grand.

The ever-growing fame of the poet brought autograph hunters and unbidden callers. People climbed trees to glimpse him in his study. Such unwelcome intrusions caused him to leave Farringford for Aldworth near Haslemere; but he always returned to the island during the winter months. Tennyson had for years suffered from hay fever but the altitude and air of Aldworth appeared to cure it. When walking or driving, he particularly liked the landscape around Blackdown and Haslemere.

When Alfred, Lord Tennyson died, he was buried in Westminster Abbey; Emily, Lady Tennyson, is buried in the quiet churchyard at Freshwater, Isle of Wight.

SEE ALSO PAGE 89

EDWARD THOMAS

A remarkable writer by any standards, Edward Thomas (1878–1917), had written by the time of his death some 30 books of prose, mostly travel, essays and biography, plus some 150 poems. Many of the poems are among the finest written this century, and place him among the best nature poets of any period.

The remarkable thing about his life as a writer was that by the age of 36 he had never attempted to write a poem, so that all of his poetry was accomplished in the last two and a half years of his life. In many ways he was a tragic figure, wanting the life of a writer, loving the countryside, and bringing up a family on 'a pound a thousand words'. He felt guilt, depression, and considered suicide. His first published poems appeared in *Six Poems*, a little book printed by his friend James Guthrie of the Pear Tree Press at Flansham, near Bognor. Apart from that small collection he saw no more of his poems in print. The early poems were published under the assumed name of 'Edward Eastaway'. Being well known as a reviewer, he felt that by using a pseudonym he was far less liable to a prejudiced reception.

Following his death during the battle of Arras, Easter 1917, his poetry was hailed with enthusiasm; he was also described as a war poet, which he was not. Later he was to be heaped among the many lacklustre 'Georgian Poets' and generally disregarded. Since the 1950s the poetry of Edward Thomas has been rediscovered and brought into the light, to gleam with a low-key mystical beauty. It was Walter de la Mare who wrote, 'When Edward Thomas was killed, a mirror of England was shattered of so pure and true a crystal that a clearer and tenderer reflection of it can be found no other where.'

Although Edward Thomas was born in Lambeth, his parents were Welsh, and he became increasingly proud of his Welsh ancestry, visiting Wales whenever he could. He married Helen Noble, the daughter of a reviewer and literary journalist. After Edward's death Helen Thomas published books of her own. *As it Was* and *World without End*, first published in the early 1920s, did much to arouse interest in Edward Thomas, and in their life together.

When he was 19, Edward published his first book of essays, *The Woodland Life*:

A rustling breath of wind sighs through the dense foliage and disperses the fog, till all around countless points of frosty crystal glitter in the tardy sunlight. Slowly the landscape is unfolded as the fog retires, and depths of woodland, unseen before, loom slowly into view. Instantly, as in answer to a signal, the shivering birds scatter from their retreats of knot-hole, tussock, and rugged oak-limb. Widespread companies of rooks go dinning overhead and the starlings take a hurrying flight eastward.

Much of his writing was mere hack work, done to keep the wolf from the door: at one time the Thomases only had eightpence in the world. An important part of his small income —the most he ever earned in a year was £250 —came from his book reviewing. He was highly perceptive of original work, which led him to encourage poets then unknown, such as Ezra Pound and W. H. Davies. His enthusiastic review of Robert Frost's early poems *North of Boston* resulted in the two men becoming firm friends. Thomas maintained, 'I couldn't write a poem to save my life'. Frost, with his new conversational style of poetry, was quick to point out that much of Edward Thomas's prose was poetry in itself. Although Robert Frost gave the impetus to Thomas to write poetry, he did not influence it. But the solitary new poet was certainly excited to find in Frost a man whose ideas about poetry were so similar to his own.

Edward Thomas had walked or travelled by train in many parts of England and Wales. Favourite areas included the Brecon Beacons and the Cambrian Mountains, also the counties of Wiltshire, Oxfordshire, Gloucestershire, Hampshire, Sussex and Kent. But the true crucible for his creativity lies in the Hampshire village of Steep, close to the border with Sussex. This, undoubtedly, is Edward Thomas country.

OPPOSITE ABOVE *Petworth Park* looking towards the village of Tillington, Sussex, by Joseph Mallord William Turner (*see* p. 180)

OPPOSITE BELOW Beech trees on Selborne Hanger (*see* White, p. 182)

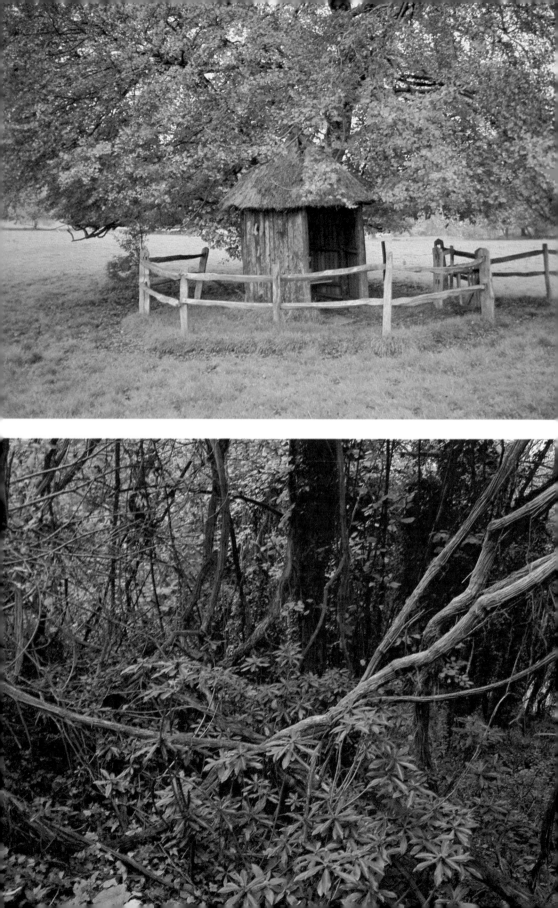

It was at Steep that the poems began to come. Over a period of five or six years, Edward and Helen, with their family of a son and two daughters, were to live in three houses in the village. To walk the hills, woodlands and lanes of Steep is to open yourself to the same stimuli that Thomas received. Their first home was at Berryfield Cottage; as Mrs Thomas was to write years later: 'We are very isolated here, for though it was not much more than a mile from the village and the school, we were tucked away among trees and hills, and the winding lane which led to the outer world was the darkest lane I have ever known: so deep and dark it was that the entrance to it on the main road looked like the entrance to a tunnel.' The school referred to was Bedales, where the two eldest children, Mervyn and Bronwen, were educated.

The next house, on Stonor Hill, now called the Red House, was more spectacular, built by a man named Geoffrey Lupton, a wealthy disciple of William Morris and John Ruskin. Hand-made bricks, tiles, glass, ironwork, and English oak were the order of the day when Lupton built; but even so, Edward Thomas never really cared deeply for the house. It is situated high on the ridge of the hill with magnificent views over Steep and on to 'Sixty miles of South Downs at one glance'. It attracted many writer friends, including Rupert Brooke and W. H. Davies. Near by was a thatched hut, now re-roofed and made part of a substantial house. It was here that many of the first poems were written.

Thomas refers to the Red House, his 'Cloud Castle', in his poem 'Wind and Mist'.

Alone in all the world, marooned alone.
We lived in clouds, on a cliff's edge almost
(You see), and if clouds went, the visible earth
Lay too far off beneath and like a cloud.
I did not know it was the earth I loved
Until I tried to live there in the clouds
And the earth turned to cloud.

OPPOSITE ABOVE A bird hide reconstructed in memory of the late James Fisher. Gilbert White had a similar hide on this spot (*see* p. 182)

OPPOSITE BELOW Spurge and laurel and wild clematis, Selborne (*see* White, p. 182)

1 Steep Church with Edward Thomas Memorial Window
2 The poet's first home in the village
3 The poet's last home in the village
4 Second Thomas home, many poems written here.

The final move in the village was to No. 2 Yew Tree Cottages, and here he became even more restless. Not far from the cottage is the crossroads of the village, so well described in that splendid poem 'Aspens' that begins:

All day and night, save winter, every weather,
Above the inn, the smithy, and the shop,
The aspens at the cross-roads talk together
Of rain, until their last leaves fall from the top.

The inn has been rebuilt and the smithy's now a garage, but the aspens still remain. Edward Thomas is commemorated in Steep church with an engraved window by Laurence Whistler, and beyond the Red House, a footpath leads through woodland to the open slope of Shoulder of Mutton Hill, where a sarsen stone with a bronze plaque forms another permanent memorial.

THIS MONUMENT,
IN HONOUR OF THOMAS GRAY,
WAS ERECTED A.D. 1799, AMONG
THE SCENES CELEBRATED BY THAT
GREAT LYRIC AND ELEGIAC POET.
HE DIED JULY 30TH 1771, AND
LIES UNNOTICED IN THE CHURCH YARD
ADJOINING, UNDER THE TOMBSTONE ON
WHICH HE PIOUSLY AND PATHETICALLY
RECORDED THE INTERMENT OF HIS
AUNT AND LAMENTED MOTHER.

JAMES THOMSON, THOMAS GRAY, AND WILLIAM COLLINS

The poet James Thomson (1700–48) is one of the most important poets of the 18th century. Born at the village of Ednam, near Kelso in the Border country, he brought a new eye and voice to nature. He had intended to follow his father into the ministry, but his Professor of Divinity found his sermons too imaginative, so he abandoned the Church and left for London.

It was at this time that there was a movement beginning increasingly to link Christianity with the natural world, wild landscape, woodland and farmland. Already there were painters showing a romantic view of landscape. So the ground for Thomson's nature poetry was already made fertile. He arrived in London in 1725. His poem 'Winter' appeared in 1726, followed by 'Summer' in 1727, 'Spring' in 1728, and 'Autumn' in 1730, when all were published together as *The Seasons*. It was all so fresh to the reading public:

See, Winter comes, to rule the varied year,
Sullen and sad, with all his rising train;
Vapours, and Clouds, and Storms. Be these
* my theme. . .*

Or the robin who comes to the farmhouse window and then:

. . . brisk, alights
On the warm hearth; then, hopping o'er the floor,
Eyes all the smiling family askance,
And pecks, and starts, and wonders where he is—
Till, more familiar grown, the table-crumbs
Attract his slender feet.

The Seasons was reprinted, and pirated, many times, yet even in the late 18th century, editions of the work were still to be found with the advertisement:

Blank verse, as it not only will admit of, but always requires, a more sublime and elevated stile [sic] and manner of expression suited to its nature and design, so generally it is more difficult to be understood by those who have not enjoyed a liberal education, or are proficients in classical erudition.

OPPOSITE Monument in honour of Thomas Gray adjoining the churchyard at Stoke Poges, Buckinghamshire

When Thomson died, William Collins wrote an Elegiac Ode that begins:

In yonder grave a Druid lies,
Where slowly winds the stealing wave!
The year's best sweets shall duteous rise
To deck its poet's sylvan grave.

Collins and Thomson had been close friends. Thomson had received a pension of £100 from the Prince of Wales, and was made Surveyor-General of the Leeward Islands. After paying a deputy to carry out any duties for him, Thomson was still left with £300 a year and settled comfortably in a villa at Richmond in Surrey. Thomson died in middle age, but the life of Collins (1721–59) was even shorter and far more tragic. Little more than a thousand lines of Collins's poetry has survived, but it includes his beautiful 'Ode to Evening', filled with all its enjoyment of landscape and natural beauty. The following twelve lines breathe its quality:

Then lead, calm votaress, where some sheety lake
Cheers the lone heath, or some time-hallowed pile,
Or up-lands fallows grey
Reflect its last cool gleam.

But when chill blustering winds, or driving rain,
Forbid my willing feet, be mine the hut,
That from the mountain's side,
Views wilds, and swelling floods,

And hamlets brown, and dim-discovered spires;
And hears their simple bell, and marks o'er all
Thy dewy fingers draw
The gradual dusky veil.

Thomas Gray (1716–71) brought a similar delicate touch to his poetry. His 'Elegy written in a Country Churchyard' was published in 1750. Gray and his mother, to whom he was devoted, lived at Stoke Poges, Buckinghamshire, and it is to that churchyard that the Elegy is linked. They are both buried in the same vault outside the east end of the church.

In a field next to the churchyard, now known as Gray's Field, a fine classical monument was created in Gray's memory by John Penn, a grandson of William Penn, founder of Pennsylvania. The field and its monument are now the property of the National Trust.

It is said that General Wolfe made a comment before the battle of Quebec to the effect

that the composition of Gray's Elegy was a greater accomplishment than the climbing of the Heights of Abraham. These opening stanzas must surely be familiar friends to all:

The curfew tolls the knell of parting day,
The lowing herd wind slowly o'er the lea,
The ploughman homeward plods his weary way,
And leaves the world to darkness and to me.

Now fades the glimmering landscape on the sight,
And all the air a solemn stillness holds,
Save where the beetle wheels his droning flight,
And drowsy tinklings lull the distant folds;

Save that from yonder ivy-mantled tower
The moping owl does to the moon complain
Of such as, wandering near her secret bower,
Molest her ancient solitary reign.

Beneath those rugged elms, that yew-tree's shade,
Where heaves the turf in many a mouldering heap,
Each in his narrow cell for ever laid,
The rude forefathers of the hamlet sleep.

ARCHIBALD THORBURN

The animal and bird paintings of Archibald Thorburn (1860–1935), form a unique link between the 19th and 20th centuries. He saw the many changes that were taking place in book illustration and colour printing. By 1890 he was already recognized as a major talent. His first illustration appeared in 1883, in *Sketches of Bird Life* by James Edmund Harting, one of the leading naturalists of the day.

Thorburn was born at Lasswade in Midlothian near Edinburgh, the fifth son of Robert Thorburn a brilliant miniature painter who was made an Associate of the Royal Academy in 1848. He painted Queen Victoria and Prince Albert, and his work continues to be much admired. Archibald Thorburn, who received much advice and training from his father, also spent some time at an art school in St John's Wood, London. His 144 illustrations for Swaysland's *Familiar Wild Birds* in four volumes appeared between 1883 and 1888, and it made his reputation.

He illustrated sporting books, contributed the colour plates to W. H. Hudson's *British Birds* (1895) and to Dresser's *Birds of Europe*. Thorburn specialized in gamebirds and his paintings are full of painstaking detail that shows a real knowledge and understanding of his subject.

Thorburn's own books are of great beauty and rarity and his later work becomes increasingly naturalistic. The most delightful plates are those that show a bird or animal in its natural environment. He painted plants with great skill and many of his paintings and colour plates are enhanced by the addition of yellow horned poppies, or thrift, in juxtaposition to sea birds.

Thorburn's final painting was of a goldcrest, which he completed on his deathbed. He made his home at Hascombe, Godalming, in Surrey, from just before the First World War, an excellent area in which to pursue his observation of the many song birds and gamebirds that gave him so much pleasure.

J. M. W. TURNER AND PETWORTH

George Wyndham, third Earl of Egremont, was the main patron of J. M. W Turner (1775–1851). The earl's home, Petworth House, saw a continuous coming and going of visitors, many of them artists. The hospitality was generous, and Lord Egremont good natured. The house was, and still is, an astonishing picture gallery, containing fine works by Van Dyke and twenty superb oils by J. M. W. Turner.

Petworth is not merely a great house; it looks out upon one of the most beautiful parks in Britain, a landscape of small hills, woodlands, and a Capability Brown lake. This, for Turner, was undoubtedly a creative landscape. He painted several major works here including *The Lake Petworth: Sunset: Stag Drinking*, *Petworth from the Lake*, *Dewy Morning*, and *The Lake Petworth: Sunset: Bucks Fighting*. This group of twenty canvases constitutes the largest number outside the Turner Bequest.

Turner and the earl were firm friends; no demands were made of the artist, and he came and went as he pleased. When Turner first arrived at Petworth in 1809, a bedroom in the northeast corner of the house was reserved as a

OPPOSITE *Peregrine on the Lookout,* by Archibald Thorburn

studio. Only the artist and the earl were permitted to enter it. Turner also painted several interior watercolours at Petworth including his studio over the Chapel. The range of the remaining oils, in geographical terms, extend from Cockermouth to the Thames and the Tamar, the Medway and Brighton.

The earl's taste in pictures leaned particularly towards naturalistic views, especially those including water, and it fortunately happened that during the period he was buying, Turner was painting just such scenes. He also painted *Chichester Canal* while at Petworth. As a painting it is much admired and reproduced, although it is a picture in which Turner has altered the heavens as well as the topography with the sun setting in the north!

Petworth Park is open to the public and the house is a National Trust property.

GILBERT WHITE

The village of Selborne must be the place of pilgrimage for all who love the English countryside and its wild creatures. That people continue to journey each year to Selborne from the most distant parts of the world is entirely due to the life of one man, the Reverend Gilbert White (1720–93). The compulsive attraction held by this little village, which lies along the B3006 road between Liss and Alton, in Hampshire, is due to the manner in which Gilbert White described his native village. In his book, *The Natural History and Antiquities of Selborne*, published in 1789, Gilbert White wrote in loving detail of his daily observations of people, plants, animals and birds. His writing style is simple and straightforward. The book in fact has its basis in a series of letters to his two friends, the distinguished naturalists Thomas Pennant and Daines Barrington; but what a fascinating correspondence it is. This book was to find itself fourth in the list of books most printed in the English language. *The Natural History and Antiquities of Selborne* now stands as one of the classics of English literature.

Gilbert White was educated at Oxford, held several curacies, and became curate of Faringdon, the neighbouring parish to Selborne, in about 1758. In 1784 he was appointed

curate of Selborne. A very small man, he had an eagle eye and an insatiable curiosity. He walked every footpath in the parish, poking about in the hedgerows with his stick, noting a new plant or nest.

Gilbert White maintained calendars of bird departures and arrivals. He also noted weather, and the progress of his garden plants and vegetables. The fact that he remained unmarried, and was free of financial worry, no doubt suited his work, and he is frequently claimed to be the 'father of field naturalists'. Perhaps his greatest gift was that of being able to retain an open mind in all things.

The house where Gilbert White lived is called 'The Wakes'. He first went there at the age of 9 and, apart from brief periods of absence, it always remained his family home. Today the house is maintained as The Gilbert White Museum and The Oates Memorial Library and Museum. The early part of the house dates from the 17th century, but a succession of owners since 1839 have carried out many alterations and additions to the property. Behind the house are the fine gardens and lawn. White's sundial still stands at the edge of the ha-ha that creates an uninterrupted view to the heavily wooded hillside, or 'hanger', beyond. A wall that Gilbert White built for fruit growing still bears the inscription G.W. 1761.

Gilbert White also laid a brick path from his back door, opening out from a porch at the side of his study, leading into the field beyond the ha-ha, where he had a hide for watching birds. The brick path remains, but the hide has been reconstructed in memory of the late James Fisher. It was Fisher who edited the Penguin edition of *The Natural History of Selborne* in 1941, a blessed raft of sanity in the midst of war.

Together with his brother John, Gilbert White cut the zigzag path that leads to the top of the hanger, where now, as in White's day, great views spread out above the village and to the distant South Downs.

A whole day may be pleasantly filled in the exploration of Selborne. The sunken lanes and wooded paths east of the church are full of

OPPOSITE 'The Wakes', Selborne, seen from the garden (*see* White)

beauty and peace. St Mary's Church has a superb window of stained glass filled with the birds that are mentioned by Gilbert White. Outside, on the north side of the church, is the grave of Gilbert White, with a simple headstone marked G.W. and the date, 1793. White requires no other memorial; what he achieved remains, and a rare beauty still flowers in Selborne.

W. B. YEATS

This great poet and playwright (*see* p. 54, 55; and for association with Ezra Pound *see* p. 167) was very much the voice of Ireland, but a number of his works were written at The Chantry House, at Steyning in Sussex, the home of the late Miss Edith Shackleton Heald. On the front of the house is a plaque

Miss Edith Shackleton Heald, W. B. Yeats and Mrs Edmund Dulac at the Chantry House, Steyning, Sussex (*see* Yeats)

with the simple inscription 'William Butler Yeats, 1865–1939, wrote many of his later poems in this house.'

In 1938 Yeats wrote to Maud Gonne: 'I am staying with an old friend here, one of the best paid women journalists in the world.' He spent nearly a year in Sussex during the last five years of his life when his *Last Poems and Two Plays* were written; he regarded The Chantry House as a retreat. Miss Heald drove him all over the South of England and their journeys would be punctuated with his questions about houses, wondering what sort of people would live in them and what they did for a living. One drive took them to Field Place, near Horsham, where Shelley was born. They were shown the birth room and Yeats was delighted, for he greatly admired Shelley.

He wrote the whole of his best play, *Purgatory*, while at Steyning. His routine was to write in the very early morning, before breakfast, on old scraps of paper. When writing a poem, he spoke the words aloud, developing the rhythm of the composition. The poems 'Those Images' and 'The Long-legged Fly' were developed and completed at Steyning. Yeats liked to hear of any unexpected associations with Ireland, and he became excited when he learned that a Victorian house in Church Street, Steyning, had once been the Register Office where Charles Stewart Parnell and Mrs O'Shea were married.

Steyning is an ancient market town that, like Rye, feels like a village. The surrounding hills and the richness of the lush green countryside must certainly have suggested many parallels with Ireland, and in so doing brought happiness in the last years of his life. Miss Shackleton Heald and Mrs Yeats together watched over the poet the night he died in the South of France.

SEE ALSO PAGES 54, 55

Bibliography

A Family History—1688–1837. The Wyndhams of Somerset, Sussex and Wiltshire, by H. A. Wyndham. Oxford University Press, 1950.

Autobiography, by Eric Gill. Jonathan Cape, 1940.

The Life of Eric Gill, by Robert Speight. Methuen, 1966.

Blake's Hayley. The Life Works and Friendships of William Hayley, by Morchard Bishop. Victor Gollancz Ltd, 1951.

Tennyson A Memoir, by Hallam Lord Tennyson, 2 vols. Macmillan & Co, 1897.

W. B. Yeats. 1865–1939, by Joseph Hone. Macmillan & Co Ltd, 1942.

The Collected Poems of W. B. Yeats. Macmillan & Co Ltd, 1955.

Vision and Revision in Yeat's Last Poems, by Jon Stallworthy. Oxford University Press, 1969.

Memories, by Julian Huxley. George Allen and Unwin Ltd, 2 vols. 1970 & 1973.

Young Thomas Hardy, by Robert Gittings. Heinemann, 1975.

The Older Hardy, by Robert Gittings. Heinemann, 1978.

The Oxford Illustrated Literary Guide to Great Britain and Ireland, Edited by Dorothy Eagle and Hilary Carnell. Oxford University Press, 1981.

Literary Britain, A Readers Guide to Writers and Landmarks, by Frank Morley. Hutchinson, 1980.

Rudyard Kipling. His Life and Works, by Charles Carrington. Macmillan & Co Ltd, 1955.

A Sketchbook of Birds, by C. F. Tunnicliffe, R.A., Introduction by Ian Niall. Victor Gollancz Ltd, 1979.

George Morland, Painter, by Ralph Richardson. Elliot Stock, 1895.

Rupert Brooke, A Biography, by Christopher Hassall. Faber and Faber Ltd, 1964.

John Keats, by Robert Gittings. Heinemann, 1968.

Down, The Home of the Darwins, by Sir Hedley Atkins K.B.E. Phillimore, for The Royal College of Surgeons of England, 1976.

Charles Darwin, by John Chancellor. Weidenfeld and Nicolson, 1973.

English Painting, by R. H. Wilenski. Faber and Faber Ltd, 1933.

The Eye of the Wind, by Peter Scott. Hodder and Stoughton, 1961.

Aspects of E. M. Forster, Edited by Oliver Stallybrass. Edward Arnold (Publishers Ltd.), 1969.

Autobiography, by John Cowper Powys. A New Edition with an Introduction by J. B. Priestley. Macdonald, 1967.

Skin for Skin, by Llewelyn Powys. Jonathan Cape, 1926.

The Brontës and their World, by Phyllis Bentley. Thames and Hudson, 1972.

A Writer's Britain, Landscape in Literature, by Margaret Drabble, Photographed by Jorge Lewinski. Thames and Hudson, 1979.

George Borrow, by Edward Thomas. Chapman & Hall Ltd, 1912.

Ring of Bright Water, by Gavin Maxwell. Longmans, 1960.

Raven Seek Thy Brother, by Gavin Maxwell. Longmans, 1968.

Goodbye West Country, by Henry Williamson. Putnam, 1937.

Tarka The Otter, by Henry Williamson. (First Published 1927), Published by the Nonesuch Press Ltd, 1964.

The Cantos of Ezra Pound. Faber and Faber, 1964.

Modern English Painters, by John Rothenstein, 2 vols. 1952 & 1956.

Edward Thomas, The Last Four Years, Book One of the Memoirs of Eleanor Farjeon. Oxford University Press, 1958.

A Literary Pilgrim in England, by Edward Thomas. Jonathan Cape, (First Published 1917). First issued in Travellers' Library, 1928.

Edward Thomas, A Critical Biography, by William Cooke. Faber and Faber, 1970.

Coleridge and Wordsworth in Somerset, by Berta Lawrence. David and Charles, 1970.

David Jones, Writer and Artist, by Harman Grisewood. (Annual Lecture for 1965 of the BBC in Wales).

The Poet and the Landscape, by Andrew Young. Rupert Hart-Davies, 1962.

Complete Poems, Andrew Young. Secker & Warburg, 1974.

The Lake District: An Anthology, Compiled by Norman Nicholson. Robert Hale, 1977.

Some Portraits of The Lake Poets: and Their Homes, by Ashley Abraham. Published by G. P. Abraham, Keswick, 1914.

The Faber Book of Poems and Places, Edited with an Introduction by Geoffrey Grigson. Faber and Faber, 1980.

The Lilting House. An Anthology of Anglo-Welsh Poetry, 1917–67, Editors: John Stuart Williams and Meic Stephens. J. M. Dent & Sons Ltd, Christopher Davies Ltd, 1969.

The Complete Poems of Thomas Hardy. The New Wessex Edition. Macmillan London Ltd, 1976.

Vernon Watkins, 1906–1967, Edited by Leslie Norris. Faber and Faber Ltd, 1970.

The Oxford Companion to Music, by Percy A. Scholes. Tenth Edition. Edited by John Owen Ward. Oxford University Press, 1980.

Edward Elgar: Memories of a Variation, by Mrs Richard Powell. Oxford University Press, 1937.

R.V.W. A Biography of Ralph Vaughan Williams, by Ursula Vaughan Williams. Oxford University Press, 1964.

The Master Musicians Series. Britten, by Michael Kennedy. J. M. Dent & Sons Ltd, 1981.

On Receiving The First Aspen Award. A Speech by Benjamin Britten. Faber and Faber, 1964.

The Georgian Literary Scene 1910–1935, by Frank Swinnerton. Hutchinson & Co. (First Published 1935), Revised Edition 1969.

A Century of British Painters, by Richard and Samuel Redgrave. Phaidon Press Ltd, 1947.

The Life of William Blake, by Mona Wilson. Peter Davies Ltd, 1932.

The Seasons, by James Thomson. 1777.

The Poetical Works of Gray and Collins. Oxford University Press, 1917.

Moments of Vision, Kenneth Clark. John Murray, 1981.

Writer's Houses, A Literary Journey in England, by Michael and Mollie Hardwick. Phoenix House, London, 1968.

The Phaidon Companion to Art and Artists in The British Isles, by Michael Jacobs and Malcolm Warner. Phaidon Press Ltd, 1980.

The Natural History of Selborne, by Gilbert White. (First Published 1788–9). The Penguin English Library, 1977.

Delius, As I knew Him, by Eric Fenby. (First Published 1936 by G. Bell & Sons Ltd). Revised and Edited by the Author and Published by Icon Books Ltd, 1966.

Middlemarch, by George Eliot. (First Published 1871–2). The Penguin English Library, 1982.

John Betjeman's Collected Poems. Fourth Edition. John Murray, 1980.

Cider With Rosie, by Laurie Lee. The Hogarth Press, 1959.

Far From the Madding Crowd, by Thomas Hardy. (First Published 1874). The Penguin English Library, 1978.

Literary Associations of The English Lakes, by Rev. H. D. Rawnsley. James Maclehose and Sons, 1909.

Landscape in Britain 1850–1950. Arts Council of Great Britain, 1983.

Dylan Thomas, Letters to Vernon Watkins, Edited with an Introduction by Vernon Watkins. J. M. Dent and Sons Ltd and Faber and Faber Ltd, 1957.

Lark Rise to Candleford, by Flora Thompson. .Oxford University Press, 1954.

Mendelssohn In Scotland, by David Jenkins and Mark Visocchi. Chappell & Company in Association with Elm Tree Books, 1978.

Illustration Sources

The publishers would like to thank the following:

Bryan and Cherry Alexander: 149

Birmingham Museums and Art Gallery: 162/63

The Bridgeman Art Library: 59, 75, OPPOSITE 112 (Private Collection), 117

The British Museum, London: 75

British Tourist Authority: 12, 22, 23, 44 (2), 83, 84, 85, 88, 133, 154, 156

Christie, Manson & Woods, London: 71

Darwin Museum, Kent: 143, 144

Martin Dohrn: TITLEPAGE, 29, 30, OPPOSITE 32 ABOVE, INSERT BETWEEN 64/65 RIGHT BELOW, OPPOSITE 65, 69, 73, OPPOSITE 80 ABOVE, INSERT BETWEEN 80/81 LEFT, INSERT BETWEEN 80/81 RIGHT, OPPOSITE 81 BELOW, OPPOSITE 96 ABOVE, INSERT BETWEEN 96/97 LEFT ABOVE, INSERT BETWEEN 96/97 RIGHT ABOVE, OPPOSITE 96 ABOVE, OPPOSITE 96 BELOW, 98, 101, INSERT BETWEEN 112/113 LEFT, 169, OPPOSITE 176 BELOW, OPPOSITE 176 BELOW, OPPOSITE 177 ABOVE, OPPOSITE 177 BELOW, 183

Courtesy Curtis Brown Ltd: 172

Derby Art Gallery: 94

Robert Estall: INSERT BETWEEN 96/97 RIGHT BELOW, 155

Mary Evans Picture Library: 46, 167

The Fine Art Society, London: 27 (2), 28

Reproduced by courtesy of the Syndics of the Fitzwilliam Museum, Cambridge: OPPOSITE 112 BELOW

Foto Bank: 77

Robert Harding Associates: 142

John Hedgecoe: 32

Irish Tourist Board, Dublin: 50, 54, 55, 56/7

E. A. James: OPPOSITE 161

Leeds City Art Gallery and Museum: 171

Jorge Lewinski: HALF-TITLE, 13, 20, 21, 39, 79, 82, 87, 93, 114–15, 152, 174

Colin Molyneux: 65, INSERT BETWEEN 64/65 LEFT, INSERT BETWEEN 112/13 RIGHT

Jeremy Mulcaire: OPPOSITE 114 BELOW, 147, 151, OPPOSITE 160 ABOVE, OPPOSITE 160 BELOW

The National Gallery, London: 102

The National Portrait Gallery, London: 31, 70

The National Trust: 180

Norwich Castle Museum: 104, 106

Perth Museum and Art Gallery (on loan from a Private Collection): 19

Piccadilly Gallery: 126

Paul Popper Ltd: 98

Bernard Price: 139, 184

S. & G. Press Agency Ltd: 134

Scottish Tourist Board: 17

The 79 Slide File, Dublin: 49, 50, 52

Courtesy Colin Smythe: 53

The Society of Authors: 53

Sotheby Parke Bernet & Co.: 51

Spectrum Colour Library: OPPOSITE 16, 90/91, 111, 137

Collect on Lady Spencer-Churchill: 142

The Tate Gallery, London: 49, 61, 64, 68, 74, 105, 107, 108, 121, 123, 128, 130 (Rissell Collection), 140, 150, 158, INSERT BETWEEN 160/61 RIGHT, 173, OPPOSITE 176 ABOVE

Art Gallery and Temple Newsam House, Leeds: 45

Tryon Gallery: 180

The Victoria and Albert Museum, London: 14, INSERT BETWEEN 64/65 RIGHT ABOVE, 117, 160, 161, 165

Tina Walker: OPPOSITE 144 ABOVE, OPPOSITE 145 ABOVE, OPPOSITE 145 BELOW, INSERT BETWEEN 160/61 LEFT, 166, 168, 172

Frederick Warne Ltd: 37

Simon Warner, Yorkshire: 127

Tom Weir: 16

Welsh Tourist Board: 63

Derek G. Widdicombe: OPPOSITE 17, 32, OPPOSITE 32 BELOW (Noel Habgood), 41, 42/43 (Noel Habgood), 67 (Noel Habgood), OPPOSITE 80 BELOW, OPPOSITE 96 BELOW, 112, 119, 153

R. L. C. Williamson: OPPOSITE 113, 125

(c) Woodmansterne Ltd, Watford: OPPOSITE 81 ABOVE

Acknowledgments

The author gratefully acknowledges the following for permission to include material which is their copyright:

Oxford University Press for extracts from *Lark Rise to Candleford*, by Flora Thompson, and an extract from *R.V.W.: A Biography of Ralph Vaughan Williams*, by Ursula Vaughan Williams.

David Higham Associates Limited, and J. M. Dent (Publishers) for extracts from *Dylan Thomas Letters to Vernon Watkins*, and lines from *Dylan Thomas Collected Poems*.

The Society of Authors, on behalf of the Bernard Shaw Estate, for lines from *Bernard Shaw's Rhyming Picture Guide to Ayot St Lawrence*.

The Society of Authors as the literary representative of the Estate of John Galsworthy, for extracts from *The Life and Letters of John Galsworthy*, and the poem *Scatter My Ashes*.

The Society of Authors as the literary representative of the Estate of John Masefield, for extracts from *London Town*, *Sea-Fever*, and *The Everlasting Mercy*.

Robin Haines, Sole Trustee of the Gurney Estate 1982 for ' *The High Hills*'. Reprinted from *Collected Poems of Ivor Gurney*, edited by P. J. Kavanagh (1982), by permission of Oxford University Press.

John Betjeman, for extracts from the *Collected Poems of John Betjeman*, published by John Murray (Publishers) Ltd.

The National Trust and Macmillan London Limited, for extracts from the *Collected Poems of Rudyard Kipling*, and extracts from *Rudyard Kipling, His Life and Work*, by Charles Carrington, 1955.

Messrs Secker & Warburg Limited for two poems from the *Complete Poems, by Andrew Young*.

Laurence Pollinger Limited; "copyright © 1962 The Estate of Frieda Lawrence Ravagli", for an extract from a letter to Rolf Gardiner dated 3 December 1926, from *The Collected Letters of D. H. Lawrence*.

Laurence Pollinger Limited, and the Estate of John Cowper Powys, for extracts from *Autobiography*, by John Cowper Powys, published by Pan Books Limited.

Laurence Pollinger Limited, and The Estate of the late H. E. Bates, for an extract from *The Four Beauties*, by H. E. Bates, published by Michael Joseph Limited.

The Society of Authors, as the literary representatives of the Estate of Llewelyn Powys, for an extract from *Skin for Skin*.

The Royal Academy of Arts, and Derek Hill, for an extract from *The Royal Academy Landseer Exhibition Catalogue of 1961*.

Henry Moore, and The Henry Moore Foundation, for an extract from a talk recorded by Henry Moore for The British Council, 1955; and an extract from *The Listener*, August 1937.

Ted Walker for an extract from his poem *Breakwaters*, included in *Fox on a Barn Door* (poems 1963–4), published by Jonathan Cape.

Faber and Faber Publishers, for six lines from *canto LXXXIII from The Cantos of Ezra Pound*. Also extracts from *On Receiving The First Aspen Award*, by Benjamin Britten. Also extracts from '*In Parenthesis*', by David Jones.

Extract from a Broadcast Talk given by David Jones, for BBC Wales 1954, Copyright © Trustees of the David Jones Estate.

Lines from *Taliesin in Gower*, by Vernon Watkins, Copyright © Gwen Watkins.

Penguin Books Limited, for permission to use extracts from Gavin Maxwell: *Ring of Bright Water*, (Longman, Green 1960) Copyright © Gavin Maxwell, and *Raven Seek Thy Brother*, (Longman, Green 1968) Copyright © Gavin Maxwell, 1968.

Macmillan London Limited, for extracts from *Far From The Madding Crowd*, by Thomas Hardy, and lines from *The Collected Poems of Thomas Hardy*.

Chatto & Windus for two extracts from *Cider With Rosie*, by Laurie Lee.

Victor Gollancz Limited, for extracts from *Frenchman's Creek*, by Daphne du Maurier.

Mr R. S. Thomas for lines from his poem *The Bank Clerk*, from 'Vernon Watkins, 1906–1967.' Edited by Leslie Norris, and Published by Faber and Faber.

Jonathan Cape Limited, and the Executors of the W. H. Davies Estate, for two poems by W. H. Davies: *The Ways of Time*, and *Days that have been*, from *The Complete Poems of W. H. Davies*. Also extracts from *Kilvert's Diary*, Edited by William Plomer, and Mrs Sheila Hooper, the editor. Also extracts from *Autobiography*, by Eric Gill, by permission of the executors of The Eric Gill Estate.

Mrs Menai Williams for lines from the poem *Cwm Farm Nr Capel Curig*, by Huw Menai.

George Allen & Unwin Limited, for extracts from *Memories*, vols. I and II, by Julian Huxley.

Extracts from W. B. Yeats: *The Wild Swans at Coole*, and *Coole Park, 1929*, by kind permission of Michael B. Yeats, Anne Yeats, and Macmillan London Limited.

Index